DOGS *in* ART

DOGS *in* ART

SUSIE GREEN

REAKTION BOOKS

Published by Reaktion Books Ltd
Unit 32, Waterside
44–48 Wharf Road
London N1 7UX, UK
www.reaktionbooks.co.uk

First published 2019
Copyright © Susie Green 2019

Printed and bound in China by 1010 Printing International Ltd

A catalogue record for this book is available
from the British Library

ISBN 978 1 78914 129 0

CONTENTS

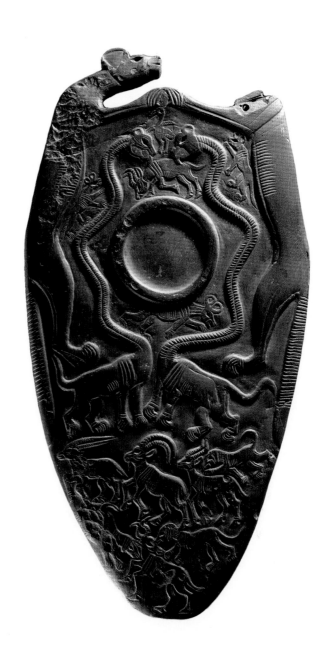

1 The *Two Dog Palette*,
c. 3300–3100 BC, siltstone.

Introduction

'Without the dog no herds, without herds, no sustenance,
no clothing, no time to waste, consequently no astronomical
observations, no science, no industry.'
OSCAR HONORÉ, 1863

The above quote from Oscar Honoré (de Bourzeis), French author of *Le Coeur des bêtes*, 1863, says it all.

In prehistoric times hominids stood alone against a fearsome, awe-inspiring world. Assaulted by the elements, astonished by glittering stars and stunned by lunar eclipses, they had two main aims. To avoid the malnutrition and starvation engendered by a diet of roots and berries by being successful in the hunt; and to escape from predators, larger and more fearsome than themselves, who viewed hominids as tasty snack items.

The dog, when it finally evolved (a history too long for a short introduction), helped these early hominids in the hunt, dragged home heavy mammoth kills and saw off marauders, be they animal or human. And slowly life began to change. When *Homo sapiens* finally began to keep herds of goats and sheep, it was the dog who rounded them up and brought them home, the dog who saw off frightening predators who viewed a goat or a nice fat sheep as an easy picking. Civilization, as we think of it today, had begun.

The ways in which the dog helped, and continues to help humanity is infinite. She hunts, she retrieves, she moves heavy loads, she guards houses and babies, she herds everything from turkeys to sheep and can lead her master to a trapped or lost beast, she is the eyes of the blind (when the twin towers in New York were burning, calm Labrador Roselle led her blind owner and a

further thirty terrified city workers down nearly eighty floors, through fire and thick smoke and out to the pandemonium-filled streets[1]) and the ears of the deaf, she may rescue the drowning and her incredible sense of smell allows her to detect cancers and locate those buried alive when buildings collapse, her coat may be used as wool, she races for our pleasure and acts as a status symbol. And in a gross betrayal smacking of cannibalism for a creature considered by many to be an honorary human, she has her body, her very flesh, devoured, even today.

Above all she is the loyalest of friends and the most steadfast of companions, a spirit that can be relied upon even in our darkest hour. And in the twenty-first century, when in Western civilization friendship is marginalized to a form of slow quasi-communication via a screen, when a man or woman may have 5,000 friends on Facebook and still dine alone, when nature is marginalized, poisoned and destroyed, the dog still remains our true and loyal friend, a creature of flesh, blood and emotion and a poignant reminder of all we are losing.

Unsurprisingly then, since the elegant *Two Dog Palette* (illus. 1) was first carved from stone in Hierakonopolis (southern Egypt) more than 5,000 years ago, there has been a vast and unceasing outpouring of art featuring canine images from almost every culture and school of art imaginable, excepting that of Islam (in general meaning the visual arts produced from the seventh century onwards by people who lived within the territory that was inhabited, or ruled over, by culturally Islamic populations) and strictly religious schools of art.

The dog appears in classical Greek carvings and the most extreme Cubism. She is the lauded star of the great cynegetic works emerging from the courts of Louis XIV and Louis XV and in the form of a tiny lap dog is seen as the companion of those in medieval and Renaissance religious orders. She hunts with the goddess Diana and is seen ratting. She figures in Expressionism,

photo-realism and actual photography. She has been transformed into porcelain ornaments by Meissen and is Eastern Buddhism's beautiful Dog of Fo. She has been made into a secret sign to indicate membership of the Freemasons in Germany, figured as the powerful Egyptian deity Anubis and been painted crouching in pain and starving at the end of a cruel chain.

The engaging history of the dog in art is, on one level, a reflection of humanity's own story. It is also an account of humanity's relationship with the dog in both its broadest and most personal sense. And so this book not only includes a startlingly rich diversity of canine images, it goes beneath the surface of those works to place them in the cultures that gave rise to them and to look at exactly *why* they were painted or sculpted in the way they were. It looks at the intimate relationships that have so often given rise to canine portraits and endeavours to tell the tale behind them. In particular it examines the fascinating relationships that so many artists from Dürer to Warhol, from Hogarth to Munch have had with their own dogs and the extraordinary paintings that these relationships have given rise to. Every picture tells a story and these particular paintings tell some of the most fascinating of them all.

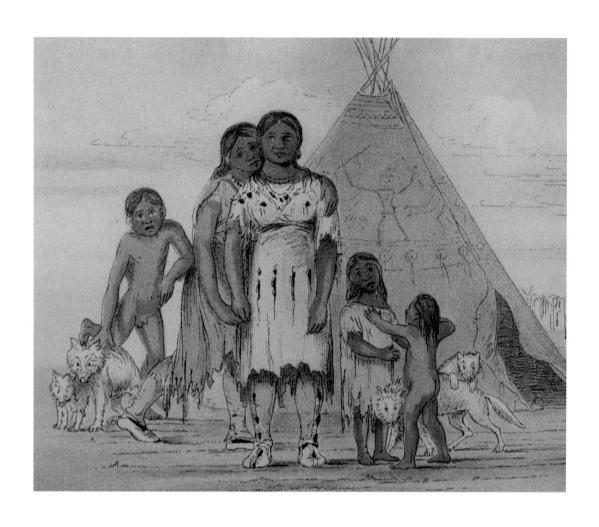

2 George Catlin, *Comanche Squaws with their Dogs, c.* 1835, watercolour.

ONE

In the Beginning

'Dog: A kind of additional or subsidiary deity designed
to catch the overflow and surplus of the world's worship.'
AMBROSE BIERCE, *The Devil's Dictionary* (1906)

Dogs have always been with us. But art is not as old as the
dog and cannot show us what the *Canis familiaris* of
100,000 years ago looked like. And not even the wondrous 32,000-
year-old art gallery discovered in the caves of Chauvet in France
give us the image of a dog. Although tantalizingly, it does contain
the footprints of a ten-year-old child with accompanying paw prints.
Footprints which show that the child had been moving slowly and
bending. So it is not hard to imagine that she was stooping to caress
a pet.[1]

Certainly 6,000 years later – the blink of an eyelid in prehistoric
time – Siberian husky-type dogs lived at Predmostì in what is now
the Czech Republic. Weighing in at around 35 kg (77 lb) and stand-
ing 60 cm (24 in.) to the shoulder, these were solid, hefty dogs who
were well equipped to haul home the gigantic bones, tusks and
meat joints extracted from their masters' mammoth kills. But the
care and attention given to their bodies after death shows clearly
that these huge dogs were much more than beasts of burden to
these early hunters. One had been buried with a large bone between
its jaws, placed there to ensure that his soul had enough food for
its long journey to heaven. Others had had their skulls perforated
to remove their brains – not for food, for the Predmostians were
richly supplied with nutritious meat, but because, like many indig-
enous peoples, these hunter-gatherers believed that the animal's

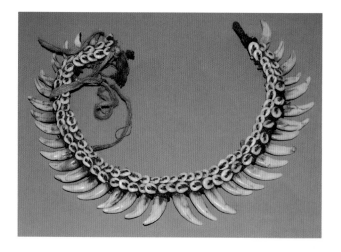

3 Dog-tooth necklace, Papua New Guinea. It was not only early Europeans who used dogs' teeth to create talismans and jewellery. The practice was common to indigenous peoples across the globe and continues into the 21st century. In Papua New Guinea a dogs' tooth necklace was, and is, both an article of adornment and an item of considerable value – exactly as a gold necklace is in many other cultures. With only this photograph as reference experts have identified the teeth as originally belonging to dogs and/or boars.

head contained its spirit and that by doing this they would set it free to journey to the afterlife.[2]

Early Europeans showed regard for their dogs in other ways too. Forty thousand years ago they began carving mammals' teeth and wearing them as jewellery. But these teeth were not taken from any animal at random; they were from animals that held some kind of real significance. Maybe they were from a species of animal that gave their tribe or group its identity, or from one who had mysterious magical powers and whose teeth could thus be used as talismans to ward off evil or bestow strength. Or they might have been taken from a favourite dog or one that they held in high esteem for its great strength, which seems likely to have been the case with the simply carved dog's tooth unearthed at Predmostì.[3]

Without art the dogs of these prehistoric peoples can only be the dogs of our imaginations, hazy ghosts we clutch at and which disappear just as we feel we are getting close to them. There are, however, two nineteenth-century artists and diarists, George Catlin and Alfred Jacob Miller, who give us a glimpse of at least some of these phantom dogs.

In the twenty-first century true hunter-gatherers and their animals have all but been wiped out. However, until the middle of the nineteenth century great swathes of the northern American continent were still inhabited by tribal Indians who lived as their ancestors had and who depended on the monumental buffalo in exactly the same way as the Predmostìans and other prehistoric peoples had depended on the mammoth. These tribes were accompanied by dogs whose form was as ancient as their way of life. Without their dogs, tribal life would have been brutal. For not

only did the dogs hunt, but they herded buffalo; acted as informal babysitters by rounding up wandering children; slept with their owners, keeping them warm in bitter winters; tracked; guarded; provided fleeces as usable as those of sheep; and, crucially, hauled loads just as the Predmostian dogs had. Catlin, watching a six-hundred-wigwam encampment of Crow moving on, noted that the Crow possessed around 7,000 dogs and that 'every cur of them, who is large enough, and not too cunning to be enslaved is encumbered with a car, or sled on which he patiently drags his load . . . faithfully and cheerfully.'[4]

Unfortunately Catlin's watercolours do not allow us to see these dogs in very great detail. However, those of Miller do, thanks to the wealthy merchant, art collector and gallery founder

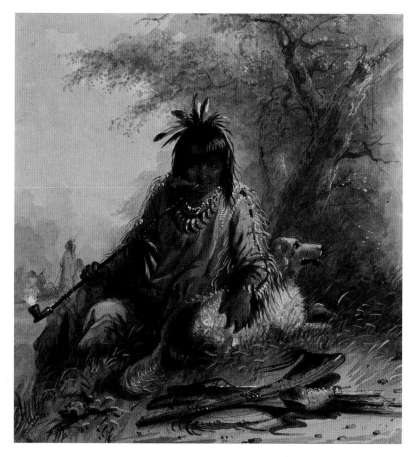

4 Alfred Jacob Miller, *Snake Indian with his Dog*, 1858–60, watercolour heightened with white on paper.

overleaf:
5 Detail of Giovanni de' Vecchi's Mappamundi, 1574–5, at the Villa Faranese, Caprarola, Italy, showing several constellations including Canis Major. Sirius is its brightest star.

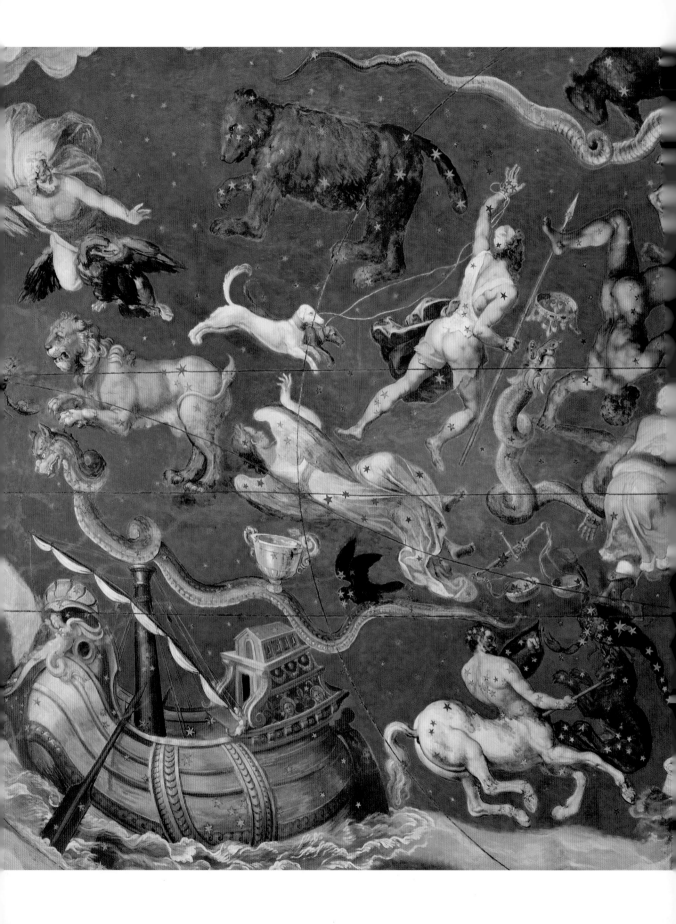

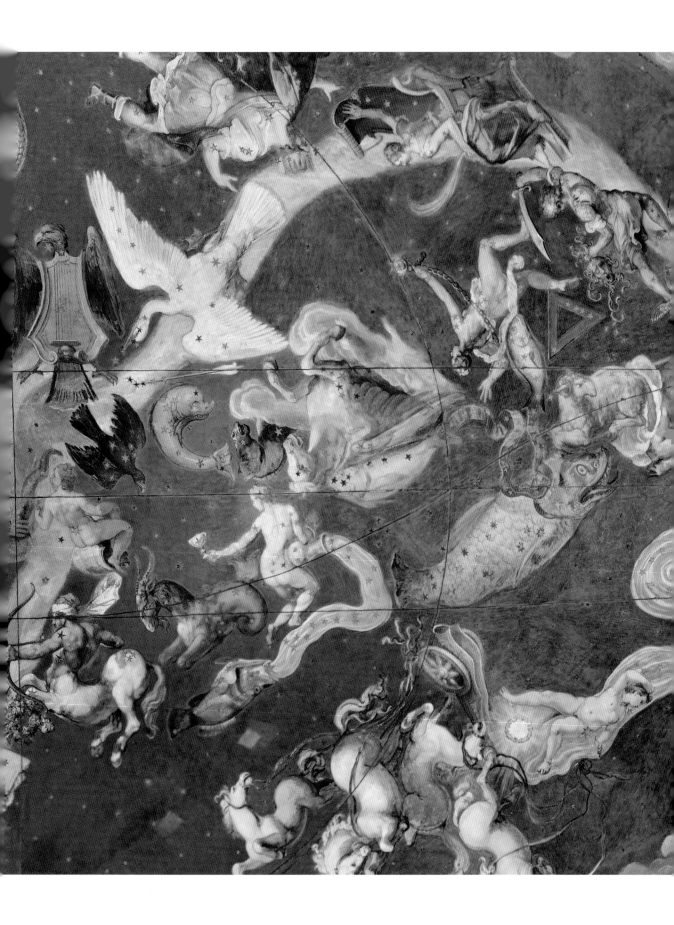

William T. Walters, who in 1838 commissioned Miller to paint transcriptions of the field sketches he had drawn while at the annual fur-traders' rendezvous in the Green River Valley. These Native Americans mainly trapped beavers, but because demand for beaver fur petered out at the end of the 1830s this chronicle, like Catlin's, is of a time and way of life lost for ever. *Snake Indian with his Dog* is a gorgeous, exotic, yet realistic painting of an everyday scene, that of a man smoking with his dog by his side (illus. 4). And the creamy-coloured dog with his deep coat is especially interesting, for he appears to be extremely similar if not identical to those painted by Catlin.

As our lives have always been intimately intertwined with those of dogs, it is not surprising that they frequently appear in our art. Partially this is an acknowledgement of the wide-ranging practical help they afford us, particularly as hunters, trackers, herders and watchdogs. But it is also due to the deep and enduring love so many people feel for their dogs and the underlying knowledge that even in our darkest hours our dogs will not desert us, that they, at least, are still to be trusted. In contemporary times the most obvious expression of this trust is in the use of dogs to guide the blind and alert the deaf but in ancient cultures society as a whole entrusted both their spiritual and their material well-being to the entire canine race.

ANCIENT EGYPT

The ancient Egyptians believed that men and animals were created together by the Sun god Ra and thus animals were partners in life and worthy of respect. As such they trusted the dog with both their lives and their souls. On earth they relied on the crucial annual Nile flood to irrigate all lower Egypt's crops. And Sirius, the star that signalled the coming of this vital flood by becoming visible above the eastern horizon before dawn, they named the

Dog Star, thus ensuring its fidelity. While in the realms of the dead they entrusted themselves to the canine-headed deity Anubis.

To gain entrance to the land of eternal life, all Egyptians had to prove they had led a blameless life, one of truth, balance, harmony, law and morality. To determine this, their hearts were removed and placed on one pan of a balance, while on the other would be laid the feather of the deity Maat, whose hieroglyphic representation signified all those values. If the weight of the heart was even infinitesimally greater than that of Maat's feather, this was proof that the deceased had sinned. With eternal life or eternal damnation quite literally hanging in the balance, the trust the ancient Egyptians placed in Anubis, who adjusted the plumb weight for accuracy, was clearly infinite. For no greater catastrophe could overcome an Egyptian in this life or the next than to be shown to have sinned. Instead of their heart being returned to their body, the monstrous Ammit, 'The Devourer of the Damned', who crouched in readiness below the scales, would greedily consume it and they would be banished from the afterlife for all eternity.

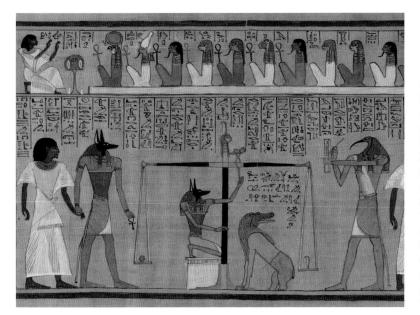

6 Book of the Dead of Hunefer, sheet 3. Judgement vignette with captions and spell 30, papyrus, early 19th Dynasty (1292–1190 BC). Hunefer (Hw-nfr) was an important official, a royal scribe and Overseer of the Cattle of the Lord of the Two Lands. In this detail Anubis can be seen leading Hunefer towards the scales of judgement and Anubis adjusting the all-important plumb weight with Ammit 'crouching below'.

Anubis was also seen as a protector of souls and even the powerful profane ruler Tutankhamun ensured that a sculpture of Anubis was placed in his tomb in order to ensure the deity's continued benevolence. Magnificent, elegant and powerful, the wooden sculpture took the form of a large dog and was painted black to emphasize Anubis's intimate relationship with death and embalming resin. Some commentators believe that Anubis takes the form of a jackal not only because of a certain physical resemblance to this wild dog, but because jackals scavenged graveyards. However, the sculpture's long, elegant legs and pricked ears are also features of Egyptian sight hounds, the greyhound-type canines whose ears were often cut to make them stand upright as a jackal's do naturally, so these hounds, too, are strong contenders for godly status.

Many wealthy individuals wanted their own dogs to accompany them on their perilous journeys to Osiris's kingdom and so tomb art often featured images of a dog seated beneath the deceased's chair. Other, rather less fortunate pets were sacrificed, mummified

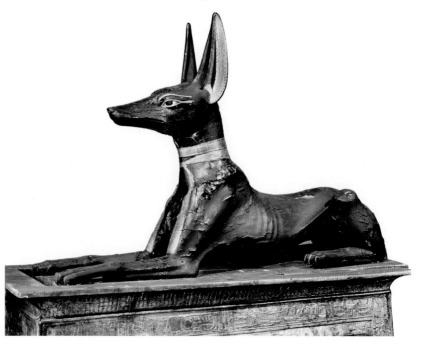

7 The Shrine of Anubis, from the tomb of Tutankhamun. The jackal is made of wood, plastered and painted black.

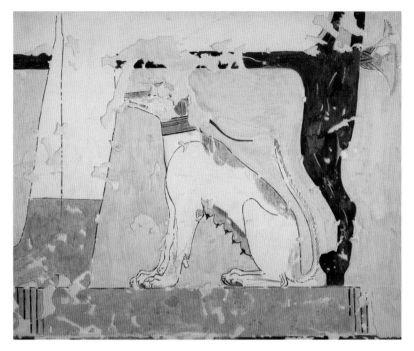

8 Charles K. Wilkinson, *Dog Seated Beneath Its Owner's Chair, Tomb of Nebamun,* c. 1479–1458 BC, 1920, facsimile tempera on paper painted at El-Khokha for the Egyptian Exhibition of the Metropolitan Museum of Art.

and laid to rest next to their earthly owners: certain, if unwilling, companions in the afterlife.

GREECE AND ROME

As the Egyptian culture waned Graeco-Roman culture waxed, and with it, art. Egyptian paintings and carvings were often powerful and give us a fascinating insight into both early breeds of dogs and the culture that surrounded them, but the Egyptians' stylized art, combined with their particular use of perspective, did not lend itself to natural, realistic images – something the Greeks were to remedy.

By the early classical period, circa 500–450 BC, Greek vase artists had stopped painting figures simply as flat black silhou-ettes and had taken to using lines, a kind of simplified drawing in paint, which meant that for the first time they could show a body's roundness, its true corporality. The heads of those bodies,

9 The Berlin Painter, amphora depicted with a musician and dog, *c.* 480 BC. This delicately rendered red-figured vase displays both the Berlin Painter's subtle use of line as well as his exposition of the exciting new border-less design technique. Dogs were the usual companions of musicians and revellers and the artist has rendered this one in a particularly amusing and charming manner. Aristocratic dogs also spent a great deal of time underneath their masters' couches when they attended symposia – banquets where men met to discuss philosophy and politics and to recite poetry while consuming liberal amounts of wine.

however, they still tended to draw in a mainly flat profile, which gave a hybrid perspective that hovered somewhere between realistic perspective and the two-dimensional style employed by the Egyptians.

This new flowering of creativity produced many talented artists, of which perhaps the greatest, and the most prolific, was the Berlin Painter, who was named after the location of his most famous work, an amphora in the Antikensammlung in Berlin, by the British classicist and art historian Sir John Beazley. For Beazley realized that there was a single ancient Athenian hand responsible for literally hundreds of the vases and their fragments that he had studied.

Vase painters had always surrounded their subjects by patterned borders, which meant that the subject, be it god or musician, was simply part of an overall design. The Berlin Painter eliminated these borders, which for the first time in Greek art meant the subject dominated the composition instead of being subservient to it.[5]

Graeco-Roman mosaic work was often refreshingly lively. Their canines rail indignantly at being tied up; they raise optimistic paws and loyally menace would-be intruders. Sometimes these subjects were depicted in profile but some, such as the Alexandra dog (illus. 10), are as skilfully rendered as they would be in an oil painting by an Old Master. Unearthed at El Shatby in Lower Egypt's Alexandra, this dog dates to the Graeco-Roman Ptolemaic period of the second century BC.

However, not even the Alexandra dog can compete with this culture's later marble sculptures, in which dogs verge on life, sculptures sometimes so magically rendered that we all but expect to see the gentle movement of ribs behind skin

10 Dog mosaic, *c.* 200–150 BC. The Alexandra dog is vital, his eyes bright and enquiring. The naturalistic rendition of both the dog and the fallen vase is superb. The artist has given us a living, breathing animal that we can believe in. And one that just as easily could be living today as 2,000 years ago.

that signifies breath. The idealized form that the Greeks and Romans strove for was now at its height and no sculpture since has eclipsed its flawless lines. We tend to think of Graeco-Roman sculpture as having been intentionally left white, but in reality those clean sparkling marbles that we admire in museums would have been painted in glorious colour, as, presumably, would have been the marvellous *Townley Greyhounds*.

Since only the few could commission sculptures such as these, but the many liked to display canine and other decorative works, various rather more reasonably priced art forms blossomed. In Britain and Gaul, for example, jewellers produced small, whimsical brooches that often featured animals and which were particularly popular with both provincial Roman soldiers and the local inhabitants. A brooch of a dog attacking a boar (illus. 12) features

11 *The Townley Greyhounds*, Roman, 2nd century AD. These exquisite sight hounds were found at Monte Cagniolo (Dog Mountain) to the southeast of Rome in 1774. The subtle carving renders their physical presence perfectly but more than this the sculptor has captured the sweet tenderness of their emotion: the gentleness with which the bitch nibbles at the dog's ear, one paw placed on his back; the dog's head caught just as he turns to his mate. These are no imaginary dogs, the detail and expression is too knowing, too intimate. They must surely have been the sculptor's own hounds or at least ones he knew well.

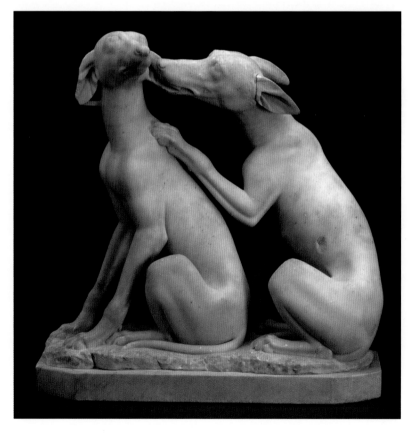

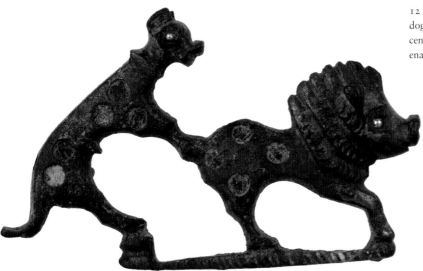

12 Brooch in the form of a dog attacking a boar, 2nd century AD, champlevé enamel, bronze and gold.

champlevé, a sophisticated technique in which coloured glass pastes are fused into designs incised in metal. Like the *Townley Greyhounds*, it dates to the second century AD.

Funerary art was also highly sophisticated in Graeco-Roman times and it was not uncommon for dogs to be given their own beautifully carved sarcophagi and to share in a family's communal burial plot. The tomb of Margarita (which means pearl) in the cemetery of Porta Pinca was marked with a detailed and charming epitaph in verse, written as if by 'the snow white dog herself'. Several of the lines were plays on phrases from works by the most important authors of the time. '"Gallia me genuit" (Gaul gave me my birth) reminded readers of Vergil's funerary epitaph "Mantua me genuit"', while others 'evoked Ovid's The Art of Love and The Art of Beauty'. Margarita was clearly a dog who had been much loved and was much missed.[6]

Although we do not have a carving of Margarita, there are many other adored pets and working dogs whose likenesses do remain. Often their reliefs were included on the deceased's sarcophagus and a particularly touching example is that of Avita, a ten-year-old Roman girl. With her stiffly waved hair and her

13 *Relief of a Herdsman*,
2nd–3rd century,
Roman, marble.

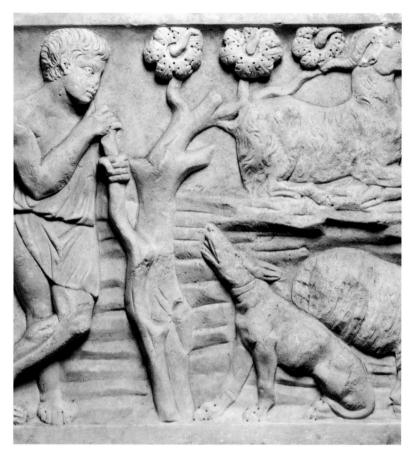

attention concentrated on a scroll on her lap, she seems more like
a little adult than a child. And perhaps this was Avita's character
in life, for behind her, her little dog puts a longing paw on her
stool, reminding her that there is always time to play.

It is relatively unusual to see a herding dog in ancient Egyptian,
Greek or Roman art, as then as now, hounds and toy dogs almost
always steal the limelight. However, some sarcophagi feature
mythological scenes and the second- or third-century Greek ex-
ample illustrated above probably features Endymion – a handsome
herdsman with whom the moon goddess Selene fell in love – with
his trusty and obviously devoted herder. His massive paws and
muscular form are noteworthy as indications of his strength and
demonstrate that not only could he shepherd his flock home but

he was perfectly capable of besting any predator that tried to harm them.

One place the herding dog did get its just dues was in ancient Persia, thanks to Ahura Mazdâ, the supreme being of the world's oldest monotheistic religion, Zoroastrianism. Ahura Mazdâ's words, as revealed to his prophet Zarathustra over 3,000 years ago, could hardly have been clearer: 'No house would stand "firmly founded" for me on the Ahura-created earth were there not my herd dog or house dog.'[7] Ahura Mazdâ, the one true god of Zoroastrianism, was giving his personal endorsement to the canine race – beings that had come 'from the star station' (a place of major importance in Zoroastrian cosmology) – and he expected humanity to show them due gratitude. For dogs had been created 'self-clothed, self-shod, alertly watchful, sharp-toothed, sharing the food of men, to watch over (man's) possessions'. And so in Zoroastrianism's sacred texts, humanity's responsibility to its own kind goes hand-in-hand with its responsibility to dogs. A sick dog, for example, should be looked after just as tenderly as any human, and a whelping mother given all the care and love someone breast-feeding would expect.[8]

It is difficult to imagine how hard life must have been for those who inhabited Persia's wilds, and just how much harder it would have been for these tribal people without their dogs. For these were dogs to be reckoned with, great forces in their own right. Massive 100-kg (220-lb) Sarabi mastiffs faithfully guarded flocks and did quite literally keep the wolf from the door – duties that, in the early decades of the twenty-first century, they still perform faithfully for those who live in traditional ways. Without them these early tribal herders might have starved and would have been easy prey for marauding bandits. With a Sarabi at their door, they

could sleep easily in their beds. No wonder they felt the gratitude to them that Ahura Mazdâ expected them to. They were quite clearly, just as the one true deity had declared them to be, humanity's 'closest companion', herd and house dog in one enormous and powerful package. A package which unsurprisingly became immortalized in Persian art, one of the few extant examples being a magnificent mastiff found in the Apadana Audience Hall at Persepolis, the ancient capital of the Zoroastrian King Darius. Dating to around 500 BC, it was sculpted from limestone and is a superb and elegant example of Achaemenian art, a style which favours decoration over absolute devotion to form. Originally one of a pair (the other has been decapitated), it once flanked the doorway of the Audience Hall's southeast tower. A strong and able guardian and surely exactly the type of dog Zarathustra wrote about.

Pollution is a concept that is central to Zoroastrianism, and thanks to the terrible Nasu, a demonic force in the corporeal form of a vile fly, the two most polluted things on earth are human and canine corpses. Dogs were created 'for the protection of beneficent animals, as if blended of beneficent animals and people', and so in death are as much a target for the powers of evil as a benign moral human.[9]

A crucial problem for Zoroastrians was, and remains, how to remove this pollution. For earth, fire and water are sacred elements and as such must never be polluted. This means corpses can neither be buried, burnt nor consigned to the oceans' watery depths. Instead the dead, be they canine or human, were carried out to distant and deserted places to be devoured by dogs and vultures. In the hot, rocky, desert lands of Persia, this was and is a practical, hygienic and spiritually consoling solution.

But such was the power of evil that even the paths over which these bodies were taken became polluted – a tricky dilemma but one resolved by dogs. In the Avesta, Zoroastrianism's primary

14 Head of a Persian Mastiff, c. 500 BC, limestone.

26

collection of religious texts composed in the Avestan language, dogs are frequently recorded as eating corpses. As this practice did not harm them, it was obvious that Nasu, the corpse demon, held no power over them. Thus a living dog was puissance personified and, reputedly, the most puissant of the puissant was a dog with 'two flecks of different coloured hair above the eyes'.[10] As such, if dogs were simply to walk along the path a corpse had taken, they would cleanse it. Dogs naturally also performed this crucial service for their own dead. And even until the mid-twentieth century a 'house dog' who had died was wrapped in 'an old sacred shirt tied with a sacred girdle' and carried to a faraway barren place to be given a simple Zoroastrian canine funeral service.[11]

In more recent times, Zoroastrians built Towers of Silence on which to place their dead. High above the earth, these bodies were mainly devoured by vultures while dogs continued to perform their pollution-cleansing in the wake of the corpses. A particularly fine example is set in beautiful wild gardens in Mumbai, which today is a major stronghold of Zoroastrians (or, as they are known in India, Parsis). Their presence in Mumbai came about because in the tenth century AD, unable to bear ever-increasing persecution by the forces of Islam, a small band of Zoroastrians fled by sea to India. After many peregrinations and trials they settled in the place we now know as Mumbai.[12] The Zoroastrians were persecuted in myriad ways, one of which was for Muslims to ill-treat their beloved and highly revered dogs – a behaviour that soon came to symbolize that one was a member of the Islamic faith, and which was a sure way of signalling that one had converted to Islam. Thus dogs became unwitting pawns in a religious conflict, which has led to a plenitude of suffering on their part as they became regarded as unclean by Islam.[13]

Zoroastrian reformists have been agitating to remove dogs from their rituals since the middle of the nineteenth century and now, in the twenty-first century, it seems that they have virtually

succeeded.[14] So in all probability the like of the skilfully sculpted Persian mastiff from Persepolis will never again guard a Zoroastrian stronghold. And yet another branch of humanity has chosen to distance itself from the natural world of which it so often forgets it is actually a part, and to which it owes so much.

THE OLD NEW WORLD

Although the Aztecs came to prominence relatively late – their two-hundred-year-old empire was only established in 1325 – their beliefs and art forms were virtually all based on those of the Teotihuacan (AD 1–750) and the Tula (AD 900–1200), who used to inhabit the same region. These earlier peoples understood the fragility of their existence and their crucial dependence upon the natural world – and it was a wisdom that the Aztecs embraced wholeheartedly. And so, even the smallest signs of the unusual in nature, such as the sudden departure of birds, a heaviness in the air that might presage a storm or a strange restlessness in dogs, were noted and acted upon materially or spiritually. Inevitably, the Aztecs' mythology, art and codices (painted books) teemed with every manner of mammal, reptile and bird, all of which took on a divine significance. As in the later western medieval era, art was employed in the service of religion and ideology. It was sacred and the artist was considered a *Tlayolteuhuiani*, 'he who puts the deified heart into objects', or a *Moyolnonotzani*, he 'who confers with his heart' – another way of saying that he experienced the divine and made it concrete through art.[15]

Hairless breeds of dog, *xoloitzcuintli* (*itzcuintli* meaning dog in the Aztec language Nahuatl and Xolotl the name of an Aztec deity in the form of a dog), have appeared in the art of the Mesoamerican cultures of western Mexico for over 3,000 years. As in ancient Egypt, one of the principal reasons for this was the faith these peoples had in the dog's ability to guide them through the

15 The Aztec deity Xolotl
(top left). Agostino Aglio,
Codex Borgia, 1825–31
facsimile of 1500 original,
tracings comprising 76 leaves.

terrible dangers of the world of the dead – a faith the Aztecs embraced with a passion.

This passion is based on mythology deep within the Aztecs' complex cosmology, which centrally believes that the universe will exist for five cosmogonic ages, the eras of the five suns. Although the procession of the five ages is linear, each age is itself cyclical and thus, as they are created, so must they perish and the next Sun god bless the skies. The world was created in the First Sun age and, like the universe, will end definitively in the Fifth.

During the First Sun, the gods' parents punished them for childish desecrations such as picking flowers from the tree of knowledge, the world tree. Those who rebelled against their punishment were sent to populate earth and the underworld, and there, in exile, one of their number courageously sacrificed himself and rose as a star in the east. But before he would cross the skies and warm the earth, he demanded the self-sacrifice of all the other gods on earth, so that they might be reborn in myriad living earthly forms.[16]

Four such ages and suns have now passed and we dwell in the fifth and final age, which it is prophesied will end with violent earthquakes and the starvation of all living creatures upon this earth. The Fourth Sun had ended with a terrible flood and the Living Bone – the only remnant of humanity that survived – was buried deep in Mictlan, the Aztecs' dangerous nine-layered underworld guarded by the skeletal Mictlantecuhtli, Lord of Death. The deity Xolotl, after terrible trials, rescued the Living Bone and carried it to Quetzalcoatl, his twin, who ground it into powder and mixed it with his own lifeblood to recreate humanity for the final time. And so Xolotl, although associated with death, had also become its conqueror: an extremely potent image.

16 This sensitively carved and rather charming stone dog dates to around 1500. This dog's owner may have affectionately called it *chichi*, *telami* or *tehui*. Dog was a glyph in the agricultural calendar, and *Ce Itzcuintli* (i-dog) was the fourteenth thirteen-day period in the Aztec ritual calendar. Those fortunate enough to be born during this period could look forward to especially lucky lives, particularly if they were destined to be rulers.

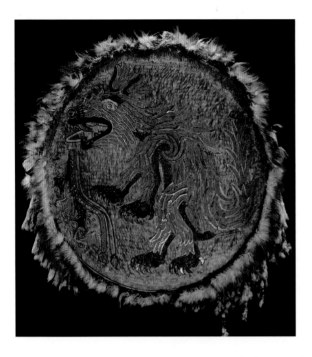

17 Feather shield of Ahuizotl.

Xolotl, fearing that humanity would again manage to lose themselves in Mictlan as they had in the Fourth Age, used a tiny sliver of the Living Bone to create a guide and protector in his own image and endowed this creature with all his knowledge and wisdom. And so the *xoloitzcuintli* or Xolotl (Xolo) Dog came to inhabit the earth. Xolotl gave this extraordinary canine to humanity and charged them to guard it with their lives. In return, when the time of their individual deaths arrived, the Xolo would guide their souls down through the Mouth of the Jaguar, over the great water, through the nine levels of Mictlan and out through the gate of living rock, to the red light of the deity's Evening Star and finally to heaven.

Two carved stone heads of Xolotl have come quite literally to light relatively recently, rescued by chance from dark, fittingly underworld obscurity beneath the heaving architecture and teeming masses of humanity in Mexico City. It is thought they were part of an 'architectural complex that described the sun's movement towards the west on its way to the underworld led by the fantastic beings depicted in the sculptures (Xolotl)'.[17]

Besides Xolotl and the *xoloitzcuintli*, a third and extremely mysterious canine form inhabited the Aztec world: the Ahuizotl, the water dog or water thorn beast, a curious being with a hand at the end of its tail, a hand that might drag the unwary to their deaths in murky waters and there consume them. The eighth *tlatoani* or ruler of the Aztecs (1486–1502) was named Ahuizotl and curiously, or perhaps by the desire of the Aztec gods, he is thought to have perished in the great flood of Teotihuacan in 1502.

Ahuizotl's shield is a rare and exquisite work of Aztec art and would have been one of his most valuable possessions (illus. 17). The Chinese consider jade to be the most precious of all materials; the majority of humanity consider gold most precious. The Aztecs, even though they employed gold, considered it to be nothing more than the excrement of the gods and prized instead that wondrously constructed miracle of nature, the feather – so much so that subjects could pay their taxes by sending plumes of all colours and iridescences to the capital.

Ahuizotl's shield (one of only six surviving Aztec feather works) features the extraordinary water dog painted in quetzal feathers. Other feathers utilized in its creation include those from the scarlet macaw, roseate spoonbill, lovely cotinga and white-fronted parrot.

18 Dog, 200 BC–AD 500, slip-painted ceramic with incised decoration, from Colima.

COLIMA

The plump pottery dogs of the Western Mexican Colima culture (200 BC–AD 500) demonstrate clearly the intricate, intimate and sometimes contradictory bond between the dog and humanity. For besides being spirit guides – who were sometimes sacrificed and buried with their master or mistress as they were in ancient Egypt – the hairless dogs were family pets, revered as healers (perhaps partially because, being hairless, their bodies radiate heat and thus give tremendous comfort), and were also farmed for food just as turkeys were.[18]

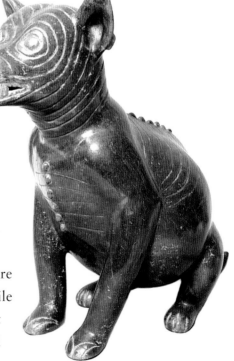

Most Colima shaft tombs have been looted long before archaeologists manage to see them. However, while archaeologists in Villa de Alvarez were unearthing cist burials (small stone coffins) containing human and

canine remains from around AD 400–600, they also discovered an earlier, miraculously untouched deep shaft tomb. It was not the mausoleum itself that amazed the archaeologists, however, but its exterior. For the tomb was surrounded by the carefully placed remains of children, infants and xolos, sacrificed to ensure the safe passage of the man interred in the vault below, a man who was already flanked by one or two other adults and a guardian shaman fashioned from pottery.[19] Fortunately for children and xolos alike it was usually pottery dogs that acted as trepid humanity's guides and protectors. The delicious slip-painted example from Colima (illus. 18) has incised decoration, a stylistic representation of the folds of skin that many xolos have on their brows. He may have been a pet, a tomb dog or simply a charming representation of what was to be a tasty dinner. Just as a painting of a lamb is.

19 Howling canine, 5th–6th century, ceramic.

Today, Mexican gift shops and museums sell innumerable copies and modern representations of these dogs not just for their sweet aspect or their artistic appeal but because they offer a tender security that resonates reassuringly in the human mind. But the xolo is much more than a reassuring reference to a long-lost past. It remains a powerful cultural icon in Mexico and it was inevitable that artists such as Frida Kahlo (1907–1954) and Rufino Tamayo (1899–1991) should incorporate it into their work. Like Kahlo, although he was principally of Spanish descent, Tamayo identified himself absolutely with pre-Columbian Indians and their culture and this is strongly reflected in his art. The similarities between the dogs in Tamayo's stirring painting *Animals* (illus. 20) and the ceramic of the west Mexican howling dog dating to the fifth to sixth century AD (illus. 19) are immediately obvious.

The received interpretation on this and a similar work by Tamayo, *Dog Howling at the Moon* (1942), is that they are intimations of apocalypse and the horrors of the Second World War. The art historian Robert Rosenblum even sees

the dark blue bones in *Dog Howling at the Moon* as 'suggesting the presence of a caring human master who has long since vanished or even been devoured'.[20]

In *Animals* the colours are a reflection of Tamayo's desire to use primaries and in particular red and black. The light that bathes the dogs is eerie, yet the dogs seem more curious, more interested than afraid, less snarling than excited. Their eyes are bright and fascinated. They do not for me represent 'that horror before a world that was turning to stone before our eyes', as they did for the Mexican painter Juan Soriano, but an engagement with the future and a clear reference to the mythology with which Tamayo so associated himself.[21] The bones at the dogs' paws can be read as an allusion to the Living Bone torn from the underworld at great cost by the deity Xolotl and used by his twin Quetzalcoatl

20 Rufino Tamayo, *Animals*, 1941, oil on canvas.

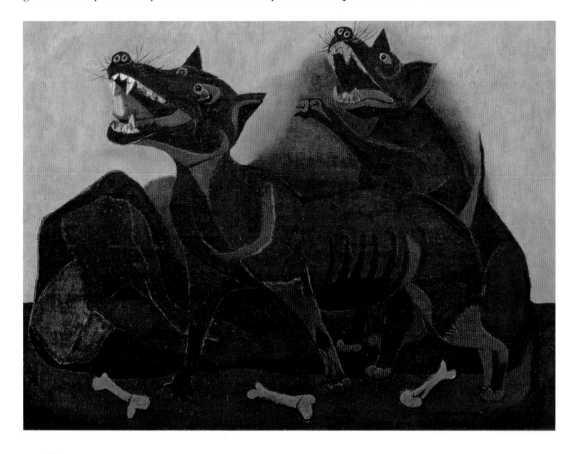

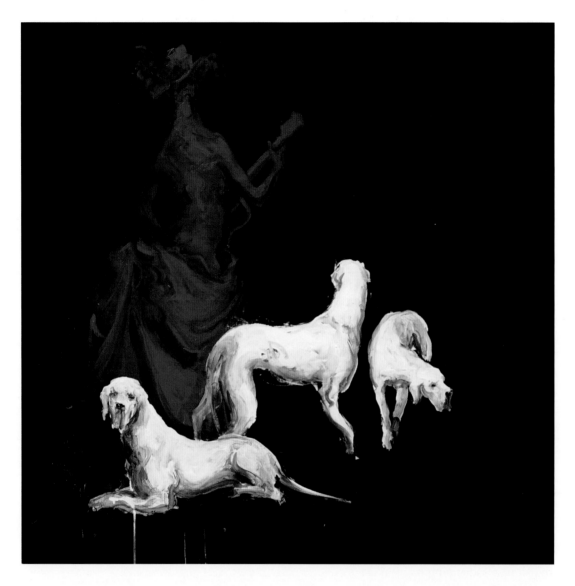

21 Luca Bellandi, *Red Song*, 2017, oil on canvas. 'I have painted a woman who is keeping herself company by singing a ballad while meandering in an indefinite space looking for a sign of light. The dogs, in this image are her guardians, and they are there to follow, protect and guide her.'

to create humanity and by himself to create the Xolo. They stand for hope in a world that is crashing, a reminder that all things must pass and can be recreated in another form.

The concept of canines as guides and protectors runs so deep in our consciousness that even when creating works of art that are light and fanciful, works created for their beauty of form the dogs still retain their ancient role. And for as long as both our species survive, they always will.

The Supreme Predator

'Hunting is not a sport. In a sport, both sides should know
they're in the game.'
Mexican comedian PAUL RODRIGUEZ

This chapter is a celebration of the dog's prowess as a hunter and its representation in art. It is a visual record of the dog's bravery, his incredible skills, his finely honed physique and that unquestioning loyalty which has allowed us to harness these qualities for our own ends. Not always, it must be said, in the most admirable of ways.

At the dawn of time men were hunter-gatherers. Life was hard. Predators bristled at every turn. Food was often scarce and protein a particularly difficult commodity to source. Almost every community practised shamanism – the belief that everything upon the earth has a spirit and that every type of animal, be it elk or dormouse, has a spirit master who holds within himself the soul of every single member of that species. Eurasian and African hunters believed that their quarry was entering a sacred pact with them, that it was sacrificing its own life for theirs, that it was *consenting* to die. And so they accorded their prey the utmost respect, performing rituals that would ensure that the animal's soul would return to the land of spirits and the spirit master, who would again return it to earth in flesh and blood form. And as for their dogs, without whom life would have been immeasurably harder? Certain death awaited anyone who inflicted purposeful harm upon them.[1]

In the days of the pharaohs, today's Egyptian desert was a savannah that teemed with life: gazelles, antelopes, rabbits, hyenas

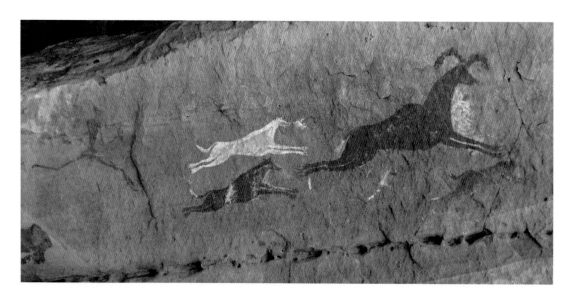

22 Rock painting of a hunter
and his dogs pursuing a goat
or antelope, from the Akakus
Mountains, Sahara Desert,
c. 5000–1000 BC.

and even lions and cheetahs. Situated on the edge of the Nile flood
plain and outside the sophistication of the cities, this savannah
represented the chaos that constantly threatened the Egyptian
cosmos and hunting was seen as helping the gods to maintain
order and so keep disaster at bay. Dogs were thus instrumental in
assuring the Egyptians well-being in the here and now and in the
nebulous future.[2]

This may account for the fact that the ancient Egyptians were
the first culture to represent their hunting dogs in any detail. By
3400 BC sophisticated artists in Hierakonpolis were carving cer-
emonial slate tablets (see illus. 1) that clearly showed sight hounds
(ideal canines for the desert surroundings) hunting their usual
quarry – gazelles.[3] This type of saluki/greyhound, along with many
others, appears frequently and consistently over thousands of
years in Egyptian tomb art and ostraca (small slabs of limestone).
One particularly fine example from the tomb of Ineni (1550 and
1470 BC) shows a splendid muscular black-and-white dog who has
in his sights not only a hyena but two gazelles (illus. 23). Hyenas
were a much-desired food item that were sometimes killed with
arrows and on other occasions captured and fattened up for the

dinner table.[4] Hyenas are still hunted and eaten in Saudi Arabia today, a practice that unfortunately is pushing these extraordinary animals to the brink of extinction.[5]

Sight hounds were just as important to the Greeks and Romans as they had been to the Egyptians and besides frequently being represented in statuary and stelae, they adorned innumerable plates and vases. Rhytons – ceramic drinking and libation cups – were often fashioned in the form of an elegant greyhound's head, a tradition which became newly popular in the eighteenth and nineteenth centuries when English potteries such as Staffordshire began to make stirrup cups in the form of dogs' heads.

With the fall of the Roman Empire in the late fifth century and the subsequent rise of Christianity, secular Western art almost entirely disappeared from view. And when it did begin to reappear in the fourteenth century, it did so in the form not of paintings but of costly status-laden tapestry wall-hangings and lavish illuminated manuscripts, one of the most notable secular manuscripts from the period being the magnificent *Le Livre de la chasse* (The Hunting Book) by Gaston III, Count of Foix (1331–1391). Consisting of four volumes – *On the Nature and Care of Dogs*, *On Gentle and Wild Beasts*, *On Instructions for Hunting with Dogs* and *On Hunting with Traps, Snares, and Crossbow* – the whole

23 Nina de Garis Davies, *Facsimile of a Hunting Scene from the Tomb of Ineni*, c. 1550–1470 BC, tempera on paper.

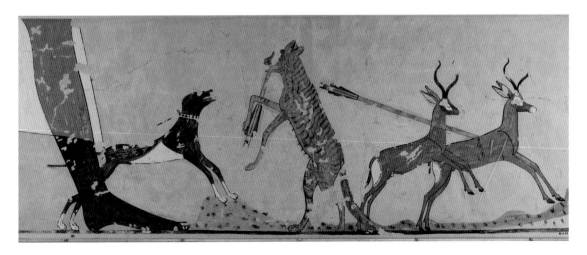

39

24 Rhyton (vase for libations or drinking), *c.* 350–300 BC, terracotta.

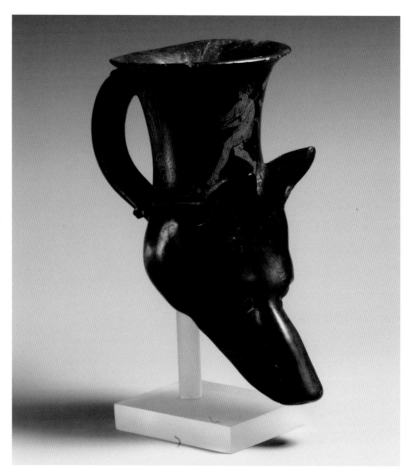

was dedicated to Foix's friend Philip the Bold, Duke of Burgundy, an enthusiastic fellow hunter and gritty warrior.

Gaston III was a master of the hunt (reputedly he owned more than 1,600 hounds of his own) in southern France, an area rich in dense forests and teeming with game of every kind. Hunting and the hound were his twin passions, and he wrote glowingly of the latter: 'It is the noblest, wisest and most sensible beast in God's creation and in general terms I make no exception for men or any other living being.'[6] He was also not abashed to write, 'Dogs give us much joy.'[7] His passion informed his wisdom, and his understanding of these dogs and their well-being, together with his mastery of the skills required for hunting, were unparalleled.

Knowledge of the subtleties of the hunt was valuable indeed in an era when across Europe, and in France in particular, the social importance of the hunt cannot be overestimated. The royal hunt was designed to be a display of conspicuous consumption, signalling that the monarch could afford to do, and be, anything he chose. To this end it took place against a theatrical backdrop of fine horses, sumptuous trappings and the lavish opulent costumes of the courtiers.

It was also a glorious opportunity for aristocrats to show their would-be legendary sangfroid in the face of death. Bravery when pursuing wild boar, ferocious animals whose tusks could rip open

25 Detail from a page in Gaston Phoebus' early 15th-century illuminated manuscript *Livre de la chasse*.

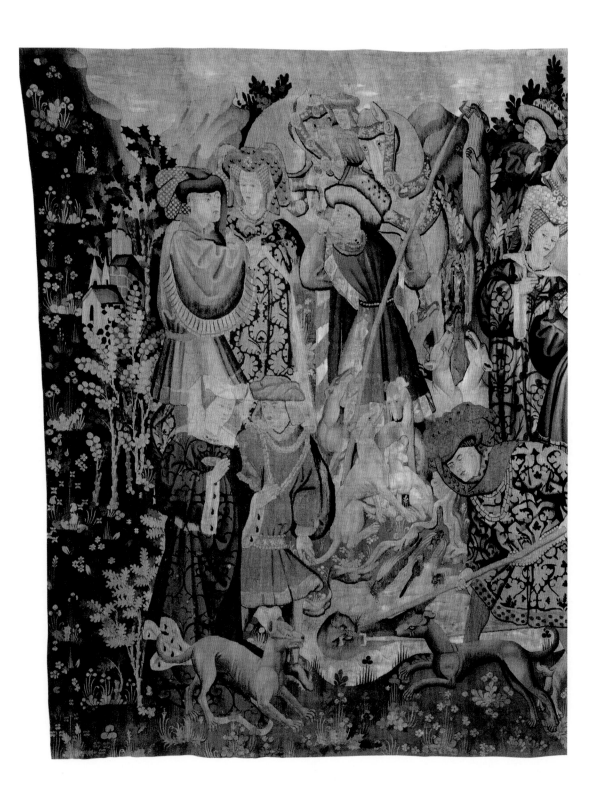

a man and his horse in seconds, was crucial. For the king of France and many other ruling aristocrats, their conduct in the hunt was seen as a reflection of how they would conduct themselves on the battlefield, a grave matter at a time when those who declared war generally actually went to war.

In either case it was essential that the royal was not let down by his hounds, who not only had to be as high spirited and courageous as the man himself, but in the peak of physical condition. This is where Gaston's book describing the cutting edge of fourteenth-century veterinary care came into its own. Although in the twenty-first century some of his cures might be considered magical, extraordinary and ineffectual, others are eminently sound and efficacious. He advised, for instance, that if one's dogs 'have hurt their feet running in "evil" country, among thorns and briars one should wash their feet with sheep's tallow boiled in wine', and 'so that they may not break their claws running on hard ground one should cut a little off the end of the claws with pincers, before the hounds go hunting'.[8]

Tapestry is so little appreciated today that it is sometimes difficult to imagine just how much this extremely labour-intensive and extraordinarily expensive art form was admired between 1400 and the end of the seventeenth century. And for a royal, besides providing much needed draught-proofing and colour in a dull, freezing castle with stone walls that radiated cold, possession of a magnificent set of sumptuous hanging tapestries was yet another marker of devil-may-care conspicuous consumption, an effect which was augmented by the use of copious amounts of real gold and silver thread. And what better subject could there be than the showpiece hunt?

Four particularly fine examples are the Devonshire Hunting Tapestries. Originally woven in the Netherlands sometime around 1430–40, they were not heard of again until the latter part of the sixteenth century, when they made their way to Hardwick Hall in

26 Otter and Swan Hunt from the Devonshire Hunting Tapestries, c. 1430s, woven tapestry.

Derbyshire, home of the Countess of Shrewsbury. In the twentieth century they were sequestered by the government in lieu of taxes owed on the estate of the 10th Duke of Devonshire and they now reside in the Victoria and Albert Museum.

In the tapestries comprising *Otter and Swan Hunt* the gruesome cruelty of an otter hunt set against a traditional backdrop of extravagantly clothed courtiers is vividly recreated. In this small section alone there are eleven hounds, the majority of which are clustered around the hunter, who is holding aloft the living, impaled otter. In the foreground, woven in a manner designed to display their svelte muscular bodies, two light-brown hounds wait impatiently as another hunter attempts to spear an otter in its underground lair, while still more dogs look for affectionate attention from a man resting on the ground. The hounds have been portrayed as individually as the courtiers, a testament to their importance in the social fabric of the era and their miraculous status-enhancing properties.

The dogs portrayed here are not specialists but by the time Sir Edwin Landseer (1802–1873) painted *The Otter Hunt* for the 4th Earl of Aberdeen in 1844 – deemed by its current custodians, the Laing in Newcastle, to show the suffering of the otter rather too realistically and graphically to be put on public show in the twenty-first century, a curious decision considering how much graphic violence proliferates in the media – there were packs of purpose-bred otterhounds.[9] Very large, rather benign and friendly dogs who display a charmingly independent character, they have webbed feet and an oily undercoat which keeps them warm even in freezing water. They also possess the stamina to pursue an otter for many, many hours through water, mud and field, until a human can deliver the *coup de grâce*.

In the twenty-first century this amiable breed is almost extinct and very few people will ever have seen one or even know what one looks like. So it is fortuitous that Rosa Bonheur (1822–1899),

a French artist painting at almost the same time as Landseer, gave us a stunning portrait of Brizo. Bonheur devoted enormous amounts of time to studying animals in farms, stockyards, horse fairs and slaughterhouses, which gave her the intimate knowledge of locomotion and anatomy she needed to produce works of complete accuracy, whether she was portraying a rabbit or a horse. And *Brizo* is an exquisite example of her work.

Brizo (her name is spelt with the Z back to front on the actual painting) currently resides in London's Wallace Collection. Despite being a female otterhound, her portrait was entitled *A Shepherd's Dog* in the Wallace Collection's first catalogue of its paintings, although curiously this was apparently not the case in earlier inventories.[10] Whether she actually belonged to a shepherd is extremely debatable. Otterhounds are certainly not herding animals and neither are they designed to tackle predators.

The legend BRIƧO is in a rather crude hand and as such may have been added later by someone other than Bonheur. The ancient Greek goddess Brizo protected sailors and fishermen. As otters are renowned for consuming fish, this dog may have been a favourite, given this name as a nod to her abilities in the field. Or perhaps she was a fisherman's dear friend.

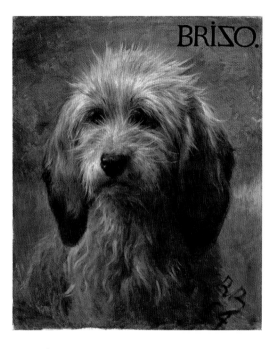

27 Rosa Bonheur, *Brizo, a Shepherd's Dog*, 1864, oil on canvas.

During the fifteenth century the weaver was the undisputed star of tapestry manufacture, but during the sixteenth century the artists who created the cartoons (the designs) for these works gradually became more important than the actual craftsmen and women. The resplendent *Hunts of Maximilian* designed by Bernard van Orley (1487–1541) catapulted this art to an altogether different level of creativity. Van Orley was the foremost exponent of

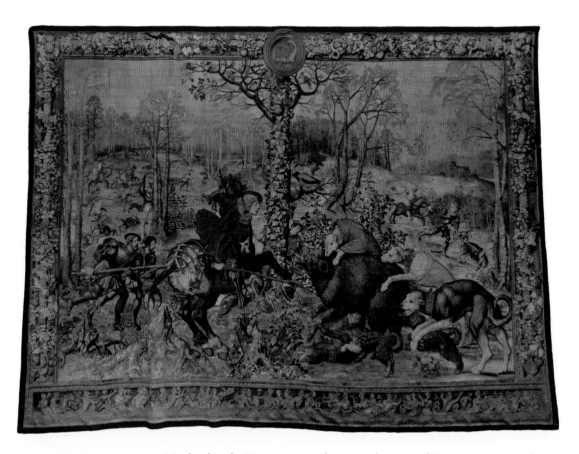

28 After Van Orley (cartoon), *The Final Assault on the Boar; or, December (Capricorn)*, detail of the central part of the tenth tapestry from the set of the 'Hunts of Maximilian', *c.* 1488–1541, tapestry, wool, silk, gold and silver thread.

Netherlands Romanism, the translation of Renaissance Italian fresco design into tapestry. This meant that instead of adhering to the overcrowded compositions of the fifteenth century of which *Swan and Otter Hunt* is a good example, Van Orley introduced space and decided composition into his cartoons so that they in effect became woven paintings.

In the tenth tapestry of the series, entitled *The Final Assault on the Boar; or, December (Capricorn)*, the forest, to which van Orley has given an almost fairy-tale air, teams with life and, inevitably, death. In the background hounds, seemingly for their own amusement, run after ever more boar. Men gallop by on horseback while other dogs pursue illusive scents. The principal hounds have already thrown themselves upon a boar and are biting into his flesh; one, presumably the leader of the pack, wears a suit of

armour to help protect him from the boar's tusks. And meanwhile, jolly little dogs which would seem to be more at home on a velvet cushion in a Flemish townhouse gambol by the boar's side, heedless of the hound that has already fallen victim to his tusks.

Falconry, also called hawking, is the sport of employing falcons, true hawks and sometimes eagles, buzzards or even kites to assist in hunting game. It was originally a Middle Eastern sport which spread through the principalities of Europe thanks to Holy Land crusaders returning with both fine falcons and their skilled trainers. Although a bird of prey, as its name suggests, may hunt alone, it can also be employed with hounds. In the Middle East, where the desert terrain is scrubby, high-flying falcons are employed to sight gazelle, which are then brought down by salukis who are able to run at up to 65 kilometres per hour (40 mph) in short bursts. In the English countryside, pointers can show falcons where feathered game is concealed and even today they may be used to hunt foxes.

By the seventeenth century, when the Flemish master Jan Fyt painted a glorious depiction of *The Hunting Party* (illus. 29), falconry, once the flourishing pastime of many an aristocrat, was already in decline. Partially this was due to general social upheaval, partially to the enclosure of open lands and partially because shotguns could now take a pheasant as readily as a hawk.

In Fyt's work the inclusion of the imposing bird of prey gives the artist an opportunity to demonstrate his outstanding ability to render the texture and exquisite colours of feathers. Hanging hares show his dexterity with fur and myriad dogs his virtuosity in portraying muscle under skin and coats of every hue. The wide divergence of form, even among dogs of the same race, tells us that these were dogs bred from a wide gene pool and that they were bred for function, not for looks, as they would begin to be by the late nineteenth century. The spotted dog in the foreground is particularly notable, as dogs of this type (possibly an early Dalmatian) are rarely depicted.

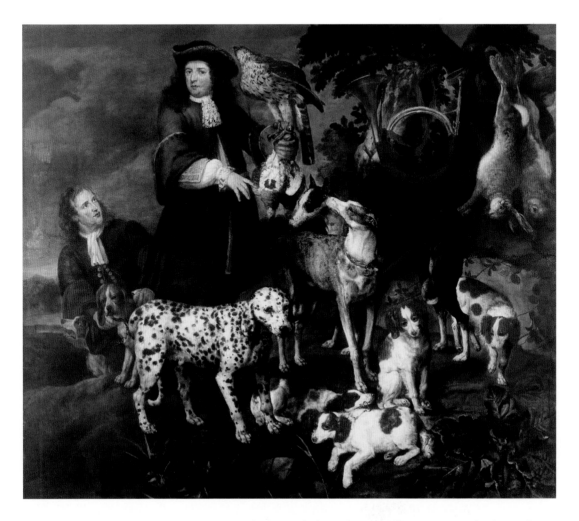

29 Jan Fyt, *The Hunting Party*, mid-17th century, oil on canvas.

As so much depended on their performance in the hunt, heirs to the French throne, rather like tiger cubs, were taught how to hunt from infancy. The Dauphin Louis (Louis XIII, *r.* 1601–43), aged only four, was charging around the ballroom of St-Germain with, among others, his favourite miniature greyhound Charbon, in pursuit of whatever small game the servants had released. This training stood him in good stead. At the age of seven he was hunting stag in the forests of Versailles (at that time a small village) with his page Bompar and his father Henry IV. When he ascended the throne at the age of nine, he was hunting three times a week and was sufficiently skilled to take on wild boar.[11] It is unsurprising,

then, that throughout Louis XIII's life his hunting dogs were not only dogs of work but the companions of his heart and that he knew the names of all his hundreds of hounds and was always distressed if an accident should befall them.

Of course, in this passion he and innumerable other monarchs before and after him were only following in the steps of the gods and in particular Diana, the huntress. In the circa 1620 oil on canvas by Breughel and van Balen (illus. 30), Diana – beautiful, voluptuous, feminine – caresses her fierce hunting dogs while surrounded by the still-warm bodies of boar, stags and pheasants. What monarch would not have wished to be in her stead or, even more wondrously, in her company?

As the company of the goddess was unobtainable, cynegetic desires were often sated, at least temporarily, by commissioning paintings. These might be of favourite hunting dogs or large-scale scenes that displayed not only grandeur, wealth and bravery but

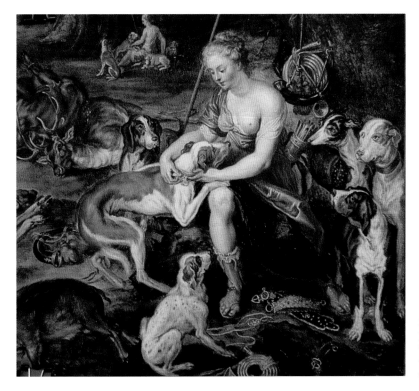

30 Detail of Hendrick van Balen the Elder and Jan Brueghel the Elder, *Diana at the Hunt*, 1620, oil on canvas.

the *coup de grâce*, the terror, of the quarry, in which the entire court and assorted onlookers would revel. The latter was a genre of painting which reached its zenith under the obsessive patronage of Louis xv of France (*r.* 1715–74).

Louis kept Jean-Baptiste Oudry (1686–1755) continuously occupied for 27 years – 1725–52 – with portraits of hunting dogs and every manner of scene connected to them. His rival Alexandre-François Desportes (1661–1743) was kept equally busy, causing him to write to a foreign patron in 1734 that *les chasses royales* were occupying all his time and that Louis xv had ordered him to work on them continuously until they were finished.[12] Oudry and Desportes may have found this onerous, but the rewards were outstanding: academic respect, the knowledge that one's opinion on any matter of visual culture would go unquestioned, pre-eminent social rank at court and, naturally, substantial wealth.

Oudry's monumental painting of 1730 entitled *Louis xv Hunting the Stag in the Forest of St-Germain* is a realistic tour de force that measures 3.9 m by 2.1 m (12 ft 9½ in. by 6 ft 10½ in.) and graced the walls of the monarch's hunting pavilion at Marley.

31 Jean-Baptiste Oudry, *Louis xv Hunting the Stag in the Forest of St-Germain*, 1730, oil on canvas.

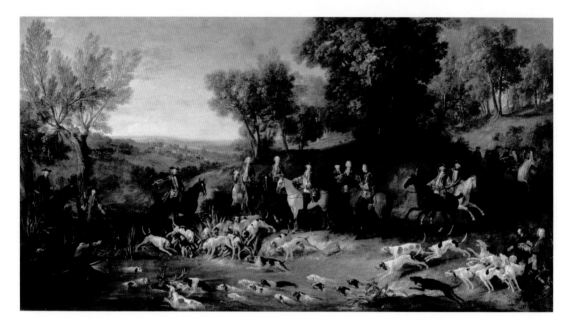

It demonstrates, as Louis xv would have wanted, the display and spectacle of *la chasse* together with the full horror and despair that the stag undergoes and its utter desolation and pain at its end. Neither of these could exist without a pack of highly trained hounds, whom Oudry painted with such care that the catalogue of its 1750 exhibition stated that 'all the horses and all the dogs are exact portraits.'[13]

Sa Majesté was not content to decorate his palaces with only domestic hunting scenes; he also required large-scale paintings featuring extraordinary wild animals and deformed curiosities. It was ludicrously expensive to transport animals by sea from the four corners of the globe and the chances of their arriving alive were negligible. This meant that naturally the resplendent Sun King had found it necessary to have not one but two menageries and had had his octagonal salon decorated with paintings of their inhabitants. However it took Louis xv, a man so obsessed with hunting that he was out with his hounds almost every day, to see these creatures as quarry models for yet more cynegetic paintings. As Oudry and Desportes were more than occupied with domestic works, Louis xv was forced to turn to a selection of other out-standing contemporary artists of the day, one of whom was the fancifully inclined Francois Boucher (1703–1770).[14]

Boucher's *The Crocodile Hunt* (1739) is a masterpiece of exotic fantasy (illus. 32). The skins of wild cats that adorn the hunters emphasize that we are in lands very different from those of rela-tively tame Europe. The pyramids remind us of ancient times when pharoahs hunted lions with spears, hounds running at their sides. The crocodile, who dominates the centre of the work, takes us back to prehistory, for the crocodile is millions of years older than the pyramids. He is the ultimate survivor of harsh nature and even harsher time. This then is a creature who surely knows how to defend himself. The beautifully detailed dogs, perhaps mastiffs, despite being fierce, energetic and equipped with vicious spiked

32 François Boucher,
The Crocodile Hunt, 1739,
oil on canvas.

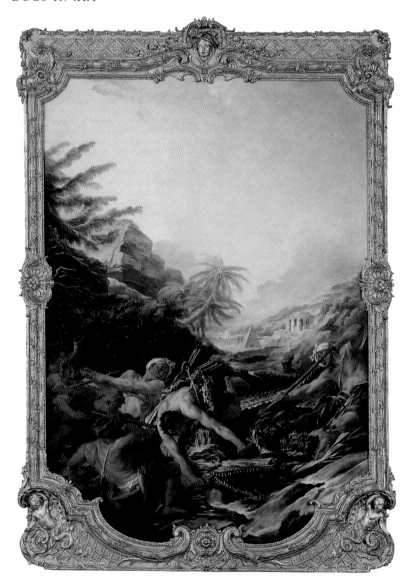

collars, wisely seem reluctant to tangle with the monster's enormous toothy jaws. No doubt they realize that it will take only one even half-determined bite on the bit of stick that for the moment keeps his jaws apart to turn the tables completely.[15]

But what of after the hunt? Of the mountains of dead game? For monarchs such as Louis XIV and Louis XV, this too needed to be celebrated and artists were kept extremely busy with still-lifes. Often these were exquisite set pieces containing yet more displays

of wealth in the form of solid gold plate and other luxuries while the game itself was draped attractively over carved balustrades. The stillness of this genre of paintings might be broken by a very alive hunting dog, which in some works is captured eyeing up with some disdain a cat that is daring to intrude on his territory. A lighter counterpoint to all those silent lives, as the French term dead game.

This type of still-life was popular throughout Europe and one of its most popular exponents in the Netherlands was Jan Weenix (1642–1719), the son of Jan Baptist Weenix. Despite the burgeoning wealth and prestige of the European merchant classes, hunting was a pastime the royals kept zealously to themselves. It was strictly illegal for commoners to hunt and penalties could be extremely harsh. However, the bourgeoisie were able to provide themselves with a little of the style and prestige associated with the hunt by commissioning paintings such as Weenix's *The Intruder* (illus. 33) for their own interiors. *The Intruder* contains considerably more life than *nature morte* and celebrates the joy of animal existence. Although a pile of dead birds hangs luxuriantly from a hook, our real attention is drawn to the healthy, lively dog, perhaps the one who flushed out this game for his master's table. Unable to resist temptation, he has leapt onto a basket containing very alive pigeons – one of whom takes advantage of the situation to escape – and in the process startled two squawking roosters. The extremely well-drawn spaniel eyes the rooster greedily. His days may be numbered.

The saluki is a magnificent sight hound, a specialist honed through generations to bring down gazelle in the desert and scrub of the Near East. However, unlike the greyhound, paintings of the saluki so beloved of the desert Arab were rather rare until nineteenth-century Europe (see Chapter Four), and in particular France, fell in love with with the lands of the Arab. One of Orientalism's chief exponents was Jean-Léon Gérôme (1824–1904) and it was in 1871, at the height of his fame, that he produced the

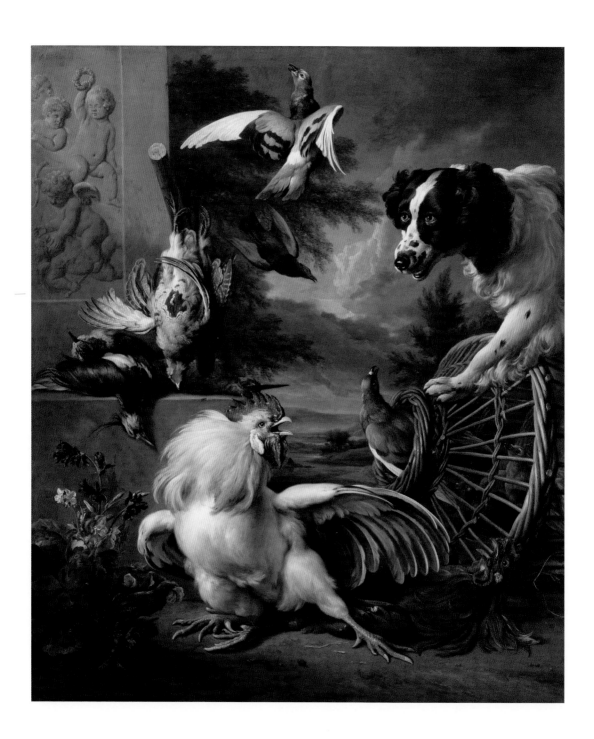

34 Jean-Léon Gérôme,
Master of the Hounds,
1871, oil on canvas.

truly exotic *Master of the Hounds*. In this glorious glimpse of Arab
life the colours are hot, rich and vibrant. The muscles beneath the
skin of man and hound, their nuances of stance, the detail in
expression, fur and cloth, are marvellous.

 The master is a Bashi-bazouk, a member of the military reserve
troops in service to the Ottoman Empire who to Western audi-
ences embodied the essence of Oriental masculinity, strength and

33 Jan Weenix,
*The Intruder: Dead Game,
Live Poultry and Dog*,
1710, oil on canvas.

determination.[16] And the elegant and delicious hounds (a griffon and presumably three salukis) are everything we would expect from pampered yet highly accomplished hunters, dogs who in the camps of the Bedouin would have been fed on the flesh of she-goats, on camel or sheep's milk thickened with couscous, and offered luscious sweet dates. Dogs whose necks would have been adorned with amulets to ward off the evil eye and who would have been transported to the hunt on the fronts of their masters' saddles.

At first glance André Dérain's art could hardly be more different in style from that of the preceding works. In his *La Chasse au cerf* (The Deer Hunt, 1938), the dogs with their pink tongues hanging out appear so benign that the only danger the deer is in is that of being licked to death – they are almost cartoons. But despite being a rebel artist, a Fauvist and a Cubist, Dérain was always strongly influenced by the classical and the composition of *The Deer Hunt*, like the epic works of the Italian Renaissance or indeed Oudry's *Louis XV Hunting the Stag in the Forest of St-Germain*, is meant to dominate its surroundings and to give us a story. In a further nod to the delights and tastes of an earlier age, this unusual painting was transformed into a tapestry at Aubusson.[17]

If hunting deer and wild boar had been the sport of kings, hunting rats was definitely for less elevated mortals and employed a completely different type of dog – the terrier. Hundreds, perhaps thousands, of years of selective breeding have produced ratters of every description. Those silky little Yorkshire terriers with bows adorning their sweet heads are dedicated killers bred specifically to hunt down rats in the cotton mills of northern England. Rats were (and still are, though nowadays they keep a lower profile) everywhere. In the country they were the farmer's sworn enemy, gnawing their way through grain sacks and making their nests in hay. In the city they ran riot on the streets. Rat catchers never went in fear of unemployment. As a spin-off to their trade they

35 André Dérain, *The Deer Hunt*, 1938, oil on canvas.

transported live rats in their hundreds to 'pits' in public houses where prime ratters, egged on by their trainers, competed to see who could kill the most rats in the shortest space of time. One celebrated nineteenth-century bull terrier named Billy could kill a hundred in less than twelve minutes.

One rather charming rendition of ratters was painted by Landseer (illus. 36). In what is a classic composition it features not only the terriers, but all the accoutrements of the rat catcher, in exactly the same way as other artists have captured those of the fox-hunting man and woman. The cage, the broken cart shaft for killing rats by a blow to the head, the leather belt decorated with rats, the green bag, the bottle of poison, the ferret and of course the dogs all belong to the rat catcher.

Landseer, using his own dogs as models, cleverly captured the action at dog's-eye level, putting the viewer right in the picture.

36 Edwin Landseer, *Ratcatchers*, 1821, oil on board. Landseer and his friends were known to frequently discuss the wondrous prowess of their own beloved ratters.

37 Wiliam Barraud, *Lord Henry Bentinck's Foxhounds with a Terrier*, 1845, oil on canvas.

Two rats have already been slain and Brutus, his rough white-haired terrier, is poised to assassinate another, which is poking its head up through the floorboards. Boxer, Landseer's Stafford-shire bull terrier, and the smaller Vixen thoughtfully contemplate their fellow ratter the ferret, whose burrowing is forcing the rats up from their underground lair. As terriers have to be trained not to kill the ferret along with the rat, their thoughts may have been somewhat conflicted. A small masterpiece in its own right, it caused the French artist Théodore Géricault to write that it was better than anything produced by the Old Masters in the same genre.[18]

In the utterly English upper-class painting of *Lord Henry Bentinck's Foxhounds with a Terrier* (1845) by William Barraud, we see the counterpoint to *Ratcatchers*. In the foreground the foxhounds' collars lie coupled, for at the moment they are just dogs, able to do as they please – there is no drama in this composition. To the right are a scarlet coat, an expensive pair of hunting boots, a whip, a riding hat and a pair of stirrups, all items which speak vividly of the man and his metier, just as the rat catcher's cage and

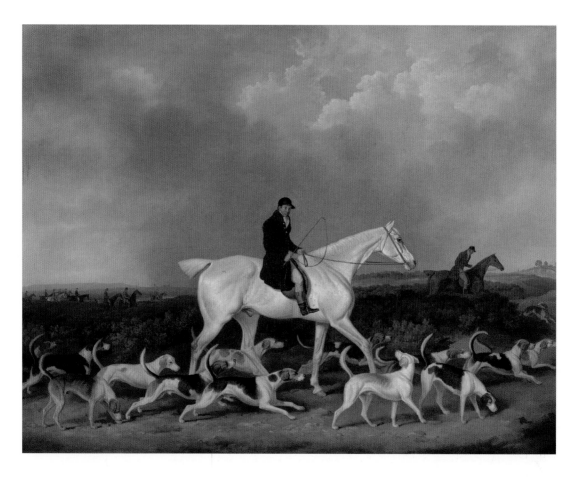

38 James Barenger, *Jonathon Griffin, Huntsman to the Earl of Derby's Staghounds, on Spanker*, 1819, oil on canvas.

39 Ghasi, *Maharana Bhim Singh of Udaipur with Dog and Attendants*, c. 1820–36, gouache, detail.

belt do of his. Barraud's portraits of the hounds and the Jack Russell captures their character, their friendships and, in the case of the hounds, their muscular but graceful forms.

Lord Bentinck devoted himself to breeding foxhounds and 'built up one of the most influential packs in the history of fox hunting, remarkable for speed, light build, drive to work and pre-potency'.[19] These hounds, however, can consider themselves lucky survivors, for when asked the secret of his success Lord Henry 'curtly remarked "I breed a great many hounds and I hang a great many."'[20]

The accoutrements, of course, are for use, and we see them modelled by Jonathon Griffin, huntsman to the Earl of Derby's staghounds, on Spanker, in a painting by James Barenger of 1819

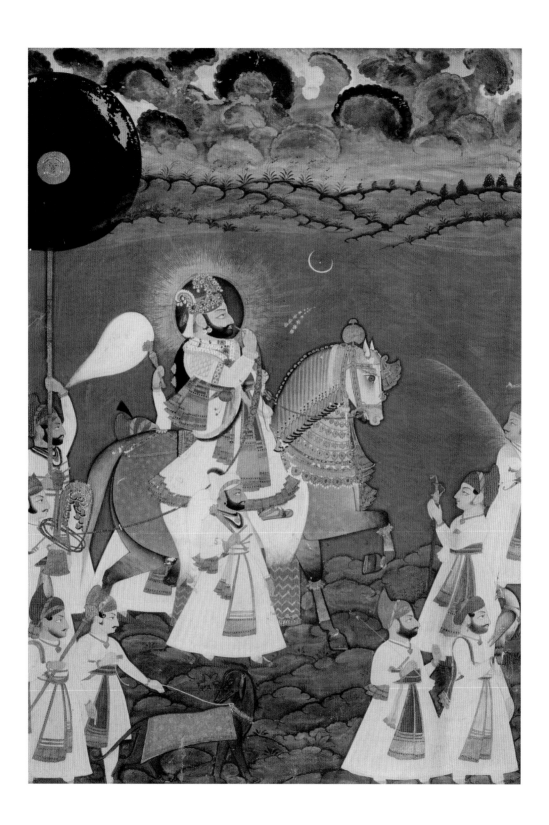

(illus. 38). The oil on canvas shows off both the elegance of the fox hounds and the fine lines of Spanker. The earl used to cart his horses, hounds and deer all the way from the family seat at Knowsley just outside Liverpool to his hunting lodge The Oaks at Epsom in Surrey, finding the latter equally convenient for hunting at Banstead and racing at Epsom.

Compared to Maharana Bhim Singh of Udaipur, hunting at almost the same time historically speaking, Griffin cuts a conservative image. The Maharana, a Mewar royal reputedly descended from the Sun god Eklingiji, rides out by moonlight with a full retinue of splendid attendents, a richly and extremely finely caparisoned horse, his falcon, his hookah pipe and a fine sight hound on a leash, who is wearing a lavishly embroidered gold coat. The dog looks rather balefully at his handler, as if sizing up the right moment to deliver a satisfying nip. Whether any actual hunting will occur is something of a moot point.

From the Dark Ages to the End of the Renaissance

'For in truth art is embedded in nature, whoever can tear it out has it.'
ALBRECHT DÜRER

The Dark Ages, which lasted from the fall of the Roman Empire until around AD 1000, were dark indeed for secular painting. Monotheistic religions now dominated and had little truck with dogs, sacred or profane. In Islam, then as now, the dog was considered unclean and something to be reviled. Hasidic Jews considered them repugnant intruders in human society and Christianity relegated them to mere servants. The Old Testament described dogs as diseased, mean and dirty and their reputation in the New was not much better. Considered far from divine and certainly not possessing souls, dogs, in common with the rest of the natural world, existed solely to be used by man. Art was essentially used only to promote religion and so only animals such as the dove of peace and the Lamb of God could feature in it. But dogs still made their way into illuminated manuscripts, even if they were usually just bit players scampering up the margins or illuminating a capital letter.

For dogs were the best friend of many a monk and nun, despite being officially frowned upon. Injunctions attempting to limit pet-keeping clearly had as much effect as prohibition did on drinking in the U.S. in the twentieth century. William Greenfield (d. 1315), Archbishop of York, lamented that 'bringing little dogs into the choir during divine services would impede the service and hinder the devotion of the nuns'. In Winchester, the bishop was forced to

40 Illustration from the Maastricht Hours, The Netherlands, *c.* 1300–1325. A nun and monk ride out for a tryst so romantic that even the horses are making eyes at one another. This does not prevent the nun from making it a threesome with her cheeky lapdog.

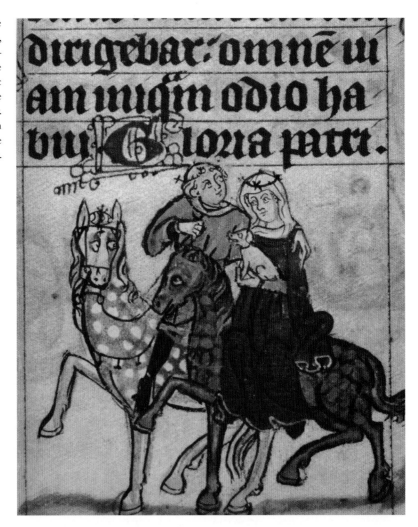

come to a compromise – the nuns could keep their beloved pets but would suffer a one-day bread and water fast if they brought them to church.[1]

Even abbots were not immune to the love a dog can engender, as this elegy written by Thierry, Abbot of St Thrond, in the late eleventh or early twelfth century demonstrates so poignantly. For the little dog was

the chief concern and grief of his master. He was not a large dog . . . he was five years old . . . modest he was in size . . . White

in colour, he bejewelled his face with black eyes. What was his function? Was it a useful one or not? That his large master should love a small dog – that was his duty, to play before his master. What was the use of that? there was none, if not laughter! No one failed to laugh at him as he stood or as he moved . . . Such you were beloved dog, to be laughed at and grieved: you were laughter while you were alive, but look at the grief when you died! Who ever saw you, whoever knew you, loves you and grieves now over your demise, pitiable dog.[2]

Medieval monasteries and nunneries were curious mixtures of licentiousness and strict morality. Witchfinders and the Inquisition prowled England and Europe waiting for an off-hand remark that might condemn a poor soul to be burned alive. Small wonder, then, that contemplatives turned to pets for comfort or that they turned to one another, and that for many, sex and excessive drinking were the order of the day.

Regardless of ecclesiastical opinion, the great and the good frequently chose to be accompanied by their own dogs to the eternal or not so eternal life ahead. The effigy of Sir Richard Pembridge, Knight of the Garter, star of innumerable battles during the Hundred Years War, is an elegantly realized example. The knight, who died in 1375, gave detailed instructions for his burial. Although he was buried facing the Virgin Mary, as requested, with his head resting on a wreath of roses and a plume of feathers, he still felt the need for his pet dog to be at his side, or, more accurately, at his feet. Beautifully carved and showing accurate and close observation, the fur is particularly well rendered and the dog's face shows great individuality. He wears his collar, a sign of his attachment to the knight, whom like the knight in Dürer's *The Knight, Death and the Devil* (see illus. 54) he will never leave.

By 1400 the ecclesiastical authorities' grip on art was loosening. The era of the wealthy, independent merchant, who commissioned

42 Jan van Eyck,
The Arnolfini Portrait, 1434,
oil on oak.

art by contract and knew exactly what he wanted, had arrived. This was particularly true across Italy and the Netherlands, where flesh-and-blood dogs were ubiquitous. Pampered darlings, courageous guards, hunting companions and wealthy symbols of prestige – it is no surprise that patrons of the arts, the commissioners of engravings and paintings, should want them to be featured in these works. So it comes as no surprise that what is probably the first appearance of a realistic pet dog in Western painting occurs in one of the most important works in the history of art, *The Arnolfini Portrait* by Jan van Eyck.[3] Van Eyck was one of the first artists to have used oils and may even have invented the medium, or perhaps more accurately reinvented it and perfected its use, as there is some evidence that the Romans, the Greeks and the Egyptians also used oil-based paints. Oils gave paintings a new and wondrous luminosity thanks to their ability not only to hold pigments but to trap light. And unlike the previously used tempera (pigments mixed with egg yolk as a binder), they gave the artist the opportunity to capture exquisite detail and immensely fine texture.[4] In this painting Van Eyck has used them not only to show us the beauty of the

41 Detail of the dog from Sir Richard Pembridge's effigy in Hereford Cathedral, *c.* 1375.

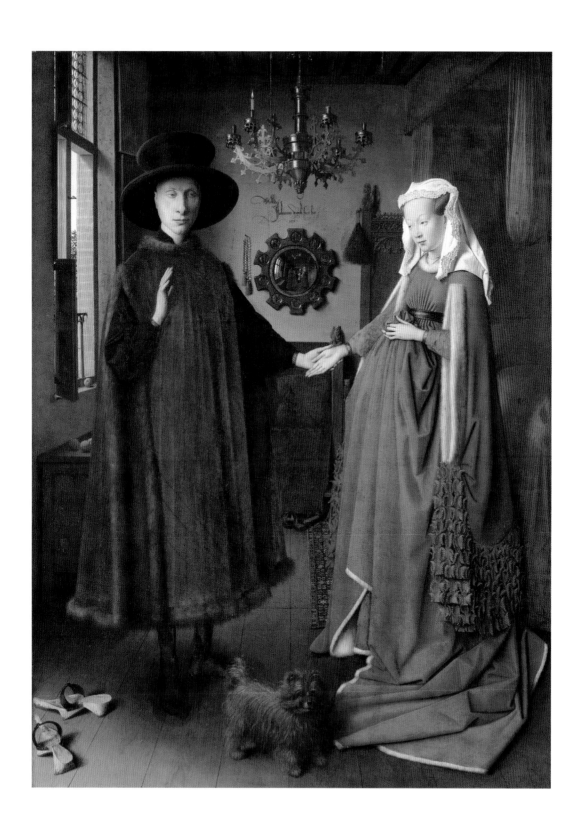

luxurious textiles in which the couple are robed, but to capture deliciously the texture and multiple colours of the griffon terrier's long-haired coat. We can almost run our fingers through his fur. The little dog wears the sweetest of expressions, but we might wonder what he was really thinking, as the bulky dress that the lady is wearing is lined with white strips of fur that in life would have covered the chests of around 2,000 red squirrels.[5]

Van Eyck was the first artist to paint such a realistic domestic scene (with or without a canine), hence *The Arnolfini Portrait*'s enormous importance. Decades-old speculation continues to rage to this day on the true identity of the couple; on whether the lady was pregnant or simply wearing the fashion of the day, which delighted in emphasizing a nicely rounded stomach; and on whether seemingly symbolic devices were in fact faithful transcriptions of reality. And this debate of course extends to the griffon terrier. Symbol of lust or faithfulness, or beloved pet?

Intensive research by the National Gallery, London, much of which relies on infrared reflectograms, has led experts there to conclude that the work is probably a portrait of Giovanni Arnolfini, probably with his wife, and that she is not pregnant but holding up 'her full skirted dress', which as we know is simply full of squirrels. As many of the apparently symbolic elements of the painting were not in its underdrawing but added at a somewhat later date, the National Gallery concluded that they were not part of some long thought-out symbolic scheme.[6] And so it seems that the griffon terrier was probably an adored pet, regardless of the identity of the couple.

A rather different kind of dog inhabits the world of *St Mary Cleophas and her Family*, realized by the rather more Gothic and still ecclesiastically inclined Bernhard Strigel (c. 1460–1528). St Mary's family, apart from their halos and visiting angel, are extraordinarily earthly. Even the angelic child, undoubtedly bored with the attention being lavished on the new arrival, is, as children (and

43 Bernhard Strigel,
*St Mary Cleophas and
her Family, c.* 1520/28,
oil on panel.

44 Follower of Hieronymus Bosch, *The Conjurer*, after 1525, oil on oak.

adults) do, playing with a gingery and extraordinarily appealing dog, who, as dogs do, is wresting for power of a stick.

Dogs are the companions of angels and scoundrels alike – they hold few of the prejudices associated with humanity. And so it is in a typical morality painting on greed and incredulity dating to the early to mid-1500s (illus. 44). Once thought to be an extraordinary, quotidian work by the Flemish artist Hieronymus Bosch, and as such invaluable, it is now thought probably to be by a follower of Bosch.[7] As the matter is still to some degree undecided, and the painting may yet still be attributed to Bosch, the work remains under lock and key at St-Germain-en-Laye, having already

been stolen once and then miraculously restored. The conjuror's crafty intelligence (he plays mind games with his audience, distracting them so his assistant may relieve them of their wallets) is for many commentators indicated by the owl he keeps in his basket, but if this painting really were by Hieronymus Bosch, then perhaps the owl represents Satan, as it does in the *Paradise* panel of his *Garden of Earthly Delights* triptych.[8] This would be a nice counterpoint to his little dog, who is dressed as a circus devil, his red cap endowing him with pointed red ears and the fur on his tail cut to look as a benign devil's should, with a 'forked' tip. Although the dog is part of the show – he is waiting for his turn to perform a trick with his hoop – he may also be the conjuror's only trusted companion, for how many human friends can a trickster have?

The dog's association with passion and lust combined with a reputation for fidelity made him the perfect guest at any wedding feast. For example, the one attending *The Marriage of Renaud de Montauban and Clarisse* by the Flemish illuminator Loyset Lièdet (illus. 45), a work which surely encapsulates everything archetypically medieval that inhabits popular consciousness, from the pointy shoes to the pointed hat known as a hennin. As befits the status of the bride and groom, the canine guest is an aristocratic *levrier* or greyhound type and is wearing a fashionable wide collar. He walks jauntily through the feast chamber – a dog as secure of his status as his owners are of theirs.

In illustrated manuscripts featuring the medieval bath house, a louche multifunctional space providing delicious food, spaces for amorous trysts, extremely comfortable bathing facilities and live music, the musician, in a tradition that stretches back to the time of the ancient Greeks, was usually shown accompanied by a small dog. Naturally, in this environment he unashamedly symbolized passion and lust. Flemish manuscripts were known for their rigid and formal style, but the French illuminator Philippe de Mazerolles introduced a rather more lively note to them. This

may be seen in Valerius Maximus' *Facta and Dicta*, where his illustration of the bath house, although making a moral point concerned with luxury, in fact sings with life and pleasure, epitomized by the little dog dancing happily to the strains of his master's lute.

Artists of the Italian Renaissance took a particular interest in the work of classical antiquity and in nature. Inevitably, dogs in all their myriad forms began to find their place in what was the modern art of the day. Although dog portraits were still not considered a suitable subject for a serious artist, they nonetheless appeared in innumerable paintings, often playing an extremely important role.

45 Loyset Lièdet,
*The Marriage of Renaud de
Montauban and Clarisse,*
c. 1460–78, illumination.

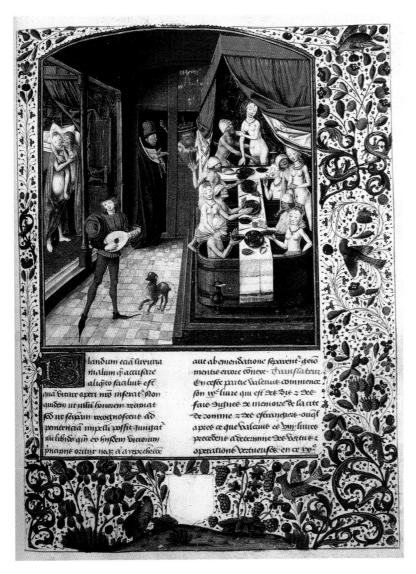

landum eaā turuna
malum đ accusare
aliḡto facilius est
qua bitur operi mō insēat: Non
quidem ut illi honorem rcapiat
sed ut seipm recoḡnoscent ad
penitencia impelli possit Jungat̄
illi libido qn eo hnsdem biciorum
pnapne oritur nex a reprehese

aut ab emendatione spawent: geio
mentie errore conewe· transfateur
en cesse partie balement commence
sōn we liure qui est de die z de
fais signies de memorie de la cite
de comme z de estranchier ougl
apres ce que balement ce vin liure
precedent a determine des bertu z
operatione bertueuses· en ce xp·

46 Philippe de Mazerolles, *Example with Respect to Luxuries*, from *Valerius Maximus Facta and Dicta memorabilia Bruges* (*c.* 1470), parchment.

Florence may be said to have been the birthplace of the first flowering of the Italian Renaissance and Piero di Cosimo (1462–1522), one of its most innovative artists, was known for his idiosyncratic and imaginative works and his pioneering development of evocative landscapes. He was also, according to Vasari, a great lover of animals and plants,[9] as is clearly demonstrated in his *A Satyr Mourning Over a Nymph*, which is set on a flowered grass carpet with a backdrop of sand, sea and animated nature.

Although our eyes are drawn to the tragic yet beautiful rendering of the nymph and the heartbroken expression of the satyr, they are equally drawn to the large brown dog on the right-hand side of the painting. His stance and position mirror those of the satyr; like the satyr, he is framed on one side by plants bursting into flower; and like the satyr, the dog's expression is sad and he is just as exquisitely and realistically drawn. Piero leaves it up to us to decide whether the dog was the nymph's dear friend or whether he is sharing in the grief of his master the satyr. But he gives us hope, letting us know that life continues by painting three dogs engaged in everyday canine activities on the shore behind and surrounding them with animated birds and lively grasses.

We may not know the identity of the dog in *A Satyr Mourning Over a Nymph* but we certainly know a great deal about Rubino, the favourite of the Marchese Ludovico Gonzaga III of Mantua (1412–1478) and one of the seven dogs depicted in his *camera picta*. In 1460 the Marchese had put his reputation as a man of discernment as well as the image of the Gonzaga dynasty firmly into the hands of Andrea Mantegna (1430/31–1506) when he commissioned him to create a fashionable *camera picta* (a room in which the walls became the artist's canvas and on which he painted a kind of portrait gallery of the family and their important political connections) at the ducal palace. He was not to be disappointed: the

47 Piero di Cosimo, *A Satyr Mourning Over a Nymph*, *c.* 1495, oil on wood.

ensuing frescos are among the Renaissance's finest works. As Mantegna was using tempera the details in his work cannot match those of artists working in oils: the fur of his dogs cannot equal that of Van Eyck, his textures pale before those of Veronese. But Mantegna was a master of illusion, perspective and *trompe l'oeil* and always included pertinent material detail.

The project took a lengthy seven years (1467–74), possibly owing to Mantegna's extremely litigious nature. For this was an artist who expressed regret at being unable to sue his own generous patron when the Gonzaga cows broke into his vineyard in search of lush leaves.

Two of the *camera picta*'s rooms were covered with court scenes and it was here that Mantegna painted the Gonzaga family's past, present and anticipated future with friends, courtiers and important figures of the time. And as the Gonzagas, as a dynasty, were particularly fond of horses and dogs, he also included their elegant greyhounds, what appears to be an early spinone, German pointers and a magnificent pair of uncastrated Molossian hounds. The latter were huge, heavily muscled hounds mainly used to bring down wild boar, but in the days of ancient Rome they were also pressed into use as formidable warriors on the troublesome borders of the empire; used as bodyguards by the wealthy and symbols of prestige by the fashionable.

A glorious example of an ancient Greek Molossian (Greece probably being their country of origin) is the British Museum's Jennings Dog (illus. 51) – a second-century Roman copy of the earlier Greek bronze which was rescued from a pile of rubble in

48 Mantegna, *Parete dell'Incontro*, detail. A long-haired hunting hound, possibly an early type of spinone, pictured underneath Gonzaga's *faldistorio*, an ecclesiastical form of chair.

49 Mantegna, a greyhound behind with two German pointers to the front, from *Parete dell'Incontro*. Note the beautiful, individual and luxurious collars the dogs are wearing. The fashionable hound in Renaissance Italy (and France) sported a wide collar, quite often of velvet on leather and richly embroidered with gold and silver thread. It might also be decorated with the owner's coat of arms perhaps in solid gold and with other charming decorative devices.

50 Andrea Mantegna, *Camera picta*, Molossian dogs, detail from meeting wall, 1465–74, fresco and dry tempera, Castello di S. Georgio, Mantua.

51 *The Jennings Dog*, 2nd century BC, marble.

an ancient Roman marble workshop and brought to England in 1753. As the dog's tail was broken, Jennings, its then owner, decided to name it the 'Dog of Alcibiades' after the Athenian statesman of the same name. According to Plutarch, Alcibiades owned a large and handsome dog whose tail was 'his principal ornament'. Alcibiades cut off this unfortunate creature's tail and when told that 'all Athens' felt pity for the dog, laughed and said 'I wished the Athenians to talk about this, that they might not say something worse of me.' Following in Alcibiades' footsteps the Molossian grew more famous than his owner, who became known as Dog-Jennings. A gambler, by 1816 Jennings was deeply in debt and forced to sell his dog, but with remarkable sang-froid commented 'A fine dog it was, and a lucky dog was I to purchase it.'

But it is Rubino, a great Dane and Ludovico's beloved pet, who steals the scene and our hearts (illus. 52). He lies securely under his master's throne. Protection is granted by a pillar to the left, and by his master's thick and sumptuous cloak to the right. His huge paws rest commandingly on the carved wooden framework of the chair while his massive head, equal in size to those of the humans in this scene, inclines outward,

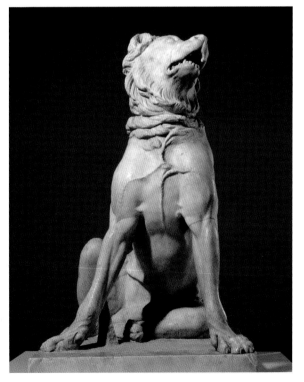

52 Rubino, beloved pet of Marchese Ludovico Gonzaga III of Mantua (1412–1478). Detail from Andrea Mantegna, *Camera picta*, 1465–74, fresco and dry tempera.

its expression revealing the inevitable tedium that attaches to affairs of state and the true gentleness of a giant.

Certainly he has a symbolic function. His presence and particular position in the scene imbue Ludovico with faithfulness and wisdom while also representing the fidelity of the nobility, which is itself invincible, and so confirmed Ludovico's faith in the Church and the Holy Roman Empire. Rubino also refers back to the Gonzagas' coat of arms, which appears several times in the *Camera picta*. This is formed of a white Great Dane, his muzzle turned to the right, on a red background above a green meadow. The colours represent the three theological virtues: white for faith, red for hope and green for charity.

However, Rubino was included for far more personal reasons. He had been dead for four years when Mantegna began his masterpiece, but having read all the correspondence about this beloved

canine, it is impossible to believe other than that Ludovico Gonzaga wanted an ever-present memory of him, one that quite possibly showed him in a room he used to frequent, under the very chair where he used to curl up, secure in his master's love. We first hear of Rubino on 29 October 1462, when Ludovico, away on business, wrote to Barbara, who was at home in Mantua, asking her to search for Rubino absolutely everywhere. For the Marchese, who was on his travels, had lost him not once, but twice: first, when he was ready to leave for Revere by boat, the Great Dane was nowhere to be found, and he had to leave without him. And then, when finally the servants did manage to find him, he escaped while they were taking him overland to Mantua. 'You know he doesn't like to stay with anyone but us,' wrote the distraught Marchese.

Rubino, fortunately a dog of many parts, made his own way back to Mantua, arriving wet and bedraggled the very same evening. He then began to search for his master, wandering disconsolately from room to room. He didn't have to search for long. Barbara quickly despatched him to Rivere with the trusted Luca da Mariana. He arrived the next morning and, full of contrition, caressed and nuzzled his master, asking for forgiveness, which Ludovico, full of joy at being reunited with his pet, could not possibly resist giving.

We next hear of Rubino on 18 February 1463 while he is staying with Barbara at their villa di San Georgio, Ludovico having become too nervous to take Rubino with him on his travels in case he got lost. But Rubino missed his master terribly. 'He doesn't want to eat his beef, he doesn't want to play, and it seems to me that he only wants to escape. When I took off his chain he caressed me, but after that didn't want to know me. His eyes are red as if he has been crying. I feel compassion for him, but I don't know what to do,' wrote Barbara. 'Look after him as best you possibly can,' quickly responded Ludovico, 'make sure that he eats, and for God's sake make sure he misses me as little as possible.'

But *Il Poverino* (poor little thing) could find no peace without his master and so Barbara sent him back to Mantua, his true home. And here the Great Dane regained his health. He stopped trying to run away, as he had from San Giorgio, because once at Mantua, he was certain that sooner or later Ludovico would return. And so he regained his appetite and soon began to put on weight.

Four and a half years went tranquilly by and then, unexpectedly, Rubino became seriously ill. *Il Poverino* wandered deliriously from room to room with a high fever and swollen glands, symptoms strangely shared by Ludovico's chief adviser Guido di Nerli. Rubino's death seemed imminent. Worried he might not make it back to Mantua before the end, Ludovico asked his wife to bury Rubino in a particular patch of ground beneath his study window – the place where his pet had always played with one eye on his master – because here Rubino's tombstone and its epitaph would always remind Ludovico of his unwavering constancy.

On 6 August Rubino was restless. Groaning, he paced from room to room, unable to find any kind of peace. Perhaps knowing he was dying, he must have been hoping against hope to have a last glimpse of the Marchese. He refused an omelette (a favourite snack), then gulped down a pound of raw meat. The next morning at 9 a.m., in a terrible omen for Rubino, Guido di Nerli died. Two hours later, the gentle Great Dane also lay dead. The raw meat had been his last supper.

However, he lived on in opera. In *De quadrupedibus digitatis viviparis* (Of Four Footed Mammals) commissioned by the Marchese, his epitaph featured in the third libretto, translated here by James Murray.

RVBINVS CATVLVS

LONGO AT FIDO AMORE PROBATUS DOMINO

SENIO CONFECTVS SERVATA STIRPE HIC IACEO

HOC ME HONORE SEPVLCHRI

HERVS DIGNATVS EST

LITTLE RUBINO

LONG AND FAITHFULLY APPROVED IN LOVE BY HIS MASTER

HERE I LIE, OLD AND WORN OUT IN SERVICE TO THE FAMILY

THIS SEPULCHRE IS IN MY HONOUR

MY MASTER IS WELL SATISFIED

Ludovico must have missed Rubino terribly. Ten years later, in 1473, his agent Pietro da Gallarate managed to find a puppy descended from Rubino at Zaccaria and sent word to the Marchese. Ludovico responded at once and requested that the puppy be despatched immediately, on mule back, 'with every comfort'. He arrived safely in Mantua 25 days later and Ludovico declared him *carissima*. But darling as the new dog was, Ludovico, like so many owners before him, declared there could never be another as faithful to him as his own darling Rubino had been.[10]

No chapter that concerns itself with the Renaissance can overlook the German master Albrecht Dürer (1471–1528), who first visited Italy in 1494 to study its art and returned triumphant a little over ten years later as one of the most celebrated artists of the age. Dürer was at the pinnacle of his achievement as an engraver when he created *Knight, Death and the Devil*, which together with *Melencolia I* and *St Jerome in his Study* forms the so-called trio of Master Prints, each of which contain an hourglass, a skull and a dog.

The influence of his Renaissance studies in Italy is obvious in his *Knight, Death and the Devil* – a delicious melding of styles in which he has given us a German Gothic knight mounted on a horse drawn in the Italian Renaissance style, and accompanied by that frequent companion of pilgrims and saints, a faithful

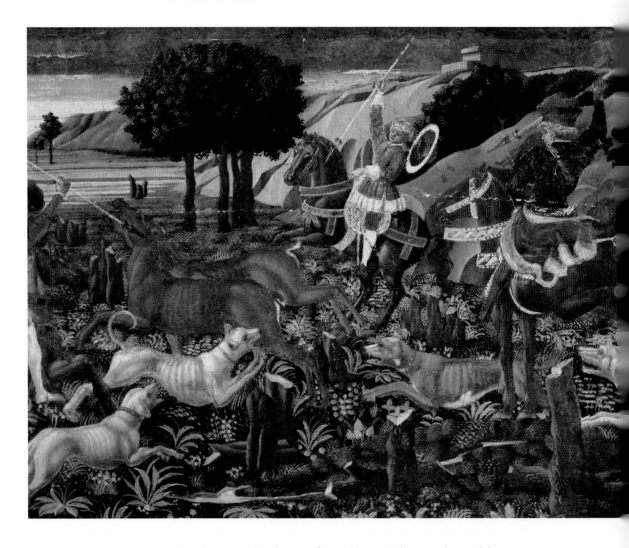

53 Detail of Giovanni di Francesco aka Franco, *The Hunt*, c. 1450–60, tempera on wood.

dog, here in the form of a substantial scent hound known as a talbot. As greyhounds and talbots frequently figured on heraldic devices, it is doubly fitting that Dürer should have chosen a talbot to accompany the knight on his mysterious, possibly fatal mission.

It is interesting to note that at one time talbots must have been extremely popular in England, as innumerable venerable public houses and inns are named The Talbot or The Talbot Arms and still boast signs painted with this great hound's image. (In earlier times pictorial inn signs made sure that a largely illiterate clientele

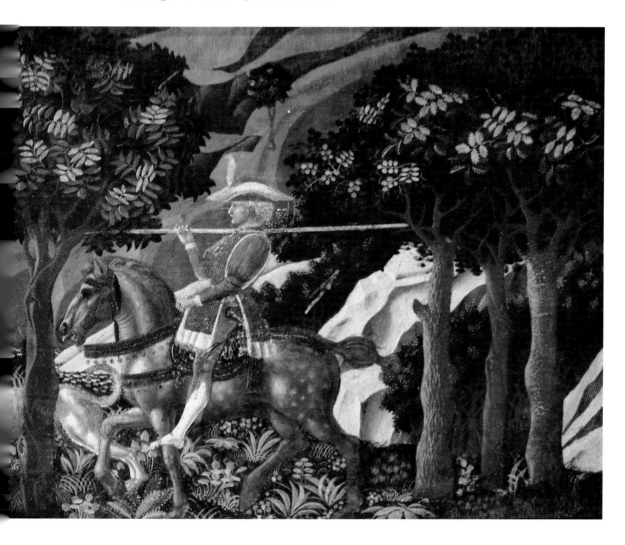

could still unerringly recognize their local hostelry, and indeed, what better marker than a scent hound, who naturally can sniff out anything?)

Although Dürer was influenced by many Renaissance artists, including the Venetian-based Leonardo, Verrocchio, Pollaiuolo and Donatello,[11] it is still interesting to note the obvious similarities between this early Renaissance work attributed to the Florentine artist Giovanni di Francesco (1425/6–1498) and *Knight, Death and the Devil*. The knight, the horse and the dog are all shown in profile, as they are in Giovanni di Francesco's work. The particularly

54 Albrecht Dürer,
The Knight, Death and the
Devil, 1513, engraving.

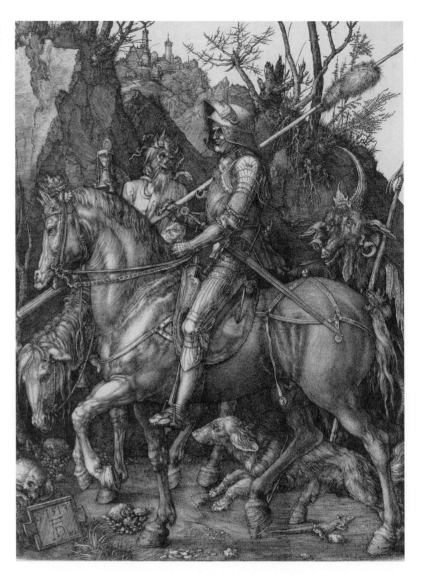

proud bearing of the horses, even the gait of the dogs, are reflections
of one another. In the Italian work, the trio are concentrating
single-mindedly on the hunt. In Dürer's work they are determined
to reach a mysterious destination.

The dog in the Italian work is guiding his master to game; the
knight's dog echoes ancient religions in which dog-gods safely
guided man through perilous unknown paths. Despite being assailed
by a hideous devil and Death, a vile decaying yet animate corpse

(who holds an hourglass as a reminder of life's brevity), nothing shakes either from their path.

It is in sentiment, in emotion, then, that the works differ. In Giovanni's painting the dog's tail is up: he is running in anticipation of sport to come. In Dürer's the dog's ears are back, indicating fear and trepidation; his mouth is shut, his tail at half mast. Run next to his master he might, guide him he might, stay with him certainly – but he is not looking forward to what is to come. And who can blame him? The portents are already looking grim.

Originally painted for the ducal palace of Urbino, Giovanni's work is colourful and lively; Florence, city of art and light, is its backdrop. It served as the back of a long bench and brought together two hunting scenes: one of commoners who are hunting wild boar on foot with their dogs; the other, featured here, of nobles hunting deer on horseback. A charming confection, it has a somewhat magical air and completely lacks the menace and intimations of misery of Dürer's work. As *Knight, Death and the Devil* represents no particular biblical or historical event, Dürer leaves us to draw our own conclusions as to what he might have meant.

Paolo Veronese (1528–1588), a major player in Renaissance Venice's art world, came originally from Verona and, being the son of a stone cutter, had first trained as a sculptor. Fortunately for art admirers, thanks to his contact with the Veronese architect Michele Sanmicheli, he became a skilled painter of frescos and ceilings – talents which he later transferred to his glorious oils on canvas.

Many luxurious paintings emerged from the Veneto but none rivalled the subtle rainbow colours and glorious melanges of people, architecture and animals that Veronese created. John Ruskin, the nineteenth-century English art critic, after having stood before the marvel that is the *Marriage at Cana*, wrote in his diary: 'I felt as if I had been plunged into a sea of wine of thought, and must drink to drowning.'[12]

Intoxication indeed, from a confection of oil. But who could resist the delights Veronese created with the gorgeous pigments that were flooding into cosmopolitan Venice from the four corners of the world? Cool pastels, intense primaries, brilliant shades of every hue – Veronese used these new pigments to create extraordinary textures. The luxurious textiles that were the stuff of upper-class Venice could make us believe we are looking at costumes in a museum. The silks glisten, the velvet pile has dense depth, the gold glitters. There are plump luscious limbs, golden curls, the muscular arms of soldiers and of course his inimitable rendition of fur and the warm flesh beneath it. The renditions are so marvellous that Vasari in his biography of Veronese was moved to write of the two dogs attending his *Feast in the House of Simon* that they were 'so beautiful that they seem alive and natural'.[13]

55 Detail of Veronese (Paolo Caliari), *Feast in the House of Levi (The Last Supper)*, 1573, oil on canvas. The dogs that survived the Inquisition. This masterpiece originally graced the refectory of Venice's Dominican convent of Santi Giovanni and today may be admired in the city's Accademia Galleries.

Veronese – whose dogs also feature in Chapter Six – like Titian, set many of his works among the playful hedonism of Venetian high society, whose opulence, grandeur and canines lent themselves so well to his talents. As such, not only did his dogs attend feasts, but they featured in weddings, martyrdoms, allegories, mythologies, conversions and family scenes. Both *The Adoration of the Kings* and *The Marriage Feast at Cana* feature no fewer than four dogs – and at Cana one even jauntily walks among the delicious dishes, perhaps helping himself to the odd tidbit. By the fifteenth century etiquette books deemed it bad manners to feed dogs at the table, let alone allow them to walk on it. But what did independent, cutting-edge Venice and its pet owners care for etiquette? Or indeed for the disdain of the saintly Albertus Magnus (1200–1280), the author of what today we would call an encyclopaedia, who scathingly wrote: 'The most ignoble genus of dogs before one's table are those that are thought to be on guard but which frequently so place themselves that they keep one eye on the door and one eye on the generous hand of their master.'[14]

Veronese, like many other Renaissance artists, was commissioned by a convent to paint a monumental *The Last Supper* (and at around 12 m wide by 5 m tall (39 ft by 17 ft), truly monumental it was). His interpretation was a wondrous banquet in which he in effect set *The Last Supper* among the colourful and fashionable denizens of the Venice of the day, turning it into a joyous, decadent feast in which all life abounds, including a sulky jester and, naturally, Venice's myriad dogs. The Inquisition, those searchers after blasphemers whom they might punish by death, found much to fault in this celebratory work and word had already been sent via the convent's prior that these bastions of Catholicism expected him to paint out one of the dogs and replace it with Mary Magdalene. But Veronese held firm. An artistic dissident, he claimed the same licence as that accorded to poets and fools and replied that 'he worried for many reasons that the figure might may not fit

56 Detail of Benvenuto Tisi
(Il Garofalo), *The Marriage
Feast at Cana*, 1531,
oil on canvas.

properly in the painting.' The Inquisitors explicitly accused him of profanity and, extremely leniently in Inquisition terms, gave him three months to 'improve' the painting at his own expense. At the end of that time Veronese had made only one alteration – and that to the title. He transformed *The Last Supper* into another biblical event, *The Feast in the House of Levi*.[15] And, son of a city state that had always resisted the power of Rome, he, and the dog, got away with it.

The marriage feast at Cana, at which Jesus performed his first miracle of turning water into wine, was an extremely popular Renaissance subject. A particularly beautiful example (if considerably less riotous, sumptuous and fun than the one painted by Veronese) is that by the Italian Benvenuto Tisi (Il Garofalo) painted for the San Bernardino convent in 1531. No usual convent this, it was built by the notorious Lucrezia Borgia to house the illegitimate female offspring of 'her own and other leading families'.[16] It is an interesting location for a work depicting a celebrated marriage, and perhaps reflecting this, Il Garofalo's *The Marriage Feast at Cana*, while being one of his most unusual and attractive works, is also extremely restrained. Although servants are approaching laden with covered dishes (which one hopes hide substantial victuals), in this snapshot the table bears but a sparse selection of fruit and bread. Centre front, the smiling infant Cupid plays on the shallow steps. He is offering a pear to a small and winsome dog who obligingly holds out his paw towards this extremely undesirable canine food item. The dog and Cupid symbolize the hoped-for fidelity, happiness and passions of this richly attired, although in this rather formal rendition somewhat gloomy, couple.

Although it is not as famous as Titian's *Venus of Urbino*, which controversially featured a naked, if rather pristine courtesan – that is, a mere mortal as opposed to a goddess – I prefer Titian's later, mythological and earthy Venus accompanied by Cupid, an

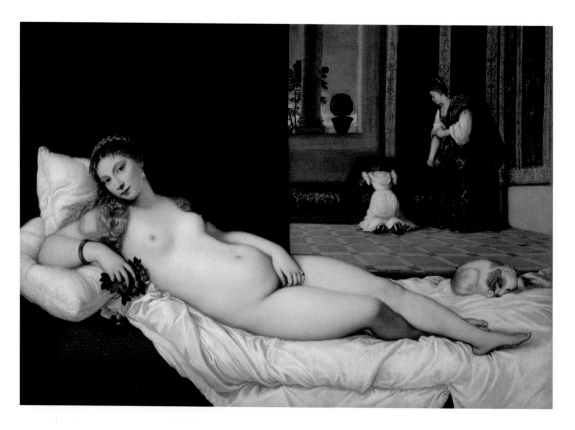

57 Titian, *Venus of Urbino*, 1534, oil on canvas.

organist who resembles Philip II of Spain, and the most cheeky of small dogs (illus. 58). No overly groomed and perfumed lap dog is this but a real dog with *attitude*, who stares out at us, ready to play, bark or chase a rat. Titian has created his tousled fur and his characterful face perfectly, giving us a tiny work of art within a larger framework. If he represents passion and love, then it is certainly passion of a rather more Rabelaisian flavour than that suggested by the overly neat spaniel in the *Venus of Urbino* or Il Garafolo's tiny timid sweetie.

Dogs were ubiquitous in Italian life and art and the Renaissance was a major influence on their portrayal in Western art right up to and including the present day, establishing two now classic genres to which I have devoted a chapter each. The first being the dual portrait of human and dog which was made uber fashionable by Titian's portrait of the Holy Roman Emperor with

90

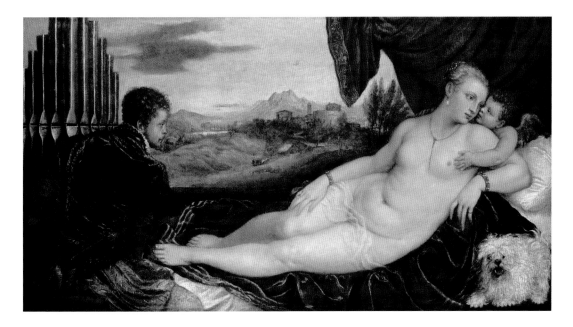

his wolf hound Sampere; the second being the stand-alone dog portrait first realized in *Two Hunting Dogs Tied to a Tree Stump* by Jacopo Bassano, on the instructions of an aristocratic patron of the arts.[17]

58 Titian (Tiziano Vecellio), *Venus and Cupid with an Organist, c.* 1550, oil on canvas.

59 Jacopo dal Ponte,
known as Jacopo Bassano,
*Two Hunting Dogs Tied to
a Tree Stump*, 1548,
oil on canvas.

FOUR

The Dog Stands Alone

'Art and love are the same thing: It's the process of seeing yourself in
things that are not you.'
CHUCK KLOSTERMAN. *Killing Yourself to Live: 85% of a True Story*
(2005)

Jacopo Bassano (1510–1592), one of the greatest painters
of the Italian Renaissance, used his sumptuous and delicious
palette to great effect in his highly elaborate paintings. However,
unlike High Renaissance artists such as Titian and Veronese who
gave us the wealth, splendour and sophistication of Venice, this
artist (born Jacopo dal Ponte) gave us nature in all its luscious
splendour, combined with the rich rusticity of daily life in his
birthplace, Bassano, after which he is named.

Many of his works, such as his allegories of the four seasons
originally created for a princely patron, were monumental in scale.
(The originals of these paintings have been lost but copies painted
by the Bassano workshop remain.) And as so many of his works
did, they contained small canine vignettes. In *Allegory of the
Element Earth*, for instance, an exquisitely drawn little spaniel
is attempting to gain the attention of a rather well-upholstered
monkey. In *Allegory of the Element Fire* Cupid plays with another
charming spaniel.

It was probably because Bassano was so fond of placing these
vignettes in his large-scale works that the aristocratic patron of
the arts Antonio Zantani chose him to execute the first painted
animal portrait in Western art.[1] Zantani's written commission
had been clear – 'a painting of two hounds, <u>only dogs</u>'.[2] Dogs had
finally stepped out of the shadow of man, and woman, and from

now on would increasingly feature in works of art on their own merits. The dogs Bassano chose for this commission were his own pointers and their portrayal is marvellous. The delineation of their coats is masterful – we can see the individual hairs and the way they lie according to the dog's posture, some standing partially at an angle, some lying flat; we can see the gradations of colour in their fur, the taut muscle beneath the skin. Their noses are cool and wet, the flesh of their ears thin, and we can imagine their warmth were we to stretch out a hand and fondle them. The attitude of the delicately raised paw of the dog on the left is perfect. His eyes look to some faraway horizon, dreaming of times past, while the pointer on the right looks us straight in the eye and holds our attention as another human would. These are living vibrant beings, individuals who, like their master, have their own agendas.

So consummate, so fine was this work that Tintoretto (1518–1594), a Renaissance master renowned for his absolute lack of naturalism, paid Bassano the ultimate compliment of copying his beautifully marked cream-and-tan pointer and placing it in his *Christ Washing His Disciples' Feet*, where it occupies the central foreground, the point from which all the other characters and

60 Detail of Tintoretto, *Christ Washing His Disciples' Feet*, 1548–9, oil on canvas.

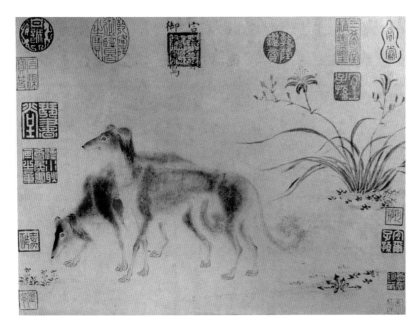

61 Zhu Zhanji
(Emperor Xuanzong),
Two Saluki Hounds, 1427,
album leaf, ink and light
colours on paper; with
inscription reading *Xuande
dingwei yubi xixie.*

events radiate.[3] But this reproduction failed to attain the genius of Bassano's hand.

However, as with gunpowder, porcelain and fireworks, it seems that the Chinese had got there first when the fifth Ming Emperor Xuanzong (1399–1435) painted a charmingly ethereal ink and light colour rendition of two slender salukis, along with greyhounds, the world's fastest and most admired sight hounds.

Salukis originated thousands of years ago in Egypt or the deserts of Arabia or with the Yemeni Bani Saluk tribe, depending on who is writing about them, but it was not until the Tang Dynasty of 618–907 that they finally conquered China. We might then be forgiven for thinking that the first portraits of salukis would have come from Islamic culture, particularly as *el hor* or the noble one is so revered for her supreme ability in bringing down gazelles. And long before Zhu Zhanji put brush to paper Arab poets were writing such lines as 'It is as though behind the place where his eyelashes meet there are burning coals constantly kindled' and 'Like a hawk swooping on sand-grouse, he peels the skin of the earth with four feet – he runs so swiftly.'[4]

However, although Islamic culture makes an exception for the saluki, whom they refer to as a 'hound' – that is to say, a hunting dog – to differentiate her from other non-hunting breeds, Muslims consider all other dogs to be unclean. So unclean that the mere touch of their fur on clothing requires a devout and strict Muslim to immediately change their clothes. This has led to an extreme paucity of dogs, even salukis, in Islamic art, something which remains the case even today.

It behoved all Chinese emperors to show an interest in art, whether it was genuine or not, but Xuanzong 'displayed genuine artistic talent and interest' and specialized in paintings of animals and in particular of dogs. Xuanzong is often grouped with artists of the Zhe school, a group of contemporary conservative, academic Chinese painters. But in reality his works are more a melange of the Zhe and the flourishing Wu school, which consisted of groups of scholar-amateurs who painted much more individualistically and expressively. This blending of styles allowed Xuanzong to produce works of delicious subtlety and structural complexity.[5] This intricate and beguiling painting, according to its inscription, was 'Playfully painted (by the) imperial brush' in 1427.

Despite the beauty and technical elegance of works such as *Two Hunting Dogs Tied to a Tree Stump* (illus. 59), the academic art world regarded, and on the whole still regards, animal portraiture as an unworthy subject for a serious artist and certainly one unfit for learned academic papers. While classicism held sway, only paintings of historical events, mythology or biblical scenes were considered to be suitable subjects. And although the Victorian love of romance and sentiment (a term which in those far-off days meant emotion and was not employed sarcastically), realism and the rise of Expressionism broke down the boundaries of this narrow remit, during the twentieth century postmodernism's cynical flowering again relegated animal and sporting art to a lowly position in art's hierarchy. And this, in general terms, is where it still remains.

In the twenty-first century academics such as Ernst van de Wetering, one of the major authorities who wrote in the catalogue for the National Portrait Gallery's *Rembrandt by Himself* show, found it fashionable, or perhaps career-enhancing, to propose that prior to the dawning of the Romantic era in 1800 even humanity did not possess self-consciousness. There were no men 'of feeling' whose individuality was 'the main touchstone in the experience of their existence and that of others'. Why? Because before this, man was ruled by 'categories of Christian and humanistic ethics, and by the doctrine of temperaments and dispositions, topped off with a liberal dose of astrology'.[6] According to van de Wetering this reduces Rembrandt's entire lifetime's output of self-portraits to nothing more than advertisements intended to spread his fame and celebrity and display samples of his extraordinary style and technical ability, an opinion seemingly in step with the contemporary market's view of art as a commodity on a par with pork belly futures or the price of corn.

These self-portraits and particularly those executed in Rembrandt's latter years, when his career was in steep decline and he was in terrible financial difficulty (at one point he only just avoided bankruptcy), clearly and self-evidently reveal his inner emotions, his increasing introspection and his soul-searching. The changes over the decades are profound and demonstrate far more than the decline of the flesh – they chart the decline of a spirit. They were, as one critic puts it, 'the expression of an ever increasing reflective self consciousness expressed not through the eloquence of words, but through the medium of paint', or to put it another way, 'Rembrandt . . . could not have portrayed himself without self-awareness.'[7] These views, along with the 'penetrating self-analysis and self contemplation',[8] that another critic sees, are dismissed by the unperceptive van de Wetering as 'an anachronistic view', and, he adds condescendingly, 'one evidently attractive to the public'.[9] When art academia seriously proposes that Leonardo da Vinci,

Shakespeare, Titian and advocate of sensibility Laurence Sterne are incapable of self-reflection and conveniently forgets that over 2,000 years ago Aristotle wrote 'whenever we perceive, we are conscious that we perceive, and whenever we think, we are conscious that we think, and to be conscious that we are perceiving or thinking is to be conscious that we exist', clearly it is never going to admit that animals have sentience, awareness and self-consciousness.[10]

So, in the twenty-first century, canine art, like all renditions of living fleshly nature, in general remains critically ignored, a situation which has been exacerbated by the absolute unfashionability and consequent decline in output of any works employing the medium of paint, particularly if the work is in any way naturalistic. Reality has been sidelined to make way for concept. How would a Stubbs painting fare today? One can only presume it would at best be ignored and at worst lambasted. For in contemporary times any canine portraits that do appear are liable to be dismissed or mocked and given, in the 'expert's' view, the crushing label *anthropomorphic*, while works that show an individual's emotion towards their dog or other animal find themselves very speedily labelled *sentimental* – a judgement akin to announcing the artist has rabies.

Brian Sewell, erstwhile acerbic critic of the *Evening Standard*, answered the question 'Does your dog love you?' thus: 'The scientist downgrades the affectionate behaviour of the dog to "attachment" but I, mere observer, am convinced that many dogs share with us the same range of emotions, grief and loss at least as much as love.' He continues later in the same 2013 interview: 'By many, even by some dog owners, all this will be dismissed as sentimental nonsense. But my affection for dogs is not in the least anthropomorphic and I do not see them as proxy human beings easier to manage than the real thing; I see them only as dogs and it is as dogs that I love them.'[11] But then Sewell lived with many dogs and, unlike so many academics and others who voice their disdain for animal-centric

art, took the time necessary to observe, communicate, understand and love them.

Artists who paint and sculpt animals, and who have thus spent nameless hours getting beneath the fur of their subjects, usually hold views similar to Sewell's. David Hockney, to take but one example, has defied postmodernism's fear of emotion by producing a large body of work featuring his dachshunds. In the introduction to his book *David Hockney's Dog Days*, featuring Stanley and Boodgie, he unabashedly writes, 'I make no apologies for the apparent subject matter. These two dear little creatures are my friends. They are intelligent, loving comical and often, bored. They watch me work. I notice the warm shapes they make together, their sadness and their delights.' And as he says in an interview with Peter Conrad in the *Observer* in 1992, 'They live for love. Oh and for food I suppose; that's the only material interest that they have.'[12] The Tate Modern's sell-out retrospective of his work in 2017 did not include one painting out of the over forty he made of Stanley and Boodgie.

It is interesting to compare Western society's preoccupations with animal sentience, or rather the lack of it, and Western academia's attitude to animal portraiture in general, with the philosophy and painting traditions of Japan. Japanese Mahayana Buddhist thought has always considered animals sentient beings. Beings that like humans are able to be reborn into higher orders and achieve enlightenment. This is a radically different view from the monotheistic religions of the West and the Near East. While medieval Europe was expunging animals from its religious art, Japan was celebrating and communing with them. Nowhere is this more beautifully shown than in the large-scale paintings that show all manner of animals together with birds and insects 'gathering together with humans and deities to witness the passing of the Buddha Shakyamuni into the state of nirvana . . . Many animals are shown hanging their heads in lamentation, some even appear to weep.'[13]

Kawanabe Kyōsai (1831–1889), magical artist and inspired caricaturist, was a Buddhist and although he has left us no writings on the matter we can imagine that his attitude to animals, like that of the Buddha, would have been respectful and empathetic. He was also influenced by two venerable artistic traditions, the first being 'crazy pictures' or *kyōga*, which he apparently learnt by studying the works of the monk-painter Tobo Sōjō Kakuyū (1052–1140). Kakuyū, along with others, produced large-scale, comic *kyōga* of animals engaged in human activities such as wrestling or dancing. The second tradition that influenced Kyōsai was that of animal portraiture, which reached its apogee in Edo-period Japan in the guise of the Maruyama-Shijō school, whose underlying principal was to paint life or *shasei*. And this *shasei* was almost always animal. Human portraiture in the sense the West thinks of it was very rarely produced for a variety of complex reasons but deep, expressive, intimate animal portraiture flourished and may

62 Kawanabe Kyōsai, *Puppy and Insect*, 1871–9, album painting, ink and colour on paper.

perhaps be seen at its most accomplished in the monkey portraits of Mori Sosen (1747–1821).

Kyōsai was principally a painter of animals who began painting and sketching from life in his early childhood. Because of this, the vital essence of his subjects always shines through and their form, even when not detailed, is real. A great number of his paintings were in the 'crazy pictures' genre but his animals, even though they are acting as humans, never lose their animal spirit. They remain truly animals, and ones that the viewer is quite prepared to believe can quite naturally and normally perform 'crazy' feats. Feats as amusing as frogs dancing with fans or a raccoon dog impersonating a priest with a tea kettle. And this is because, as in the works of that master of the dog Landseer, the joke was never at the animals' expense.[14]

Meanwhile in Europe, despite the views of academia, the output of canine portraits gradually increased until in the Victorian era it became a veritable deluge. Often we don't know to whom the dog depicted belonged or why they were painted but the sheer individuality of portraits makes it obvious that generally speaking, artists were painting specific dogs. In the twentieth century things changed. The Expressionists, the Cubists, the Surrealists, often painted in ways that did not concern themselves with their subjects' external characteristics. The actual subject might be completely unrecognizable in real life although their portrait might vibrate with emotion. One of the greatest of these, and a work that along with his *In the Kennels* has been almost completely ignored, is the now unimaginatively titled *Head of a Dog* (illus. 63) painted in the 1930s by Edvard Munch.[15] This seems such a dark portrait – the soul of an animal in existential pain, an image of suffering that might almost be a canine version of *The Scream*. The latter is seen both as an expression of the angst and alienation of modern humanity as well as the embodiment of Munch's own horror and terror when he sensed 'an infinite scream passing through

nature'.[16] *Head of a Dog* is an expression of a dog's inner emotions – probably those of Bamse, Munch's St Bernard, as the head bears a strong resemblance to that of Bamse in Munch's *In the Kennels* (see illus. 160).

We will never know why Munch painted Bamse as so anguished. Perhaps he saw into the soul of Bamse and there found something infinitely sad. Or perhaps Bamse had picked up on Munch's infinite angst, which radiated ever outwards, affecting all who entered his orbit; or maybe Munch was simply projecting his own depression and isolation into the portrait. For *Head of a Dog* bears more than a passing resemblance to his 1916 *Self-portrait in Bergen*. That same heavy green, the same diamond shape given to the eye surround. Even the same expression around the nose, mouth and chin. But does this mean that the spirit of Munch was in Bamse or that the spirit of Bamse was in Munch or even that Munch saw them as one? Bamse was, after all, one of Munch's closest friends, if not his closest.

Does this inner portrait of Bamse tell us more about his emotions, his soul, if you will, than this exquisite and highly naturalistic Renaissance bronze does about those of this anonymous hunting dog? Does Expressionism really express more than closely observed reality? I leave that for you to decide.

Dog, from the Florentine pair *Dog and Bear* in the J. Paul Getty Museum (illus. 64), depicts a solid hunting dog dating to 1600 and was modelled at the moment when the Italian Renaissance's love affair with antiquity was at its height. And this meant its love affair with not only antiquity's rich mythological heritage but its highly accomplished naturalistic bronzes. Wealthy collectors vied with one another to buy genuine antiquities, causing prices to soar, while contemporary artists frantically strove to emulate life of every variety. Bronze crabs, lizards and toads became all the rage and were sometimes cast from their carapaces, sometimes modelled from life. And in a bid to create dogs as magnificent as

63 Edvard Munch,
Head of a Dog, 1942,
oil on wooden panel.

the Jennings Dog (illus. 51), sculptors did not scruple to cast from canine cadavers.

Created as a pair with a bear, most likely this was the likeness of a favoured hound who when sent out to pit himself against these enormous animals, either in the hunt or in a bear-baiting arena, acquitted himself well. The muscles in his back speak of strength and power; his wide, spiked collar gives him some protection against his adversary. Powerful he might have been, brave he might have been, but when we study his sensitively worked face we see it is careworn and worried. As well it might be, for this was a dog who must fight whether he cares to or not. It was a hard and terrifying life, no matter how favoured he might have been.

Also from Italy, although a little later, comes the unusual rendition entitled *A Dog Lying on a Ledge*. This is no aristocratic hunting hound but an everyday dog, someone's pet, and he has been painted in what must have been one of his favourite spots. There is no attempt to glamorize him. He has been napping and his tongue hangs out in an attempt to keep cool in the shaded heat

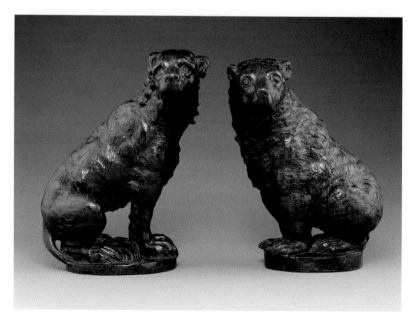

64 *Dog and Bear*, *c*. 1600, bronze.

65 Genoese school,
A Dog Lying on a Ledge,
c. 1650–80,
oil on canvas.

of a northern Italian summer. Once owned by King Louis Philippe and thought to have been painted by Velázquez, Zurbarian or Sinibaldo Scorza, currently the Ashmolean Museum have attributed it to a 'Genoese artist' owing to the style of its brushwork.[17]

Meanwhile in the sumptuous French courts of the Sun King and Louis XV, Desportes and Oudry began to produce canine portraits in quantity. And they did so because these monarchs were obsessed not only with both shooting and *la chasse* but with their personal sporting and companion dogs.

The first portrait commissioned by Louis XIV, and one which was to set the fashion for those to come, was of his two pointers Diane and Blonde setting game in the familiar countryside of Île-de-France (illus. 66). The dogs' names were indicated with capital letters – these, the king was signalling, are true favourites. And indeed they were. They, along with Bonne, Ponne, Nonne, Lise, Zette, Tane, Nonette, Folette and Mite, were so privileged, loved and trusted that it was they who kept guard in the king's ante-chamber at Marly – a favour the monarch's courtiers would have

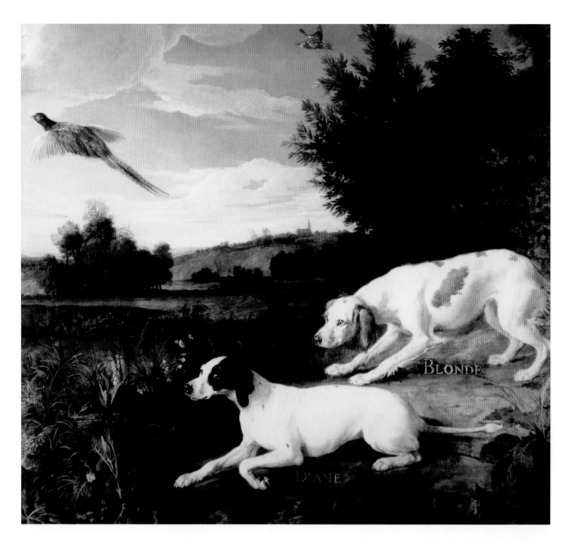

66 Alexandre-François
Desportes, *Diane and Blonde,
Louis XIV's Dogs*, 1702,
oil on canvas.

killed for. For Marly was the relatively simple hunting lodge or
pavilion where Louis XIV retired to escape from the rigours of
protocol, and a place where a man or woman on the rise might
finally obtain the ear of the king.[18] Marly is no more, demolished
in 1806 by a manufacturer of cotton who had bought it for
industrial purposes.

Oudry, despite the never-ending court commissions, relent-
lessly marketed himself to foreign clients and had great success in
Sweden, selling eleven paintings to the crown thanks to Carl
Gustaf Tessein, Swedish ambassador to Paris and aficionado of

French contemporary art. As a mark of his gratitude Oudry painted a portrait of his dachshund Pähr, which Tessein remarked was the 'most beautiful he has ever made'. And when it was exhibited at the Salon of 1740, the public agreed.[19] Everything about Pähr is superb, from the skilfully executed shine on his coat to the thoughtful and instantly amiable expression upon his face. Pähr is in his element as he looks out from the painting, perhaps towards the advancing figure of his master.

In England there were to be no major canine portraitists until 1760, when George Stubbs (1724–1806) decided to turn his

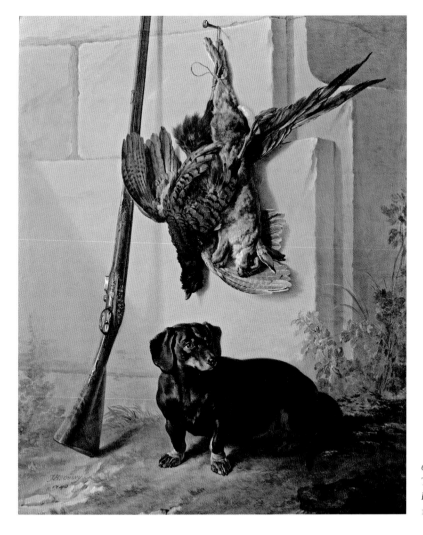

67 Jean-Baptiste Oudry, *The Dachshund Pähr with Dead Game and a Rifle*, 1740, oil on canvas.

attention away from portraits of northern urbanites and towards those of horses and dogs. Stubbs's genius was to make his animals vibrate with life; he used the colours of his palette with all the care, subtlety and precision that Shakespeare took with his words. And like Shakespeare he was a man of thoroughly independent character and thought. In 1754 he spent three months in Rome, epicentre of classical art, to prove to himself 'the inaccuracy of the aesthetic doctrine that nature was inferior to art and returned with the conviction that he was right'.[20] That 'Nature was superior to art' was his creed, and one which he frequently expressed.[21] And this conviction was surely what led him to literally get beneath nature's skin. For during the 1750s Stubbs spent

68 George Stubbs, *Brown and White Norfolk or Water Spaniel*, 1778, oil on panel.

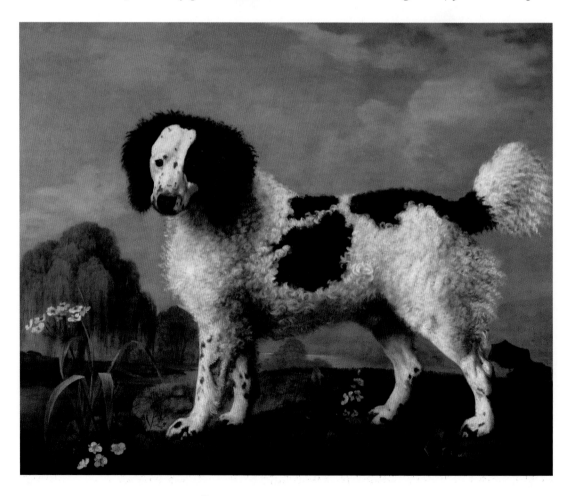

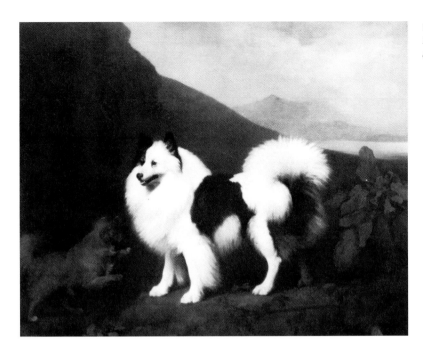

69 George Stubbs,
Fino and Tiny, 1791,
oil on canvas.

sixteen months dissecting horses and making detailed drawings of their musculature and skeletal form. This task meant dealing with mountains of decaying flesh and all that that involved – the nauseous stench, the dark clouds of flies, the physical exhaustion that was the result of hauling those heavy bodies and bones. In 1766 his *Anatomy of the Horse* was published and for the first time, the link between movement, muscle and skeleton became clear. Animal painting was about to get *real*.

Like the exceptional Franz Marc, whom we shall come across later in this chapter, Stubbs saw nature as a whole, a creation in which every living creature has its place and its dignity. And it was this worldview, combined with his extensive knowledge of physiology and his acute powers of observation, that gave rise to masterpieces which have yet to be surpassed.

The Brown and White Norfolk or Water Spaniel (illus. 68), as the painting has come to be known, shows Stubbs's exceptional ability to depict both form and character. The rendition of texture and spring in the spaniel's dense curled fur is matched only by his

exposition of its gentle demeanour and somewhat thoughtful disposition. The contrast between this spaniel and Fino, a Pomeranian spitz, is a telling demonstration of Stubbs's versatility. Fino, it seems, belonged to the Prince of Wales (later George IV), a man who, fortunately for many, spent without restraint on his horses and his art. Opportunely, his personal painter and art acquisitions manager, Cosway, was a good friend of Stubbs, and probably recommended him for a whole series of works as well as for *Fino and Tiny* and *The Prince of Wales's Phaeton*, which features a somewhat less coiffured Fino as a bit player.[22] In the latter the prince has chosen to be portrayed as a man, albeit a man of wealth and taste, rather than the heir to the throne, so it must have been a mark of signal favour that Fino was his chosen canine companion.[23]

The desire to put out a hand and plunge it into Fino's thick warm fur is almost irresistible, so realistically has Stubbs rendered it. Tiny, the spaniel, is observed with less detail but he is after all only a foil for the magnificent and supremely self-confident Fino – a 'face in the corner' for the main player. Luxurious and pampered, Fino's demanding presence utterly dominates the painting. A dog with charisma and the determined character which enables spitzes to herd reindeer and pull sledges across icy wastes, Fino was certainly a fitting companion for the future king.

If Fino, like so many twenty-first-century celebrities, earned his keep by simply *being*, Philip Reinagle's (1749–1833) spaniel in *Portrait of an Extraordinary Dog* seems to have had to work somewhat harder for his. Reinagle was particularly interested in the degree to which spaniels could be trained, and it seems that this spaniel had an aptitude for the piano . . .

In 1805 Ludwig van Beethoven used the tune of 'God Save the King' as the subject for a set of variations and Reinagle painted his *Extraordinary Musical Dog*. A coincidence? Laurence Libin, musicologist and curator at the Met, thinks not. Inspired by art historian

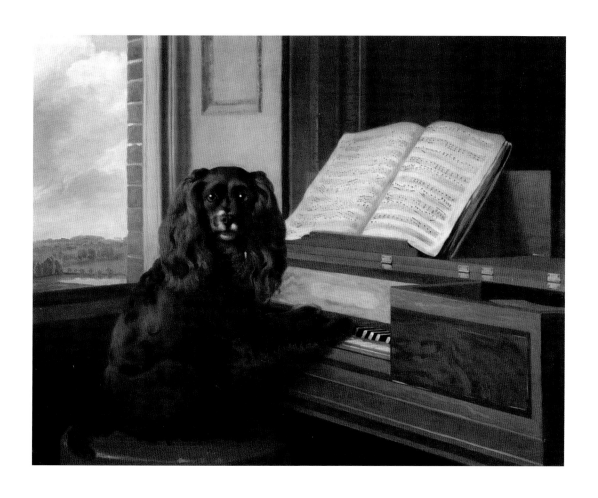

70 Philip Reinagle,
*Portrait of an Extraordinary
Dog*, 1805, oil on canvas.

71 Thomas Gainsborough,
Tristram and Fox, c. 1775–85,
oil on canvas.

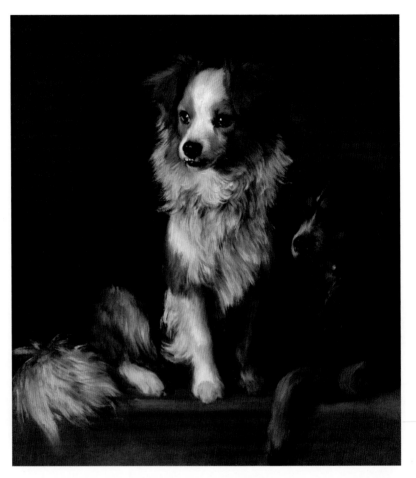

71 Thomas Gainsborough, *Tristram and Fox, c.* 1775–85, oil on canvas.

Robert Rosenblum's commentary on the painting,[24] he discovered that this truly *extra* ordinary pet spaniel was playing an elaborated version of the very same anthem in F major. So was it a dig at the huge number of child musical prodigies emerging at this time, as Rosenblum thought? They did after all include both Mozart and one William Crotch, who at less than five years old was reputedly an adept at picking out 'God Save the King' *with the bass line* on the piano.[25] Or was it simply a charming fantasy commissioned by a doting owner, something akin to portraits of children dressed as fairies and magical princesses? Whichever it is, it is a wonderful romantic portrait from a time when sensibility seemed to have triumphed and dogs in Europe were truly in the ascendant.

Thomas Gainsborough (1727–1788) was the supreme master of melting colours and easy, pretty elegance. Although he is mainly associated with frothing silken petticoats and elegant gentlemen in fancy waistcoats, the dogs in his compositions were equally stunning. Devoted dachshund keeper Andy Warhol's verdict on the 1981 Gainsborough show in Paris was: 'a lot of beautiful people and their dogs'.[26] Gainsborough's marvellous ability to capture character, human and canine alike, is clearly shown in this affecting portrait of his own rather rapscallion dogs, Tristram and Fox. That Gainsborough adored them is evident from the tenderness that permeates the entire work and the charming, questioning expressions with which he endowed them.

The pair were very much part of the family, Gainsborough even using Fox as a go-between when seeking forgiveness from his wife.

Whenever [Gainsborough] spoke crossly to his wife . . . he would write a note of repentance, sign it with the name of his favourite dog, 'Fox', and address it to Margaret's pet spaniel, 'Tristram'. Fox would take the note in his mouth and duly deliver it.[27]

The humane Gainsborough probably named Tristram (the dog on the right) after the eponymous hero of Laurence Sterne's raging best-seller *The Life and Opinions of Tristram Shandy, Gentleman* (1759–67). Although expressed through the medium of a bawdy comedy, Tristram showed compassion for the oppressed and was a proponent of sensibility – which in this context meant that he saw animals as he did people, as individuals having sentience and awareness. And this, in turn, meant that they, like all humans, should be treated with kindness. (Sterne was also a passionate advocate for the abolition of slavery.)[28]

Canine portraiture reached its zenith in the nineteenth century thanks to the patronage of Queen Victoria and Prince Albert. The

couple were simply wild about dogs – and where royals went, their subjects followed. At any one time they owned between 43 and 88 dogs; the most dearly beloved, such as Albert's greyhound Eos, resided in the palace, the others in well-maintained quarters. And every one of their literally hundreds of dogs had their portraits painted, a great many of them by Edwin Landseer. As a token of her admiration Victoria knighted the artist in 1850 and on his death honoured him with a state funeral. At that time, she owned 39 of his oil paintings, sixteen of his chalk drawings, two frescos and innumerable sketches.

The distinguished member of the Humane Society that Landseer's monumental portrait immortalized was intended to be a large black-and-white Newfoundland called Bob. Legend had it that Bob was shipwrecked off the English coast (Newfoundlands were often crew members and were employed, among other duties, to rescue sailors should they fall into turbulent seas) and made his way to London, no doubt to seek his fortune. And indeed Bob found it, for over a period spanning fourteen years he saved 23 people from drowning along the London waterfront. He was made a distinguished member of the Royal Humane Society (founded in 1774 with the purpose of giving awards to those who saved human lives and still extant today), which meant he was fed every day and, probably less interesting from Bob's point of view, awarded a medal.

When Landseer went looking for Bob in 1837 he was unable to find him but he did run into the path of another black-and-white Newfoundland, Paul Pry, who was engaged in the serious business of delivering a message for his mistress. And it was Paul Pry who became the model for Bob, posing on a table in Landseer's studio.[29]

Landseer gave Paul Pry all the gravitas and power that Bob so richly deserved. We can look at 'the distinguished member' and know, without doubt, that we would not be mistaken to put our trust into his great paws. Seagulls wheel against a foreboding and

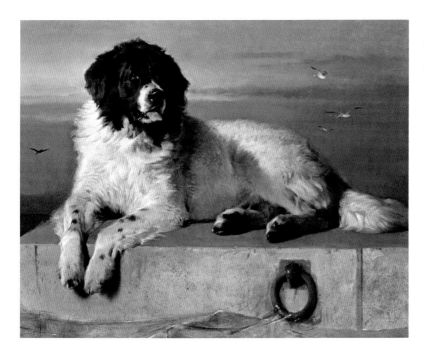

72 Sir Edwin Landseer,
*A Distinguished Member
of the Humane Society*, 1838,
oil on canvas.

angry sky and sea; the weather is shaping up for a storm. A storm for which Bob will be ready.

A Distinguished Member of the Humane Society is one of a number of portraits that Landseer painted of black-and-white Newfoundland dogs, including the monumental *Lion*, which hangs in London's Victoria and Albert Museum, and *Princess Mary of Cambridge with Nelson, Newfoundland Dog* (illus. 95). These paintings of Newfoundlands and their prints became so popular, and Landseer himself so associated with the breed, that it wasn't long before black-and-white Newfoundlands became known as Landseers.

Landseer was undoubtedly the most loved animal artist of all time. Engravings of his works sold in their thousands. And the reason for his success was that he captured the essence of his subjects and granted them their emotions. He was able to do this because, like the Nüremberg master Dürer, he spent his whole life studying animals, be they foxes, deer or horses. Landseer was not only an artist, he was a naturalist, and his most beloved subjects

were dogs. The intimate knowledge gained by intense observation allowed him to not only give us the curl in the coat of a poodle but to vividly express the complexity of his subjects' inner lives; suspicion, guilt, faithfulness, envy, love, rage, happiness, fear, cunning, joy, terror and despair were all within his repertoire and are, of course, all emotions that we too understand. He acknowledged the individuality of his canines and also their dogmanity. Like humans, dogs have personal idiosyncrasies and universal expressions. What dog does not raise a hopeful paw to ask for attention? Yet each will do so with a subtle difference. And like a great human portraitist, Landseer always treated his subjects with respect and compassion. His dogs were autonomous beings and if he used them to express satire or humour, he did so in a way which left their integrity intact.[30]

During roughly the same period in France (*c.* 1830–70), the Barbizon School arose as a counterpoint to the dominant Romantic Movement. It took its name from the small village of Barbizon near the then wild forests of Fontainebleau, where Constant Troyon (1810–1865) and many others including Jean-Baptiste-Camille Corot and Theodore Rousseau spent their time painting. Initially Troyon concentrated his efforts on landscapes but his immersion in nature stirred in him an intense interest in animals and revealed his exceptional talents for portraying dogs.

In *Gamekeeper and his Dogs* (illus. 73) the remnants of Troyon's classical past may be seen in the typical device of a path disappearing into the trees, but from thereon this work breaks with tradition.[31] He portrayed all the reality around him, including the actuality of the gamekeeper's dogs. These dogs are not symbols of a royal master's status, but real working animals. And let there be no mistake – although the gamekeeper features in this painting, it is he who is 'the face in the corner', he who is but an accessory. Troyon does not even paint his face. In contrast, Troyon has lavished a great deal of care on the faces, on the character, of

three of the four dogs. One raises his head to the sunlight, glad to be in the forest, returned to his natural habitat. The cream dog in the forefront looks at us knowingly from the corner of his eye – no poacher will escape his strong jaws – while the brown dog to the left looks down with a serious expression. As if woken from a deep sleep, he realizes that he must now prepare himself for a hard day's work. There can be no doubt that these animals are painted from life and Troyon has executed their portraits with a marvellous lightness of touch, softness of form and delicious and subtle palette.

The iconic American painting *On Point* (illus. 74) could hardly be more different in style or content from Troyon's *Gamekeeper*. D. G. Stouter (whose only known work this is) copied the entire painting from a print in an 1854 edition of *Gleason's Pictorial*. Yet it shares with Troyon a common subject in that it illustrates the concerns and interests of everyday men and women; here farmers and frontiersmen, who would have found the grouse that the dog is flushing an extremely desirable addition to the menu.

Copying a print was common practice among American naive artists of the period, although Stouter took some artistic licence. He omitted a second dog and a bird's tail and gave greater scale to the central dog so that she loomed ominously and omnipotently above the small, as yet foolishly unconcerned grouse. (Clearly Stouter also granted this pointer supernatural powers rendering her invisible, or by now, surely the grouse would have flown.) The dog stands alone, mistress of her world at a time when in American art dogs as a subject were still relatively rare, appearing only in the works of a handful of sporting artists. Although it illustrates an article on grouse shooting, the painting also allows for the pointer to have been a freelancer – spying on the game for her own reasons.[32]

Russia, like the UK and France, was often ruled by dog-admiring royals. Tsar Peter the Great (1672–1725), not a man renowned for

73 Constant Troyon,
*The Gamekeeper and
his Dogs*, 1854,
oil on canvas.

his sentimentality, had his favourite, a small terrier named Lisetta, stuffed. Currently she resides in St Petersburg's museum while another of his stuffed canine darlings still snoozes next to the fireplace in his Winter Palace. Eternal testaments to the love and trust absolute he placed in his four-legged friends.

With the accession of Nicholas I to the throne in 1825 came more canine art, and in particular a stunning portrait of the magnificent and intelligent poodle Hussar. Using thousands

upon thousands of tiny tesserae laboriously placed by hand, the Russian master mosaicist Georg Ferdinand Wekler has created an extraordinarily detailed portrait of the Tsar's favourite (illus. 75). The gradations in texture and colour on Hussar's coat are staggering in their complexity, the composition masterful. Wekler has positioned Hussar on the wide-open spaces of the gulf of Finland and its flat eternal sea. His bearing is regal, as if he knows these lands belong to his master and that the ships behind him are carrying who knows what treasures to him. The sky is a shade of blue which perfectly complements the silver poodle's coat. He is shown to every advantage, although we can hardly

74 D. G. Stouter (active 1854), *On Point*, oil on canvas.

75 Georg Ferdinand Wekler,
*The Poodle Hussar
on the Shore of the Gulf
of Finland*, 1847, mosaic.

keep from smiling at the way his facial hair has been clipped to endow him with marvellous bushy eyebrows and fulsome side-burns – a fashion also sported by the tsar himself.

Hussar's tale is one of rags to riches. Far from being born of canine royalty, Hussar had originally, as many poodles had, worked for his living in a circus, under the name of Monito. Quick-witted and celebrated for his amazing tricks, Monito's fame spread from the circus's hometown of Bohemian Karlsbad until finally news of him even reached the ears of the Viennese Russian ambassador, Dmitry Tatishchev. Seeing an opportunity for advancement, the ambassador quickly acquired the canine genius and presented him to the Tsar. At court Hussar-Monito quickly learnt the names of all the Tsar's courtiers and in his new world earned his living by bringing them to the royal presence when so requested.[33] A bronze sculpture of Hussar even graced the Alexander Garden at Tsarskoye Selo and although lost during the revolution it eventually resurfaced at a Paris auction and now resides in the Tsarskoye Selo State Museum-Preserve.

A sheepdog, if one appears in art at all, is usually a small figure in the distance herding its owner's precious sheep or goats. A small but determined figure that will give its life to protect its charge. One Australian sheepdog of my acquaintance, who resides in southern Italy (dogs are very multinational), had his throat ripped almost in two by something large that during a long, dark and lonely night tried to predate his herd of prize goats. He almost died, but round-the-clock care pulled him through and now, bravely, he protects the goats anew. But what Italian Renaissance master would have painted his portrait? What royal would have posed with a hand placed possessively on his head?

Among the very few to immortalize the peerless sheepdog is the accomplished Spanish artist Ángel Andrade y Blázquez (1866–1932), who painted the Spanish countryside and the everyday life of its people. And what more quotidian scene can there have been in nineteenth-century Spain than this?

76 Ángel Andrade y Blázquez, *En la Presa*, 1897, oil on canvas.

77 Unknown artist, *The Dog*, n.d., oil on canvas.

Andrade y Blázquez has dignified this dog of work and accorded him his true worth. His paws planted firmly on verdant green grass, intelligence and true grit clearly visible in every nuance of his face, he stands proudly next to his charges, brought safely home yet again. A dog in every way as magnificent as the fastest of salukis, the most imposing of wolfhounds. And a master of his world.

Another dog that is certainly master (or mistress) of their world – and undoubtedly their owner – is the extremely striking, naively realized chow who has simply been entitled *The Dog* by its custodians at the National Gallery of Art, Washington, DC. Occupying the majority of the canvas, this Chinese import appears all the

more exotic and imposing against what can only be a suburban
garden. He towers mightily above a doll's-house-size brick wall.
His mouth is open, revealing the blue-black interior and a magni-
ficent pair of canines. This, the unknown artist is stating, is a fine
dog and one to be reckoned with.

Chows are one of the oldest extant breeds. They date back to
at least the Han Dynasty (206 BC–AD 220) and probably a thousand
or more years prior to that. They were strong, bold dogs, hunters
and fighters who might have marched with the Chinese army as
Molossians did with the ancient Romans. They were also famed
for their meat – a fact noted by Gilbert White in his famous *Natural
History of Selborne* (1789).

To The Honourable Daines Barrington

My near neighbour, a young gentleman in the service of the
East-India Company, has brought home a dog and a bitch of
the Chinese breed from Canton; such as are fattened in the
country for the purpose of being eaten: they are about the size
of a moderate spaniel; of a pale yellow colour, with coarse bris-
tling hairs on their backs; sharp upright ears, and peaked heads,
which give them a very fox-like appearance . . . Their eyes are
jet black, small, and piercing; the insides of their lips and mouths
of the same colour, and their tongues blue . . . When taken out
into a field the bitch showed some disposition for hunting, and
dwelt on the scent of a covey of partridges till she sprung them,
giving her tongue all the time. The dogs in South America are
dumb; but these bark much in a short thick manner, like foxes;
and have a surly, savage demeanour like their ancestors, which
are not domesticated, but bred up in sties, where they are fed
for the table with rice-meal and other farinaceous food. These
dogs, having been taken on board as soon as weaned, could
not learn much from their dam; yet they did not relish flesh

when they came to England. In the islands of the Pacific Ocean the dogs are bred up on vegetables, and would not eat flesh when offered them by our circumnavigators.

Fifty years later the *American Turf Register and Sporting Magazine* noted the arrival of a pair of chows in the USA with this announcement:

To the Editor of the Turf Register from the Pacific by Mr Slacum of the Navy – a pair of 'Chinese Edible Dogs'.
N.B. – They will not be eaten until the breed has been secured for the country, though Purser Slacum, after feasting on them often, assures us they are very fine.[34]

This glorious painting, like Goodwin & Co.'s cigarette card of the celebrated Chinese Puzzle (1890) and all early photographs, shows us a chow with a longish muzzle lacking the thick folds of face flesh of contemporary chows. As was normal in these early imports, it has a relatively lean and rangy body. Inbreeding for a particular look has caused health problems for today's chunky, thick-fleshed chow, who suffers from eyelid entropion and hip and elbow dysplasia. It would be hard to imagine a modern chow marching northwards with a Chinese army, or indeed, marching anywhere at all.

The twentieth century saw sweeping changes in artistic style, with groundbreaking innovations such as Cubism and Surrealism coming to prominence. One fascinating forerunner of Surrealism was the Italian *scuola metafisica* (school of Metaphysical painting, *c.* 1910–20) founded by Giorgio de Chirico (1888–1978) together with Carlo Carrà and Giorgio Morandi, which used realistic but incongruous and mysterious imagery to produce disquieting effects on the viewer. De Chirico was much admired by Max Ernst and although short-lived, the *scuola metafisica* had a profound influence on the Surrealists.

As time went by de Chirico became much less interested in the *metafisica* style he had pioneered and developed works that had a basis in classical Italian art but which were still unique to him. The Italian painted innumerable horses but in general terms the only times dogs appear in his work are as bit players to the horses, the latter frequently being described as *Cavalli spaventati da due cani* (horses frightened by two dogs). There is however one exception to this: the distinctively marked dog which he paints several times during the 1930s and whose portrait he gives us in *Dog in Landscape* (illus. 78). This was presumably his own dog, as it appears in much the same pose next to *Diana Sleeping in the Wood* and, more crucially, takes centre stage in *Self-portrait in the Paris Studio*.

The dog's world is abstruse and impenetrable. Behind him lies a hot, dark landscape above a sky heavy with water, bringing with it the dubious gift of storm. Like the place he inhabits, the dog is brooding, magnificent and mysterious. Physically he has much in common with a harlequin Great Dane, something in common with the myriad forms of short-coated sight hound, yet also reminds us of that denizen of the deserts of the Middle East and the lands of Africa and Asia, the curious and unknowable hyena, neither canine nor feline. Why is he lying down in the middle of such a desolate landscape, a stony terrain without shelter or water? Is he a subtle feral beast, a hound waiting patiently for dusk and the advent of game? Or is he perhaps waiting for his human or hoping that the goddess of the hunt will again bless him with her magical presence?

De Chirico may have abandoned the *extra* ordinary but a host of others continued to develop revolutionary ways of painting. We have already seen Expressionism interpreted by one of its most angst-ridden exponents, Edvard Munch (*Head of a Dog*, see illus. 63), and now we take a look at the German Franz Marc (1880–1916), who gave us an altogether more gentle interpretation of

78 Giorgio de Chirico,
Dog in Landscape, 1934,
oil on canvas (later
mounted to fibreboard).

life and the natural world. Marc saw in nature and its non-human creatures a truer reality and honesty than that possessed by humanity, an innocence, even a forgotten Eden, if you will. And he felt that nature should be seen through the eyes of these purer souls, be seen on their terms, not ours. His intention was 'to intensify the aesthetic emotions . . . by blending the painted canvas with the souls of the spectator and the animal'.[35] In his own words, 'How does a horse see the world, or an eagle, or a doe, or a dog? How wretched and soulless is our convention of placing animals in a landscape that belongs to our eyes, instead of immersing ourselves in the soul of the animal in order to imagine how he sees.'[36]

Marc owned a Siberian sheepdog called Russi. Some portraits of Russi were painted naturalistically, as in his breathtaking *Siberian Dogs in the Snow* (illus. 79), in which the colours are so perfect and so intense that the cold of the snow becomes a tangible force. We can almost feel blue ice in our lungs and the sun on our faces, just as the dogs can.

However, Marc also painted Russi in the style that is more commonly associated with him, a style that was just beginning to show his interest in Cubism but which he and his circle made entirely their own – that of *Der Blaue Reiter* or *The Blue Rider*. In both of these paintings the dogs are in their natural environment. The snow is where they belong. Everything about a Siberian sheepdog is perfectly designed for a life in the cold icy wastes. In *Dog Lying in the Snow* (illus. 80) Russi is reclining comfortably on a cushion of melting snow, as well he might with his thick and waterproof coat. He is surrounded by the natural world, which protects and sustains him. For he *is* nature. A dog, as the French might say, that is happy in his own skin. This painting is white upon white, but just as the Eskimo have fifty words for snow,[37] so there are innumerable shades of white. Yellow-white, pink-white, blue-white, grey-white and every conceivable gradation. Marc has used this spectrum to form a rainbow-white in which Russi is

camouflaged and yet stands out from his world, just as he would in the real world. The extended left foreleg on which he rests his head is in a completely usual and natural position for a dog, although one commentator is driven to write that 'through iconographic tradition in German art [it] telegraphs a pensiveness that will resolve into renewed creative energy.'[38] Perhaps. For Russi is sleeping the non-sleep of dogs who have, as it were, one eye open as they wait for something, or somebody.

This painting has an interesting history and one that yet again brings into the spotlight the contempt that the art world so often has for dog portraiture. Marc was killed in the horrors of the First World War aged just 36 and in 1919 *Dog Lying in the Snow* was bought by the Städel Museum in Frankfurt from his widow Maria. It hung there until 1937 when, with the world on the

79 Franz Marc, *Siberian Dogs in the Snow*, 1909/10, oil on canvas.

80 Franz Marc,
Dog Lying in the Snow,
1911, oil on canvas.

verge of another war, it was seized as an example of *Entartete Kunst* – degenerate modern art – by the Nazis. This prompted Felix Weise, the avant-garde collector, to remark in a letter to the Bürgmeister of Halle that 'the painting of a family pet was a prize of little value "even for something dangerously pleasing".'[39] Fortunately the painting avoided destruction and the Städel Museum did not agree with Weise's assessment, spending, in 1961, 175,000 Marks to buy it back – a price which tripled the previous record price paid for a work of modern art by the Städel. In 2008 *Dog Lying in the Snow* was voted the museum's most popular painting. So much for Mr Weise.

Clive Head's millennium-year *View of San Francisco* graphically illustrates the disparity between the ever-renewing harmony of the natural world and the creations of man, so often destructive. The gigantic chasm between nature and the city, which for Marc was a corrupt material world that he chose to turn his back on, could hardly be clearer. Head's artistic mission is to represent the *now* of the world around us and in *View of San Francisco* he has surely

81 Clive Head,
View of San Francisco,
c. 2000, oil on linen.

caught all of humanity's modern angst and the crucial dilemma that faces it: to save the environment and the natural world or to accumulate ever more material objects.

The golden Labrador, nature's fleshly representative, seems to know the answer. For millennia his kind has been our guide through the underworlds, hells and heavens of so many cultures, and perhaps it is time to take a good look at where he is headed in the twenty-first century.

My Best Friend and I

'Not the least hard thing to bear when they go away from us, these quiet friends, is that they carry away with them so many years of our own lives.'
JOHN GALSWORTHY

Humanity has always chosen to be immortalized with its dogs. A friend against the vicissitudes of life, the recipient of whispered confidences and a creature to delight and trust in – who better, then, to be pictured with? Dog and human, an indissoluble bond that has lasted from the dawn of history, through the machine age, and that in the era of virtual friendships and fantasy Facebook life is more important than ever. Traditionally found in drawings, paintings and, although less frequently, also in sculpture, the dual portrait has shown itself to be remarkably adaptable to changing media and lifestyles. In the nineteenth century nascent technology gave the world early photographic media – daguerrotypes and then ambrotypes. Dogs rarely appeared in the former, as early versions required exposure times ranging from three to fifteen minutes, a long time for the family pet to be still unless it were sleeping. They do however appear somewhat more frequently in ambrotypes, whose exposure times could be as little as five seconds. The moving dual portrait of a Confederate soldier with his stoic dog is a particularly fine example (illus. 82). The dog in this photographic portrait is as prominent as the soldier and like him wears an expression of infinite weariness. The pair's candid emotions grant us a glimpse of just how much the dog must have meant to this anonymous soldier as he endured the horrors of war. Is it art? Of course. It is the art of those who could not

82 Ambrotype of an unidentified
soldier in Confederate uniform
with his dog, *c.* 1861–5.

afford the services of a professional artist, of those who had little time to spare, whose lives might be eclipsed tomorrow. And if one of true art's tasks is to communicate, to stir emotion, then this ambrotype tells us as much or more about the soldier and his hound, than for example Titian's seminal dual portrait of Federico Gonzaga II and his lap dog (see illus. 87) does about them.

In the twentieth century film photography eclipsed these time-consuming media and the dog not only became a constant in innumerable family snaps but began to appear in the work of highly fashionable photographic artists such as Cecil Beaton. Then, with digital cameras, came a proliferation of dual photographic images that were rarely printed but were posted on the Web. With camera phones, selfies became the order of the day and social media saw an explosion of these images, an explosion that every day increases exponentially.

Long before the expression 'art critic' came into any language, art was unaffectedly expressing the mutual bonds of affection between individuals and their dogs. *Kneeling Woman Kissing a Dog* is an astonishingly joyous example from 2,500 to 3,000 years ago and is among the earliest examples of representational art found to date in the Valley of Mexico and Central America. Unlike sculptures from other civilizations, including those of Europe, every terracotta from this lower pre-classical period is unique. This masterpiece, then, is an original, full of vitality, life, happiness and spontaneity. A true image of tenderness, it is a snapshot of the moment the puppy leaps into the woman's arms.[1]

83 *Kneeling Woman Kissing a Dog*, *c.* 1100–500 BC, modelled terracotta with traces of polychromy.

Rather more restrained but equally full of warmth and charm is an informally worked 2,500-year-old bronze from Middle Eastern Babylonia. Although it is the product of a culture very different from those of ancient Mexico, it too instantaneously communicates to us the human-canine bond. The protective hand the man lays on his pet's back is a gesture repeated globally a million times a day. Enduring, it is as eternal as the bond it represents. Dogs were common subjects in Babylonian sculptures, but usually they are found in conventional stylized reliefs of hunting scenes, so this is a rare, personal and important work of art.[2]

The same hand of protection, two and a half millennia later, comes from a proud warrior, finely drawn. A man who has seen much, perhaps too much. His pistol is ready in his belt; an expression of weary watchfulness and even disillusionment pervades his features. Behind him, flat, featureless lands stretch into an infinite distance. His eyes, cast to his left, are mirrored by those of his mighty dog. They are a tight-knit unit, as they need to be. This dog is no elegant sight hound, but a tough heavy dog that has much in common with the Molossians of the ancient Romans. Molossians, protected by flexible metal armour, were the Romans' first line of defence against the enemy, behind which trod their slave handlers and then, the cream of Roman might, the legionnaires.[3]

On 16 April 1529 Federico II Gonzaga, First Duke of Mantua (1500–1540), apologized to his uncle Alfonso d'Este for monopolizing Titian because 'ha conienzo un retratto mio qual molto desidero sii finito' ('he has started a portrait of me which I greatly desire to be finished'). A portrait which was to be seminal in the history of art. By painting the duke with his most adored canine subject, a gorgeous long-haired lap dog, instead of a puissant and prestigious symbolic dog such as a mastiff, Titian signalled to the world that Gonzaga was so secure in his authority and masculinity that he had no need to emphasize it and, more than this,

84 Man and dog, Babylonia, 800–700 BC, bronze.

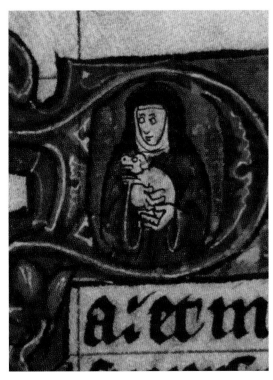

that he was a man of uncommon humanity. (An added bonus to his worldly image, as he was soon to be married).[4]

Titian's masterful portrait of Frederico II Gonzaga (illus. 87) was to change Titian's life as it gave him an entrée to Charles v, Holy Roman Emperor (1500–1558), whom he painted at Gonzaga's request in 1530. That work is now lost and we can only presume Charles was not particularly impressed with it as he immediately tasked Jacob Seisenegger with the duty of creating a distinctive visual image for him.

Between 1530 and 1533 Seisenegger toiled on five full-length portraits of the Holy Roman Emperor, together with his enormous hound Sampere. Seisenegger noted in a letter in 1535 that Sampere was an English breed (undoubtedly a wolfhound) and that he had made 'an effort to show that it was female'. The full-length portrait was not an entirely new concept but it was a revolution in imagery as far as portraying the emperor was concerned. And one on which

85 Louis Gallait, *Sentinel the Croat*, 1854, oil on canvas.

86 In this illustration from the medieval illuminated manuscript the Maastricht Hours, the Netherlands, 1300–1325, a nun holds her tiny dog protectively. He may not be able to ward off enemies (although from his cleverly drawn expression he looks as if he would certainly sink his teeth into an ankle if necessary) but surely provides her with great emotional comfort. She raises a diffident gaze, perhaps fearful of a reprimand from the ecclesiastical authorities, and as seen in the dual portrait of the Croat warrior and his dog, her pet's eyes gaze at the same external object as hers.

Titian jumped. Not a man to allow a prestigious client such as Charles V to slip through his fingers, when he bumped into the emperor in Bologna he produced a painting that was essentially a copy, or as Titian would no doubt have termed it an interpretation, of Seisenegger's 1532 portrait. And what an interpretation. Employing a little airbrushing in oils, Titian transformed Charles V and this, combined with his subtle use of colour, the magnificence of Sampere and his clever use of space, produced a work of obvious superiority to that of Seisenegger. The emperor presented him with

87 Titian, *Federico II Gonzaga, First Duke of Mantua*, 1529, oil on canvas.

500 ducats and more was to follow. He was ennobled, appointed official artist to the emperor's court, and granted the exclusive privilege of painting the monarch.[5]

Titian had achieved the Renaissance equivalent of superstardom. Then as now, superstardom garners its followers and the demand for these genre pieces became so great that Renaissance artists were forced to keep canine models on hand for clients who lacked that now essential accessory. Such was the influence of this particular work that it became the accepted format for official portraits for over three hundred years and still endures today as a classic format.[6] This is something which was clearly demonstrated in the Royal Society of Portrait Painters show of 2017 – a show in which the prestigious de Laszlo Foundation prize was awarded to a life-size full-length portrait of seventeen-year-old Alex Lederman and his dog (the dog being considerably more finely drawn than the teenager); the painting of Lord and Lady Carter and their dog, in a nice twist of emphasis, was entitled *Shell with Lord and Lady Carter* (Susan Ryder); and Liz Balkwill's dual portrait of a man on a sofa with his dog took things a stage further, simply being entitled *Old Dog*.

If the sixteenth century had been the heyday of the Italian High Renaissance, then the seventeenth century was the era of 'art and wonders' in the Spanish Netherlands, of which the painting *The Archdukes Albert and Isabella Visiting the Collection of Pierre Roose* is a particularly rich and fascinating example (see illus. 90).

At this time *contskammers*, also known as private collections or cabinets, were extremely fashionable and the artists of Antwerp established themselves as masters at representing them in sophisticated and mesmerizing paintings. Although they frequently were nothing more than genre works, this glorious and detailed *contskammer* with the archdukes Albert and Isabella visiting the immensely wealthy and extremely powerful southern Netherlandish politician Pierre Roose (*c.* 1584–1673) seems to be Roose's

overleaf:
88 Giovanni Battista Moroni, *Gian Lodovico Madruzzo and Spaniel*, c. 1551. Madruzzo was a high-ranking Catholic in an important city, making this a prestigious commission for Moroni, particularly as it was to hang with a portrait of his uncle, Cardinal Cristoforo, by Titian, the man of the moment. The portrait has an intense air of reality, in part because of the sensitive rendering of Madruzzo's spaniel, a creature with the most beautiful and unusual markings, whose ears have almost the appearance of angels' wings. The cold tiled floor (a Germanic device) and dark robes contrast with the warmth of the spaniel and the strong flesh tones of Madruzzo's face and makes a dramatic impression.

89 Titian, *Charles V HRE*, 1533, oil on canvas.

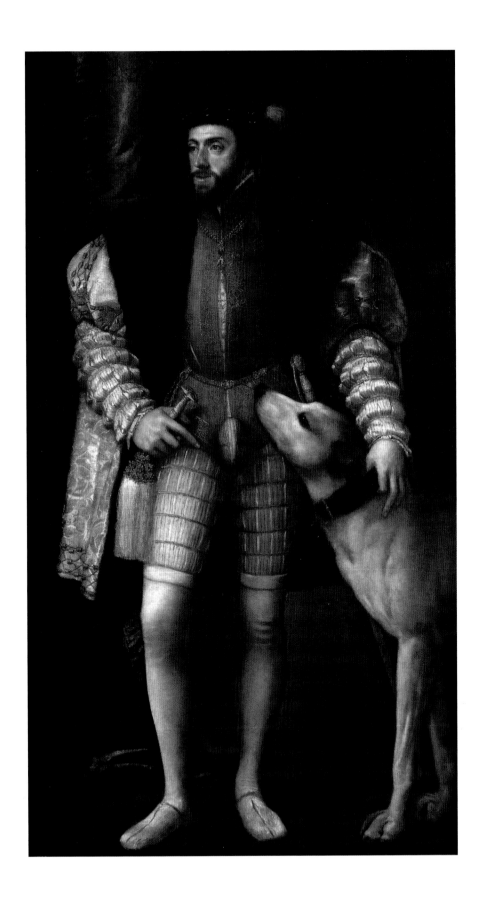

previous:
90 Hieronymus Francken II
(1578–1623) and
Jan Brueghel the Elder
(1568–1625), attributed
(under review),
The Archdukes Albert and
Isabella visiting the
Collection of Pierre Roose,
c. 1621–3, oil on panel.

own, and as such is particularly interesting. Crammed with all the curiosities and exotica of the globe, with examples of scientific discoveries that particularly interested him and displaying his personal taste in art, the cabinet is simply overflowing. George Mercator's Celestial Globe (first produced in 1551) has pride of place on a large table; one of Cornelis Drebbel's perpetual motion mechanisms is there to intrigue; there are paintings by masters of the day, a bird of paradise from the Spice Islands and a large sunflower. (Sunflowers originated in South America and it wasn't until the middle of the sixteenth century that European eyes first enjoyed their yellow splendour.)

Among all these extraordinary wonders, at their centre are yet more marvels, this time of flesh and blood: five dogs, a monkey and a tiny marmoset. Four of the dogs are in a semicircle to the right of Isabella's chair, the greyhound a little separated from the others, and they may well have belonged to the archduke (the central figure standing next to his wife Isabella's chair.) For when Jan Brueghel the Elder (1568–1625) – to whom this painting is currently in part attributed – painted his charming *Studies of Dogs* in around 1616, it featured if not this greyhound, one remarkably similar to it, as well as a little seated cream-and-tan dog which also closely resembles the one featured in the *contskammer*. Albert and Isabella, besides maintaining large kennels, patronized Brueghel the Elder, so it seems perfectly likely that the *contskammer* dogs were indeed their personal favourites. Of course Roose was also an admirer of dogs and certainly owned at least one greyhound, which was immortalized by Quellinus I in wooden, life-size splendour in 1657. As this work was sculpted thirty years after Roose's *contskammer* was painted, it is open to debate whether this was a *memento mori*, and thus possibly depicted the dog in the painting or a contemporaneous living pet.

The long-haired dog on the left, who appears to have two heads and as such should be *in* the cabinet of curiosities rather

91 Gerard (Gerrit) Dou,
The Herring Seller, c. 1670–75,
oil on panel.

than lounging around comfortably on the floor, presumably does belong to Pierre Roose, since he appears in other versions of this painting in which the other four dogs are absent. Fortunately his double head is due to an artistic change of mind, the second head being visible owing to it bleeding through the top layer of paint.[7]

Meanwhile in the Dutch town of Leiden Gerard (Gerrit) Dou (1613–1675), until the nineteenth century one of the Netherlands' most celebrated artists, was painting a rather different type of dog. Dou developed a unique, minutely detailed style of his own and was the founder of the so-called Fijnschilders or 'fine, or small-scale, meticulous painters' group. He was particularly renowned for his use of chiaroscuro, which in *The Herring Seller* he uses to great effect to take our eyes to the principal subject of the

work, the herring seller's old and faithful dog. Some see the dog as bad-tempered but in fact he is just a truly venerable dog still doing his duty, protecting the herrings, source of all of his and his mistress's meagre wealth, from any who might try to take them. A hard life with all too little reward, but at least the sun is warming his old body and lights his rheumy eyes. Over the years he and the old woman have grown alike, companions in days of plenty and in those of misfortune. And unlike many, the herring seller has not cast away an old dog; she still cherishes him, even if his days of chasing miscreants down the crowded streets of the market are over. It is rare indeed to see a dog of this age and parentage so realistically portrayed, and bearing in mind Dou's attention to detail and reality these subjects seem certain to be taken from the busy life he saw around him in Leiden.

As the eighteenth century progressed, dual portraits became ever wider in scope. Jean-Honoré Fragonard (1732–1806), a painter of rococo frivolity among many other things, often used dogs to express eroticism, most famously in his *Girl with a Dog*, where the long tail of rather long-haired lap dog is used to protect the girl's modesty. But his paintings were also often extremely romantic, his colours delicious and his brushwork light. However, in *A Woman with a Dog* it is humour that dominates. Marie Émilie Cignet de Courson (1727–1806) is wearing fancy dress, a device Fragonard used from time to time. Authorities struggle to find a reason for this; I do not. Clearly Mme de Courson dressed up for fun, to fulfil the fantasy of being a glamorous Médici, as her costume resembles that worn by Marie de Médici in a glorious series of paintings by Rubens in the Louvre.[8]

Executed with panache and style, this oil on canvas immediately brings a smile to the face. The ample bosom of the woman, down which the hapless and tiny lap dog could easily disappear, the inviting expression on her face, her red cheeks, her double chin, all speak of a woman who knows what she likes and is not

92 Jean-Honoré Fragonard, *A Woman with a Dog*, c. 1769, oil on canvas.

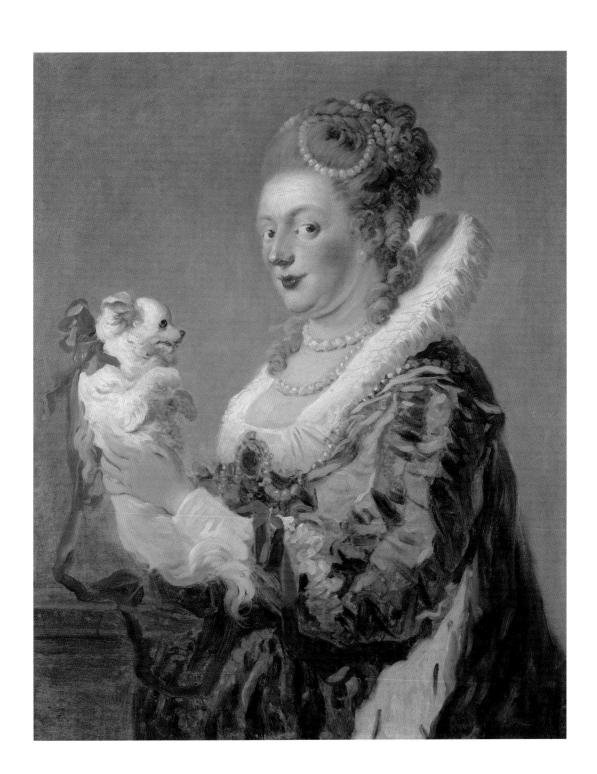

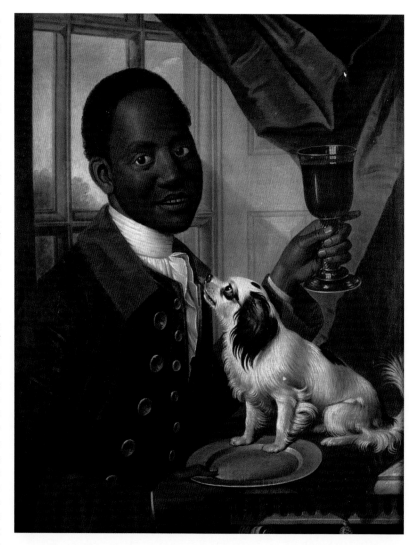

93 Colonial school artist, *Servant with a Lap Dog*, *c.* 1770. Servants and slaves were rarely painted as the main subject of an image, let alone with a darling and utterly pampered lap dog looking at them adoringly. The liver-brown ears of a King Charles spaniel (it bears a great resemblance to one featured in *Charles I and Henrietta Maria Departing for the Chase* by Daniel Mytens (1630–32)) contrast charmingly with the white of its face. Its feathered tail is curved upwards in anticipation, perhaps of a caress, perhaps of a treat. (Both these 17th-century spaniels have muzzles appropriate to the scale of their heads. However, due to a hundred years of selective breeding and inbreeding purposefully designed to produce unnaturally flat faces contemporary spaniels now suffer from a host of afflictions, including respiratory problems and eye diseases.) The servant is immaculate and elegant, his face open-and engaging. It may be that he, the lap dog and the ruby contents of the cup the servant was bearing were three of the most important things in the world of the one he served.

afraid to make her desires known. The dog dangling in space, his enormous blue ribbon and bow reflected in the colours of his mistress's costume, seems to want nothing more than to put his four paws back on terra firma. This, however, will happen only in his mistress's own good time.

In England just a few decades later Sir Edwin Landseer was rising to undreamt-of heights as Queen Victoria's canine artist of choice. Landseer was fascinated not only by the sheer dogginess of dogs, by their individuality and their characters, but by the

ways in which their lives were affected by those of their masters and mistresses and the nature of the bond between them.

The Dustman's Dog, executed when Landseer was just thirteen years of age, is a striking early example. 'There is great pathos in this figure of the poor, tired, ill-favoured, unconsidered animal, with no claim to good birth accomplishments, or good looks, and quite unaccustomed to delicate fair or good society,' wrote Cosmo Monkhouse in 1880.[9] What a character study from the hand of a child, and one which also captured not only the resigned weariness of the dog's life but the never-ending tension in his body. He is not malnourished, his owner is not a cruel man, but Landseer has shown us clearly the utter tedium of a life spent in the detritus of other people's lives. The dustman's lot was as least as hard as the dog's – so let us hope that some sympathy between them made their lot fractionally easier to bear.

As time went by Landseer left behind his portraits of the 'ill favoured' and those canines who belonged to low life and entirely concentrated his efforts on their high-living brethren. The typically Victorian work commissioned by the Duke and Duchess of Cambridge in 1839 (illus. 95), features their stonking Newfoundland Nelson playing with their daughter Princess Mary of Cambridge.

94 Sir Edwin Landseer, *The Dustman's Dog*, 1816, drawing.

95 Sir Edwin Landseer, *Princess Mary of Cambridge with Nelson, a Newfoundland Dog*, before June 1839, oil on canvas.

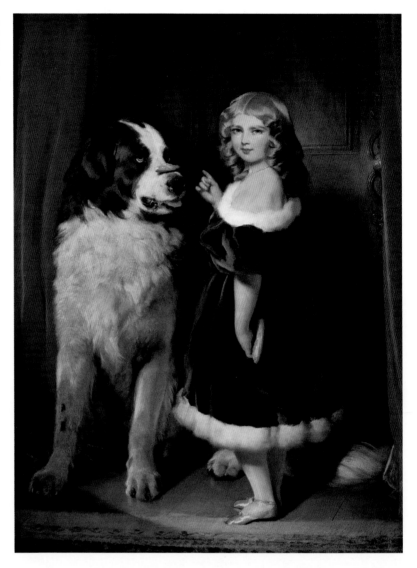

Princess Mary holds a broken biscuit, the other half of which is balanced on Nelson's nose. In due course he will throw it in the air and catch it – maybe. Besides capturing the healthy animal spirit of Nelson, Landseer has imbued him with all the patience and forbearance which the canine race habitually display to small children. The Duke noted in his diary in 1838, 'I went to see Mr Landseer's picture of little Mary which I think is exceedingly like.'[10] Nelson may also be admired in Landseer's *Favourites, the Property of* HRH

Prince George of Cambridge, along with his Arabian stallion Selim, Flora the King Charles spaniel and peregrine falcons.

Landseer's paintings encapsulate exactly how the English saw themselves and their dogs during the second half of the nineteenth century. But other eyes saw Europeans rather differently. In Utagawa Hiroshige II's (1829–1869) *Furansu (France) – A French Woman, Her Child and Pet Dog* (illus. 96) he has given the woman the slanted eyes and somewhat flattened facial features of the East, and decorated her extraordinary umbrella-shaped dress with fans. But it is the dog that fascinates. Full of energy, vitality and good humour despite the fact that a child bigger than he is riding him and using his ears as handlebars, the dog's red tongue, flashing brilliant white teeth and bright green eyes show us that far from the Labrador-type Hiroshige II was perhaps trying to portray, he is in fact a super-hound from the realms of Japanese mythology.

What worlds apart Japan and Europe were is even more vividly demonstrated in the ink and colour rendition of the wife of a wealthy Japanese merchant by Japanese artist Mihata Joryu of around 1830–40. Ethereal and deliciously delicate, the woman and her dainty dog could almost float away and yet for all their lightness they are inextricably twined, the little lap dog keeping a possessive paw on the hem of his mistress's kimono.

Painted just twenty years later, the altogether rather more French view of a woman and her dog, the nude being Gustave Courbet's (1819–1877) then mistress, Léontine Renaude, shrieks eroticism (illus. 98). The intimacy between Renaude and her medium-sized, rather shaggy poodle is a metaphor for sensuality, for the love between her and Courbet, and also contains echoes of Titian's propensity to paint seductive nudes with dogs. At a time when in metropolitan France the desire was to de-nature dogs, to take away their animal instincts and turn them into powdered bejewelled dolls who were paraded in salons wearing fashionable

96 Utagawa Hiroshige II, *Furansu (France) French Woman, Her Child and Pet Dog*, 1860, polychrome woodblock print, ink and colour on paper.

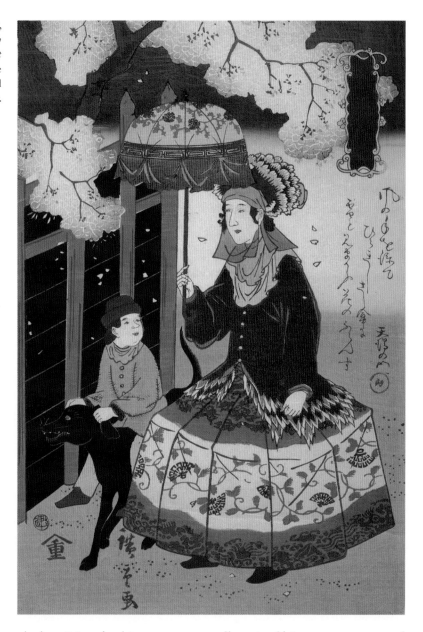

97 Mihata Joryu, *Woman and a Dog, c.* 1830–40, ink and colours on silk.

clothes, it is refreshing to see a poodle as itself, in a state as natural and unaffected as that of its mistress.

Just how far the dual portrait had been embedded into human consciousness by the mid-nineteenth century is encapsulated in *Pug Dog in an Armchair* by Alfred de Dreux (also Dedreux). This favourite of Napoleon III was an extremely accomplished equestrian

artist whose work was in constant demand. From the mid-1840s onwards Dedreux travelled frequently to England, where he became a great admirer of Landseer, whose influence we can surely see in *Pug Dog in an Armchair* (illus. 99).[11]

Opulent, corpulent and all dog, Pug has been reading France's oldest newspaper *Le Figaro*, as befits a creature of such elevated status. At his or her paws (Dedreux has delicately obscured this information by hanging a strategically placed tablecloth from Pug's side table) lies an aristocratic sight hound. Double-chinned and snoozing in a richly upholstered chair, a half-drunk glass of wine or perhaps cognac by his side together with a partially eaten snack, Pug is surely the epitome of a gentleman who has nodded off in his club, his best friend at his side. Although this is humour, even satire if you will, Pug has been exquisitely rendered, even down to the delicate pink flesh showing beneath the white fur. Pug's companion hound, his face in the corner, has also been extremely sensitively drawn.

Norman Rockwell (1894–1978) created 321 cover paintings for the *Saturday Evening Post*, paintings which reflected not the grandiose ambitions of the rich, the concerns of metropolitan sophisticates or the extravagant emotions of artists, but the feelings of normal everyday Americans from one side of the vast continent to the

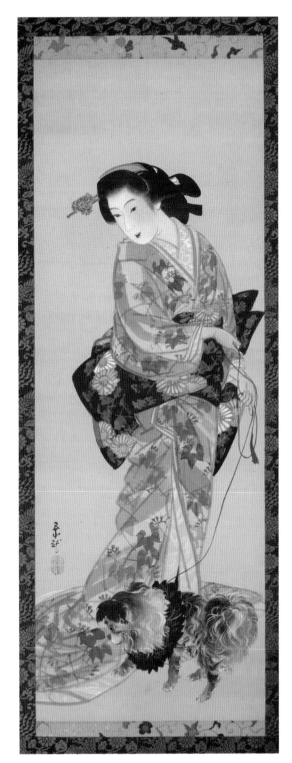

99 Alfred de Dreux, *Pug Dog in an Armchair*, 1857, oil on canvas.

other. He explained his covers thus: 'Without thinking too much about it in specific terms, I was showing the America I knew and observed to others who might not have noticed.'[12]

And who better than Rockwell to explain the content of one of his most popular, *Breaking Home Ties*?

> I once did a cover showing a father seeing his son off to college. That year my three boys had gone away and I'd had an empty feeling – it took me a while to adjust without them. This poignancy was what I wanted to get across in the picture. But there was humour in it too. I put a funny kind of suit on the boy because he was a ranch boy leaving home for the first time. And his father was holding two hats, one the boy's beat-up old rancher's hat and the other his brand-new hat. The boy was carrying a lunch box all done up in pink ribbon. I drew a collie dog with his head on the boy's lap. I got most of my fan letters about the dog. You see the father couldn't show how he felt about the boy's leaving. The dog did.[13]

98 Gustave Courbet, *Nude Woman with a Dog*, 1861/2, oil on canvas.

152

Rockwell's collie and the Border collie in Landseer's classic
The Old Shepherd's Chief Mourner, painted around one hundred
years earlier, both show us dogs expressing love for their human
friends in situations where people do not. Rockwell's collie has
his head on the boy's leg. Landseer's collie has the same aspect,
the same mournfulness, but even more poignantly is the old shep-
herd's only family, the only living being to express its grief. During
Victorian times it was greatly admired for its sentimentality, John
Ruskin writing that 'it stamps its author, not as the neat imitator
of the texture of a skin, or the fold of a drapery, but as the Man
of Mind.'[14]

In contemporary times art critics criticize *Breaking Home Ties*,
as they do *The Old Shepherd's Chief Mourner*, for their sentimen-
tality. One should perhaps always bear in mind that the current
fashion for interpreting any heartfelt emotion as sentimental is just
that, a fashion. Why should what is a perfectly ordinary expression
of affection combined with feelings of loss in a dog be so derided?
John Ruskin was the leading English art critic of his era as well as
a prominent social thinker and philanthropist. Are the views of

contemporary art critics any more valid than his? Food for thought in harsh times.

The Old Shepherd's Chief Mourner was engraved by Gibbon in 1838, and became one of the best-selling prints of the century. And the public still remain firmly in Ruskin's camp, placing Rockwell's portrayal of 'everyday love and embarrassment' second in a 1954 popularity poll of *Saturday Evening Post* readers.

An undisputed admirer of dogs in more contemporary times was the late great Lucian Freud (1922–2011). His love of the canine race goes back to his German childhood, when he struck up a friendship with Billy, the family greyhound. At school in England, Freud's animal pals ranged from goats to guinea pigs and once in a fit of teenage devilment he redirected a pack of foxhounds into Bryanston school hall and up the stairs. However it was not until

101 Lucian Freud, *Girl with a White Dog*, 1950–51. One naked breast in dual portraits such as these was once quite a standard convention. Many artists who painted 'pretty' girls with their little dogs allowed one rosy-blushed breast to escape from their bodices. Jean Baptiste Greuze (1725–1805), who was known for his somewhat salacious portraits of rather young women who were often lamenting the loss of their virginity, was a particularly enthusiastic proponent of this device.

1948, when Freud married his first wife, Kitty Garman, and was rewarded by receiving a pair of bull terriers, one black and one white, as a wedding present, that he had a dog he could call his very own. Kitty and the bull terrier are the subjects of his first dual portrait, *Girl with a White Dog*, the postcard of which in 2002 knocked Millais's *Ophelia* from the number one spot in the Tate Gallery's postcard best-seller list.[15]

However, this classic dual portrait, in which Freud has painted both his subjects with tremendous love, has sad subtexts which render it particularly poignant. Originally Freud had painted Kitty with their black bull terrier (his favourite of the pair), but even before the painting was finished he was killed in a road accident, causing Freud to metamorphose his coat to the white of his sibling. And less than a year later, Freud's marriage to Kitty was over.

Alex Colville (1920–2013) spans the same time frame as Lucian Freud yet could hardly be more different in style or character. An extremely private Canadian, Colville based his works on a precise geometric plan while his painting technique, like that of the Pointillist Georges Seurat, consists of applying thousands upon thousands of tiny dots to a canvas. Nearly a third of Colville's paintings include animals and his own dogs are frequent subjects. Like Franz Marc, Colville is capable of seeing life through the eyes of an animal; he recognizes that we are part of nature and through his work conveys his great respect for the natural world. In some of his paintings, such as *Dog and Priest* and *Woman and Terrier*, the heads of the humans are completely supplanted by those of the dogs that are with them. And so it is the dogs that see and understand the world around them rather than their humans.

He also appreciates and understands what the bond between human beings and their dogs means to the *Homo sapiens* member of the pair. In a rare comment on his own work – in this case *Dog in Car*, where the dog is painted in profile in the back window of a car, rather as a person might be pictured in taxi – he says:

It is interesting how often you see a dog in a car. Why would a person take a dog in a car? Well, there are practical reasons – you don't want to leave the dog at home or something like that – but basically the dog has a comforting presence, you know. There is this curious business of how people stand existence, how do people make it from one day to the next, without becoming anxious or crazed or suicidal, or whatever you know. And they do it by all kinds of devices, and one of which is having a dog in a car, you know.[16]

Although Colville sees life 'as inherently dangerous. I have an essentially dark view of the world and human affairs . . . Anxiety is the normality of our age,' he also paints 'almost always people and animals whom I consider to be wholly good'.[17]

The child in *Child and Dog* is Colville's own daughter Ann, surely of all humanity the person that the artist is certain to see as wholly good. And he has painted her naked and defenceless next to their pet, a large black dog with penetrating and watchful amber eyes. This is a compositional combination which goes back to the Renaissance, when the children of royals might well be painted with hunting hounds or Molossians as large or even larger than themselves and when mythological cherubs (and certainly Ann is cherubic in aspect) were frequently to be seen in the company of extremely large dogs. We have only to look at the paintings of Landseer and the Victorian animalier oeuvre as a whole to see that large dogs with tiny children are always beings of protection and benevolence. The friend the child can always turn to. The friend who will protect them to the bitter end. In paintings, was it a man or a woman who brought a child down from certain snowy death at the top of a mountain? No, it was almost always a giant St Bernard. And what better emotional and even physical security in an anxious age alienated by technology than a faithful dog?

overleaf:
102 Alex Colville, *Child and Dog*, 1952, glazed tempera on Masonite.

103 John Wonnacott RP CBE, *Mrs Janet Sheed Roberts aged 110 with Freuchie aged 4*, 2012, oil on board.

So here we have the wholly good with the wholly good. If this painting expresses an anxiety, it concerns the world outside the painting, the world that the great black dog is there to protect Ann from. And Ann herself, now a grown woman, is constantly surprised at the number of people who interpret the dog in this painting as threatening – one of whom, extraordinarily, is the commentator at the National Gallery of Canada, who considers the encounter 'ominous'.[18] But perhaps he/she is unacquainted with canine-kind.

In *Mrs Janet Sheed Roberts Aged 110 with Freuchie Aged 4* and *Reclining Nudes, Watching the Beautiful Woman*, John Wonnacott, the contemporary English portrait painter, has captured the close and tender bonds between humans and their dogs and

104 John Wonnacott RP CBE, *Reclining Nudes, Watching the Beautiful Woman*, 2005, oil on board.

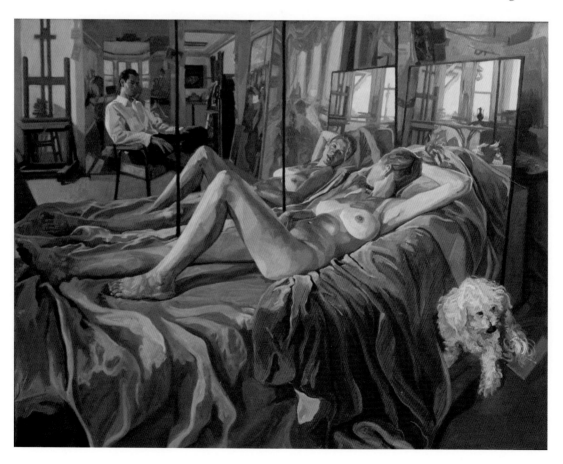

the consolations that age may find in youth. As John Wonnacott says, 'the 110-year-old lady always came to life when her 4-year-old miniature schnauzer came bounding into her room. As my daughter owns a very similar schnauzer it was irresistible to contrast the vigour of the young dog with human great age in this way.' Mrs Roberts may be 110 but Mrs Roberts is still very much alive. There is no pathos to this painting, no feeling sorry for Mrs Roberts or patronizing her – it is a celebration of a life that is still worth living and to which a schnauzer brings rays of happiness.

In *The Beautiful Lady*, he has captured a reverse situation. He explained: 'The "Beautiful Woman" owned Sophie the Bichon Frise, who was dying when I painted them together so the dog could be considered both as friend and memento-mori and is by far the best area of painting in the picture.'[19] And so it is, and not just for the masterful rendition of her fur. Sophie sits as ancient dogs do, her head not held as high as it once was, her breathing not as deep, but determined to the last to stay near those that she loves.

In one interview, Wonnacott said, 'I paint appearances. I don't understand insight into people. I don't know what that means. My colleagues in portrait painting say that they can see beneath the skin. Well, I think they're jolly clever. I find it hard enough to see the skin.'[20]

Capturing the skin, or the fur, the nuances of stance and expression is what allows us a glimpse of the mind beneath. For aren't those external clues the key to the living being underneath, if we can be bothered to take the time to really look at them? The vast majority of information we receive, even when a human is talking to us, is non-verbal, and most of that is visual, which is one of the reasons we are able to understand our non-verbalizing dogs so well if we take the time to actually observe them, instead of simply looking at them. So perhaps Wonnacott's 'skin' vision tells more than he admits. For to me he has captured Sophie's soul.

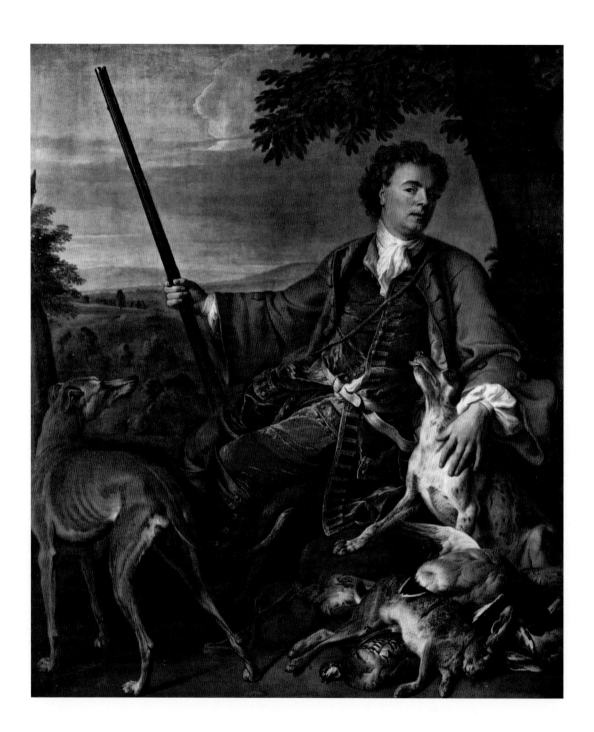

SIX

The Dog's Role as a Model in Life and Art

'Sleeps well.'
LUCIEN FREUD

Dog models, professional and amateur, have always been rife. The dog's many symbolic meanings have ensured their presence in a multitude of works where they are not featured as portraits of a particular individual but are there to make a point. And as such, they were in constant demand.

In 1419 *The Hieroglyphica*, Horapollo's reputedly circa fifth-century work explaining the meanings of ancient Egyptian hieroglyphics, was 'rediscovered' and an edition illustrated by Albrecht Dürer was published sometime between 1507 and 1519. The hieroglyph for dog, besides standing for spleen, in other words anger and melancholia, also symbolized both prophets and judges. This was, Horapollo explained, because the Egyptians saw in the dog's deep and knowing gaze – which was, 'more than any other animal', concentrated on divine images – the intense concentration that human prophets needed if they were to understand what divine revelations actually meant. And naturally, this razor-sharp perception meant that dogs could see beyond fine clothes, or rags, to the person within. They were, then, perfect judges. Anyone who has visited Battersea Dogs and Cats Home and experienced the power in the entreating gaze emitted from a hundred pairs of shining eyes can understand perfectly the ancients' reasoning.

Horapollo also wrote that the dog hieroglyph signified a sacred scribe, a master of the written word, because dogs could 'bark

105 François Desportes (1661–1743), *Self-portrait in Hunting Dress*, oil on canvas. Branding, branding, branding. Here Desportes' first important work not only signals that he is a man of quality interested in the pursuits of that class, but that he is a supreme portrayer of animal life. Like others who excel in this genre, Desportes studied nature and very frequently worked from life. Branding must have worked as Desportes was destined to become court painter of *la chasse* to Louis XV of France.

fiercely and perpetually while fawning on no one'. Like true artists, thinkers and philosophers, they are unmoved by the opinions of the powerful.

Medieval sources also associated dogs with holy learning, and hence scholars. The monk Rabanus Maurus clearly stated in his encyclopaedia that 'dogs represent a good sermon', a definition which the order of Dominican monks were happy to seize on when the populace interpreted their name as *Domini Cane*, the Lord's dogs. And naturally dogs were always *hunting* after *truth*.

All this wise and cultured symbolism was seized upon by practitioners of every art and it became almost *de rigueur* for philosophers, writers, poets, artists and ecclesiasticals of every era to be depicted with a little, or from time to time large, dog by their side. A particularly lovely example of this genre is the painting of St Augustine by Vittore Carpaccio (1460/65–1525/6), a Venetian artist who specialized in large-scale paintings for the *scuole*, the charitable confraternities. The saint is writing a letter to St Jerome,

106 Detail of the dog in Vittore Carpaccio, *The Vision of St Augustine*, *c.* 1502, tempera on canvas.

a fellow scholar, when unexpectedly a vision of his friend's death and ascent to heaven appears before him. Of course he is not the only one to see the vision; the little curly-topped Maltese and the saint gaze as one towards the window, with its glorious light and divine revelation.

In the material world the Maltese, a venerable if tiny dog, had always been a favourite with the ladies of ancient Rome and continued to be adored in Renaissance Venice. And as little dogs were such very popular pets for those in religious orders, it seems likely, considering the detail and care with which she has been drawn, that besides her role as a symbol in the overall composition, she was also a pet from the *scuola*.

Dogs came to represent so many things, a large number of which were contradictory, that artists seemed almost to be in need of a lexicon for them. Their meanings included marital fidelity, loyalty to the Church, to God, the king and the royal court, faith, lust, lasciviousness, melancholy, wisdom, craven flattery,

107 Vittore Carpaccio,
The Vision of St Augustine,
c. 1502, tempera on canvas.

protection, love, trust and devotion, to name but a few, along with the ability to endow humans with status, or remove it, depending on their own hierarchy in the human-designed canine class system. (Hunting dogs at the top – mongrels at the bottom.) They were even used to send messages. The little hunting beagle in Federico Zuccaro's 1575 portrait of Elizabeth I (a pair with one he drew of her lover, the Earl of Leicester) was not a beloved pet but a secret message referencing the time they had enjoyed hunting at his estate in Kenilworth.[1] No doubt it was not the only thing they enjoyed and as such the beagle must surely have also symbolized at least one of the following: love, lust, lasciviousness, loyalty and fidelity.

By the close of the Renaissance dogs had accumulated so many symbolic meanings that the naturalist Edward Topsell in his zoological compendium *A Historie of Foure-footed Beastes* (1607) simply captioned his extraordinary *Canis lucernarius* 'THE MIMICKE DOG': in short, it was a creature that could be anything and everything. And which, according to Topsell, 'in wit and disposition resembleth an ape, but in face sharpe and blacke like a Hedghog'.

During the Renaissance canine models were everywhere in the works of the great Italian masters. We have already seen royal favourites in portraits of the most important men of the day and now we take a look at the role of models in Veronese's work and those of his workshop. These models are so numerous and so varied that if they were all presented here they would provide a veritable Kennel Club guide to the canine inhabitants of Venice.

Two of his most hard-working models are the dog and bitch so luxuriously accompanying Cupid in his oil on canvas of 1580 entitled, unsurprisingly, *Cupid with Two Dogs* (illus. 109). They feature in the controversial *Feast in the House of Levi* (see illus. 55); the *Rape of Europa* in the Palazzo Ducale, Venice; *The Marriage Feast at Cana* in the Louvre; *The Adoration of the Kings* at Santa Corona, Vicenza; *Christ and the Centurion* at the Alte Pinakothek, Munich; *Venus and Adonis* at the Seattle Art Museum;

108 Edward Topsell, 'THE MIMICKE DOG', from *The Elizabethan Zoo: A Book of Beasts both Fabulous and Authentic* (1607).

The Adoration of the Magi at the State Hermitage Museum; and so on. And why not? They are splendid animals with the most attractive piebald markings, large and strong, yet biddable and charming. It is however in *Cupid with Two Dogs* that they they are shown to their best advantage.

It seems that with the exception of W. R. Rearick, writing in the catalogue for the 1988–9 show *The Art of Paolo Veronese, 1528–1588* at the National Gallery of Art, Washington, DC, art historians have failed to unearth either a symbolic or mythological meaning for *Cupid with Two Dogs*. Rearick however reasons as follows: the emphasized mammaries Veronese has given to the dog on the left show that she is female and probably pregnant. And indeed she bears a charmingly contented expression, as pregnant bitches so often do. He presumes (and why not) that the one to the right is a dog and a rather 'melancholy' one at that and that the laurel at the right signifies 'the continuity of natural forces'. In short, as love is the 'presiding and harmonising force in the natural world', Cupid is the darling protector of the soon to

be canine family. A charming and perfectly plausible conceit. Dogs are so often there to signify fidelity and passion in human and divine relationships that it is surely more than apt that Cupid should bless a canine one, and that Veronese should render them in such glorious detail and to such fetching advantage.

Another particularly notable example is the extremely flexible and attractively marked sight hound who may, for example, be seen emerging from under the laden table in Veronese's *The Feast in the House of Simon* and is also one of the two dogs featured in his presumed *Self-portrait Dressed as a Hunter*, which is just a small part of his wondrous *trompe l'oeil* frescos at the Villa Barbaro at Maser. In this latter work, the presence of the model is all about creating image or, as a social media guru of today might term it, brand. Renaissance artists and many others simply

loved dressing up and presenting themselves as daring men of action who were also men of quality and noble lineage. Aristocrats who were geniuses with a brush could hold their own with the most exalted in the land and judged hunting and nature to be of supreme importance. As such it was essential that they were accompanied by at least one adoring upper-class canine, and Veronese chose to represent himself with two. The sight hound stares up at Veronese, his long neck turned with almost snake-like fluidity, but the second, perhaps a form of mastiff, stares out at the viewer quite beguilingly, if a little lugubriously – no doubt to show the world that on top of his painterly genius and hunting skills Veronese was a man of likeable although charmingly eccentric character.

Rembrandt, a century later, unusually chose to dress up as an Eastern potentate and X-rays reveal that after initially working on a solo full-length portrait he decided to jettison his feet and paint a poodle in their place. Poodles may not have the cachet of a sight hound, but since when did a potentate care about such things? And more importantly for Rembrandt, aesthetically he fits the fantasy perfectly. There is something luxuriant, indolent and exotic about that curly and delicious fur. We can feel the spring in its coil, imagine its curious rough texture were we to stroke it. Its colour tones pick up those in the thick gleaming textiles of Rembrandt's costume, the golden glint on his ears echoing those in the skirt. The dog adds another layer to Rembrandt's masterful use of light and shade. He adds to the aesthetic image and hence to the exotic taste of the would-be pasha.

In Netherlandish Europe dog models were extensively used as props in quotidian scenes. They were just 'any dog', there to add texture, flavour and veracity, and can often be spied making their way down a crowded street or cocking a leg against a church's convenient pillar, as in *Interior of the Oude Kerk Delft* (c. 1650) by Emanuel de Witte (illus 111). One of the most gifted architectural

painters of his time, Witte was particularly drawn to the magnificent spaces of the Netherlands' old Gothic churches. Here, the lofty spiritual is juxtaposed with the normal realities of everyday life. The delicious light filtered through a high leaded-glass window blesses a carefree lop-eared dog urinating on one of the Kerk's imposing columns. Nearer the window a small brown dog runs past two men who are gambling and two children are happily carving their initials on a column. All life was there.

To most Western eyes an image of the Hindu deity Shiva riding a parrot would seem to be a magical, almost surreal painting. But to Hindu eyes this image is redolent with meaning and symbolism, such as in an early nineteenth-century Punjabi watercolour (illus. 113). It depicts the seminal deity Shiva in one of his most common roles, that of the wild ascetic. His hair is matted and coiled, his appearance dishevelled, his lips reveal fangs that would grace a sabre-toothed tiger and he holds a skull cup.

One of Shiva's many functions is to highlight the contradictions and dichotomies inherent in human behaviour and so he frequently behaves contrary to the norms of polite society. On appearance alone he is already presented in stark contrast to the typically pretty and innocent Kangra-style flowering creepers and trees behind him. On top of this he is deeply intoxicated – but of course, intoxication can also bring enlightenment. He rides a parrot when birds must surely fly. And he is accompanied by a happy little gold-collared pye dog. But what is so contrary about that? To Western sensibilities, nothing, but in Hindu India, the dog was seen as inauspicious, a pariah, and so for Shiva to be accompanied by a dog adorned with a gold collar blatantly flouted convention.

Dogs in Hindu India had never attained any form of status. Unlike in the ancient civilizations of Egypt, Rome and Greece, dogs were not generally esteemed for their hunting abilities. There are no ancient bronzes of great heroic hounds or paintings of

110 Rembrandt van Rijn, *Self-portrait in Oriental Attire*, 1651, oil on panel.

perfect pointers. Perhaps this was partially due to a predilection for vegetarianism, perhaps partially to the terrain and wild fauna, perhaps for myriad other reasons too numerous to go into, while the idea of keeping dogs as household pets was a concept that to a great degree was introduced by the British during the Raj.

The British may have failed to conquer the subcontinent – underneath it rumbled on much as it always had regardless of their peregrinations – but where the officials of the Raj failed, canines, despite their previous lowly status, succeeded. By the twentieth century trend-setting luminaries such as the extraordinarily beautiful Maharani Gayatri Devi (1919–2009) and her husband Maharaja Sawai Man Singh II were engaging that doyen of the worlds of fashion, celebrity and aristocracy Cecil Beaton to photograph

111 Emanuel de Witte, *Interior of the Oude Kerk Delft*, *c.* 1650, oil on wood.

112 Jan Havicksz Steen, *The Merry Family*, 1668, oil on canvas. It goes without saying that Dutch bourgeois families were almost always painted with their pets. Dogs were, as one might say, part of the furniture. As familiar and interchangeable as chairs and equally essential.

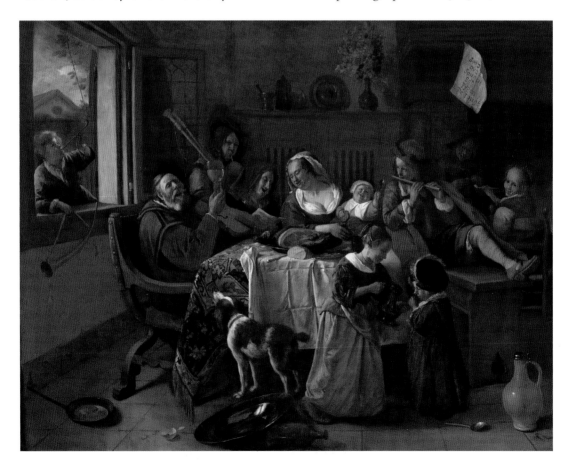

113 *Shiva, c.* 1820,
paint on paper.

them with their Alsatian. (Man Singh's eclipsed second wife kept a little dog as some consolation for the loss of her handsome, suave and wealthy husband and made sure it drank only imported mineral water.)

By the twenty-first century the dog's conquest of India was complete. Large numbers now live in India as much-loved family members, while European breeds such as Labradors are looked upon as extremely desirable furry status symbols and are often to be seen strutting their stuff in palaces.

Families that do not have a pet dog can feel their absence keenly, even in modern times. In Western culture particularly, there is something about a family dog that speaks of warmth, of enduring love, of a solid unit facing the world together. A family without

one can seem somehow incomplete, to be floating without a fixed mooring. Richard Avedon, the portrait photographer, related how when his family assembled for group photos, not only did they dress up but they posed in front of expensive cars and other people's homes. And he continued,

> We borrowed dogs. Almost every family picture taken of us when I was young had a different borrowed dog in it . . . It seemed a necessary fiction that the Avedons owned dogs. Looking through our snapshots recently, I found eleven different dogs in one year of our family album. There we were in front of canopies and Packards with borrowed dogs, and always, forever, smiling. All of the photographs in our family album were built on some kind of lie about who we were, and revealed a truth about who we wanted to be.[2]

In modern American art this need is brought home by the gloom, despair and alienation evoked in Edward Hopper's *Cape Cod Evening* (illus. 114). The collie knows their *ménage à trois* is ending and that soon he will be living a new life. And so he completely ignores the husband, who, having failed to establish any kind of rapport with his wife, is looking for a smidgeon of affection from the family dog. But in his imagination, the collie has already left and his focus has moved to nature, to the woods where the 'whipporwill [*sic*]' calls.[3] He knows that the trees and grasses, as neglected by the couple as their marriage was, will soon reclaim the land that was always theirs. The couple are not part of this world, but the collie is, and, lithe and fast, he can run into the straw-like grass and again become part of nature. His tail is up; he is ready to leave at any moment. It will only take the merest scent drifting on the summer breeze to turn desire into actuality. And when it does, the couple's relationship will have ended for good.

114 Edward Hopper,
Cape Cod Evening, 1939,
oil on canvas.

The collie model for this modern masterpiece of 'brooding estrangement' has an interesting genesis, recounted by Hopper's friend the printmaker Richard Lahey:

Edward [Hopper] was getting the dog painted and he was pretty well along with the whole composition – one day he decided to go down to the Truro Library and check the physical [identification] in the encyclopaedia so as not to be at fault – There seemed to be no actual collie dog in Truro – or at least none that had come to his attention. When he returned with meagre information from the library – they parked the car and there was this small miracle – just the kind of dog that was wanted came out of the parked car ahead – with a child while the mother went into the nearby store to shop. Jo made friends with the children and dog – Edward got out his sketch book and pencil and while Jo held the dog with patting . . . Edward got his sketch.[4]

Dogs also often made the family complete in the famous and much-loved Pears Soap posters. In the 1880s many of these posters were art-advertisements in which the work of a prestigious but popular artist was reproduced as a print to include a strategically placed bar of luscious Pears Soap. *Bubbles* by Sir John Everett Millais RA (1829–1896), a work which added more than a touch of class, immediately transformed Pears Soap into an item which was extremely desirable to the burgeoning middle classes and the bourgeoisie. Fred Morgan (1847/56–1927), another Royal Academician with cachet, was also one of Pears' most popular artists. Morgan's work typified the ideal Victorian childhood, a childhood in which Pears Soap increasingly played an indispensable part in keeping boys and girls rosy and well scrubbed, and in which even puppies enjoyed luxuriating in Pears bubbles. Dogs of every type, from adoring collies to mischievious terriers, looked

on adoringly at their diminutive masters and mistresses and romped gaily through the idyllic settings of Morgan's paintings. But they weren't painted by Morgan, who found dogs 'difficult'. The canine family members were painted in by Arthur John Elsley,

another prolific RA who specialized in happy genre scenes of children with their pets.

115 Fred Morgan, *The Bath: His Turn Next, c.* 1891. A Victorian advertisement for Pears Soap.

The life of an artist, like that of a writer, can be a lonely one, so the comfort of a warm living being breaks that solitude and provides an uncritical confidante. A confidante who also functioned as a symbol of wisdom, perception and independent thought. No wonder they were often featured in paintings of ateliers, whether real, allegorical or acting almost as artist's statements.

A prime example of the latter is Gustave Courbet's monumental *The Artist's Studio* – a work inspired by a hunting trip, the undisputed leader of realism finding this particular country pursuit to have profound effects on his painting. 'When I got back to Ornans,' he wrote to his friend and patron Bruyas in December 1854, 'I spent a few days hunting. I quite like the subject of violent exercise . . . It makes the most surprising painting you can imagine. There are thirty life-size figures in it. It is the moral and physical history of my studio.'[5] 'It's the whole world coming to me to be painted,' he later declared, 'on the right, all the shareholders, by that I mean friends, fellow workers, art lovers. On the left is the other world of everyday life, the masses, wretchedness, poverty, wealth, the exploited and the exploiters, people who make a living from death.'[6]

116 Gustave Courbet,
The Artist's Studio, 1855,
oil on canvas.

Courbet, seated and painting, naturally took centre stage in this truly monumental work and unsurprisingly placed a semi-draped nude model next to him. More surprising, considering this was a man who hunted with dogs and whose self-portrait was with a dog, is that included in the group around the canvas not a dog, but a cat. This may have been to emphasize the sensual nature of the woman or might possibly be a nod to his friend and devoted patron Champfleury (firmly to the right with 'friends'), who roundly declared: 'Refined and delicate natures understand the cat. Women, poets, and artists hold it in great esteem, for they recognise the exquisite delicacy of its nervous system; indeed, only coarse natures fail to discern the natural distinction of the cat.'[7]

A curious canine betrayal, considering that the entire work was inspired by a hunting trip, and that Courbet owned dogs and even featured a dog almost as large as himself in his most famous self-portrait. Or is it? For the two symbolic dogs sit next to a hunter who bears more than a passing resemblance to another real-life hunting enthusiast, Napoleon III. And Courbet, who possessed an

117 Detail of
A. E. Duranton,
*The Artist's Studio
of Jean-Léon Gérôme,*
undated, oil on canvas.

ego to rival that of any absolute monarch, no doubt also identified
with this figure.

Jean-Léon Gérôme (1824–1904) was one of the most famous
artists of his day. Not only did he paint the East, but he collected
its wonders, as may be seen in this rich painting of his studio in
Paris's Boulevard de Clichy by fellow Frenchman André Duranton.
Gérôme himself may be absent from his opulent Oriental paradise
but what must surely be his dog lies centre stage, master of all he
surveys, waiting for Gérôme's return. The same dog also appears
in Gérôme's *Diogenes*, and is one of a group of dog models
who surround the revolutionary Greek thinker and philosopher.
Reputedly, Diogenes preferred the company of dogs, finding their

approach to life rather more direct and sincere than that of humanity. So here the dogs have three roles: as companions of the philosopher, as symbols of wisdom and as emblems of his Cynic (Greek: *kynikos*, dog-like) philosophy, which emphasized an austere existence. Diogenes would turn in his barrel if he knew the pampering some dogs receive today.

In the late nineteenth and early twentieth centuries the first truly professional full-time dog models came on the scene. None have been more famous, or loved, than Cecil Aldin's Cracker and Micky. Aldin (1870–1935) was a master of the dog portrait. The crucial difference between Aldin and so many contemporary dog portraitists is that they paint from photographs, while Aldin painted from life and an intimate knowledge of his subjects, who came to stay with him for at least a week, and sometimes for three.

118 Jean-Léon Gérôme, *Diogenes*, 1860, oil on linen.

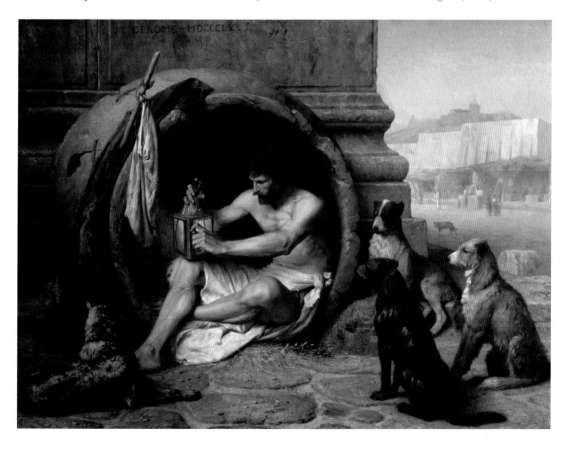

During that time Aldin and his subjects were inseparable. He took the time to gain their confidence, to understand their little quirks of character. And then he painted them as they truly were. As he writes in his charming book *An Artist's Models* (1930),

> I have always endeavoured to get at the character of my sitters in expression and feature (allowing them to pose naturally without the aid of unnecessary collars and chains), and not to produce a hard, side view representation of them as they might be if they were perfect specimens of the breed they are supposed to represent.
>
> If my models like to lie on their backs for their portraits, with all four feet in the air, they can do so here. Or, if they prefer to rest on their tummies, with their hind legs flat out behind them, in my studio there is no law even against that. We have plenty of time . . .
>
> If my model is plain Jane, she has to stay Plain Jane for her picture, and not become champion Jeanette. For that reason, with many show dog-breeders, I know my name is MUD!

119 Cecil Charles Windsor Aldin, *Micky and Cracker*, illustration.

If Aldin's name was mud with show-dog breeders, he was adored by great swathes of the dog-loving public for his wonderful illustrated books featuring his very own professional models, Cracker the bull terrier and Micky the Irish wolfhound, partners in the firm 'of which I am supposed to be the managing director', which also included Loopy, a Dalmatian, Von Tirpitz, a rough-haired dachshund, and Bogey, a kind of terrier.

Aldin held his models in deep affection and saw not their outside appearance but the characters within. He spent every day of his life with them. From breakfast to bed time, he observed their idiosyncrasies and escapades, their friendships and enmities – and it is his love of his models that shines through in his work, making us love them too.

Aldin's professionals worked for their living, just as supermodel Naomi Campbell does, but instead of being paid with infinite amounts of money, they received 'free board and lodging, two walks a day, and an annual holiday on Exmoor', not to mention innumerable juicy bones and a little cake at tea time. In return, they posed when required and showed the requisite respect when visiting models were sitting.

Aldin's methods are fascinating. He would watch his professionals carefully as they arranged themselves on the studio sofa however they pleased. When they were in a position Aldin particularly liked, he would draw the exact shape and position of the lights in each of their eyes. Then, as his models were dropping off to sleep, he would gently place their limbs in the required position. So used to this were his super-relaxed canines that they would then fall fast asleep.

But what if Aldin wanted his models standing or sitting? As dog aficionados know, there is always one thing that will fixedly hold a dog's attention. The secret is finding out exactly what it is. If Aldin wanted Cracker to look excited and stare at him, he simply put on his hat and talked to Cracker about going for a

walk, if he wanted him looking away, he would get one of his stable men to lead a horse into the yard – Cracker would always stare at the horse. Micky, however, was fascinated by cats, two of which Aldin kept as pets and studio properties – although 'Micky never chased the cats, and anyway, wouldn't have been allowed to', he was fascinated by them. So to get Micky to freeze, all Aldin had to do was get one of his men to walk *outside* his studio and hold up the pet in front of the window.

Cracker, whose principal parts were 'AFFECTION!' 'OBEDIENCE!' and 'SAGACITY!' was Aldin's most versatile professional, being able to pose, among other things, as 'a calf's head, a sucking pig, a silly ass, a Dalmatian without the spots, an old lady's lap dog [60 lbs in weight], a bad bull dog or worse bull terrier, and a bedfellow for Micky', while Micky acted as Cracker's feather bed. For the two were inseparable.

Such was Cracker's fame that he received his own obituary notice in *The Times*: 'Cracker, the bull terrier, for many years the beloved companion and favourite model of the late Cecil Aldin, died July 31st, Mallorca. Deeply mourned.'

In the latter half of the twentieth century other professionals were hurtled into the spotlight by the important American conceptual artist and photographer William Wegman (1943–). Much of Wegman's fame is based on the videos and photographs of his Weimaraners, and like so many artists who paint live subjects, much of his success and the reason he is so extraordinarily popular – David Letterman and *Sesame Street* couldn't wait to feature his Weimaraners – is that he *knows* his dogs. As Aldin did, he lives with them 24/7, he understands every nuance of their characters and, as he says, 'It's a wonderful experience photographing something you love.'[8] An experience that allows Wegman to bring his Weimaraners to us in all their svelte glory. And if they make us laugh out loud, which of course is often their purpose, like Landseer, Wegman makes sure that the joke is never at their expense, but at ours.

Wegman's first model was the deliciously smoky brown Weimaraner Man Ray. His name surely a hint of his fantastical future career and the fame that was to come his way. Wegman, who had thought about photographing dogs, bought Man Ray for $35 in 1970 and to his amazement discovered that 'He was grey and neutral. I could do him as a dog, a man, a sculpture, character, a bat, a frog, an Airedale, a dinosaur, a poodle. I never got tired of him.' For on top of Man Ray's personal attributes, Weimaraners in general combine 'a lap dog sensibility with a hunting capability'. In short, as pointers they have, just like *Vogue* models, the ability to hold a pose.[9] But how they fabulously they move. *Spelling Lesson* is *the* classic Wegman video and features Wegman and Man Ray sitting at a table while Wegman corrects his pupil's spelling homework. Man Ray is surely the most attentive pupil America has ever seen. How winsomely he cocks his head when the correct spelling is read out, how appealingly he raises a paw when told he has made a mistake! Of course this is because he recognizes certain key words such as 'beach' (cleverly, actually 'beech', as in beech tree, in the lesson) and wants to know 'When will we get there? When are we going!' For Man Ray was a dog used to the delights of Long Beach. And he surely knows that P A R K spells park.[10] It is impossible not to laugh out loud.

Spelling Lesson stars Man Ray as himself, but in many stills and videos where Man Ray and Fay Ray are dressed in gorgeous clothes or costumes Wegman transforms them into dogs with human hands and feet. He does this by sitting his model on a chair or a stool and allowing the costume to be full-length. Then from behind, an invisible human slips their arms round the dog and their hands pop out – to do the things that paws can't. But the truly remarkable thing is that Wegman has mastered the art of making this seem perfectly *normal*, just as Kawanabe Kyōsai did with the human animals in his 'crazy pictures'. And what is even more incredible is that when on occasion the dogs revert to

all fours, to make a getaway, for instance, this seems perfectly normal too!

When Man Ray was seven Wegman decided not to work with him any more because he didn't only want to be known as a dog artist. So for a whole year, around 1978, Wegman created other work. And this is what happened: 'he would come into my studio and slump down and realise I was just making drawings or little paintings or taking photographs, not of him and I'll never forget the deep sighs that he had. Like "Oh God another day of me not doing anything, with me just being a dog just sleeping at his feet."'[11] Needless to say, Man Ray was soon back to doing what he loved best. Man Ray died in 1982 (he was named 'Man of the Year' by the *Village Voice*), not long after Wegman was persuaded to start taking the creative and wacky images for which he is perhaps most famous, using Polaroid's extraordinary, enormous, almost 'sculptural' 20-by-24-inch camera.

In due course other models followed in Man Ray's paw prints. In 1986 the inimitable Fay Ray, so famous for her *fashion* shots, became Wegman's muse, and was soon joined by one of her puppies, Battina. In 2012 Penny graced the cover of *National Geographic* magazine, following in Fay Ray's catwalk footsteps by wearing some extraordinary copper-coloured curly wigs. In 2017 Wegman and his Weimaraners continue to shine in his book *Being Human*, which is, of course, all about dogs . . .

David Hockney, when drawing and painting his semi-professionals, his two beloved dachshunds, allowed them to do exactly as they pleased. These are dogs without artifice, behaving as naturally as a human baby. Hockney positioned sheets of paper all over his house and studio 'to catch them without disturbance'.[12] A fresh palette and canvas would be at the ready on the off-chance his models would 'pose' in suitable positions. Hockney worked at great speed – the dachshunds were always on the move. They were not, he wrote, 'very good models'.[13] Perhaps not, but like Wegman,

120 William Wegman, *Eames Low*, 2015, colour pigment.

186

121 David Hockney,
Dog Painting 23, 1995,
oil on canvas.

Hockney adored his subjects and knew not only their every little foible, but the way they held their heads or positioned their legs. The result was a book of the most natural and charming portraits that glow with affection.

Robert Bradford is a unique artist who on the one hand creates enormous pyrotechnic sculptures of fantastical pirate ships and wondrous animals that he burns with great abandon and ceremony on the British south coast, and on the other is currently creating poodles from colourful silk flowers and crystals. He sees dogs as a symbol of 'a kind of young curiosity and positivism coupled with a bit of naivety' and uses them constantly in his work.[14]

Bradford was investigating deerhounds as potential pets at the time he created Will, a magnificent 5-metre-tall (16-ft) deerhound head created from layers of sisal stapled onto a wooden frame. For an all too brief moment in time it stood outside the Pump House Gallery in London's Battersea, scanning for visitors approaching its 'For the Love of Dog' show. Unfortunately, vandals set fire to it and it literally went up in smoke. But as one deerhound left, another arrived: the artistically named Arty. What Bradford feels about dogs

122 Robert Bradford,
Arty, a Work of Art,
21st century, photograph.

may be summed up by the inscription on the reverse of this photo: '(A WORK OF ART) ART Deerhound puppy at 9 weeks.'

Arty, a living artwork, was nonetheless a stalwart model and would do anything that was 'reasonably dignified' for cheese. But 'not the cheap stuff! No blue stripe. I got caught that way once on Bodmin Moor trying to get a shot miles from the shops – he wouldn't go near the bit I'd bought specially for the purpose.'[15] Wanting Arty to pose at full-length for a newspaper article, Bradford cunningly put some top-quality cheese on the top of a horse sculpture. Arty was at full stretch in a nanosecond.

123 Robert Bradford, *Deerhound Head*, 21st century, sisal on wood.

124 Tibero Titi, *The Medici's Dogs in the Gardens of Boboli*, late 16th–early 17th century, oil on canvas.

SEVEN

The Dog as Adornment in Art and the Flesh

'Even the tiniest Poodle or Chihuahua is still a wolf at heart.'
DOROTHY HINSHAW PATENT

Almost all the dogs in the preceding chapters have been more or less accurate representations of flesh-and-blood creatures, whether they be portraits, symbols or simply there to add colour and veracity to quotidian scenes. As the twentieth century dawned and Expressionism and Impressionism began to hold sway, less realistic creatures such as Edvard Munch's *Head of a Dog* (see illus. 63) began to appear. And with the decline of painting and the rise of installation and video art in the late twentieth century, realistic dogs on canvas were destined to become an anachronism in the twenty-first. This chapter looks at the changing image of the dog, its transformation into a decorative object (in life and art) and its use as an artistic device and subject in *trompe l'oeil*.

Toy dogs have always been playthings, whether for Chinese emperors, abbots or isolated royals, but they were portrayed more or less as they were in life. Even in a painting of the Medici's little favourites and their dwarf keeper by Tibero Titi, the dogs, although sporting fashionable earrings and ruffled collars, are still *dogs*, play-bowing and sniffing the air in the beautiful gardens of Boboli.

Although French dogs sometimes had their eyeballs cut to make them appear more 'beautiful',[1] and although innumerable dogs worldwide even today have their tails amputated and half their ears sliced off to make them stand upright (so much more *attractive*

125 Pekingese hanging scroll, Qianlong (Ch'ien Lung) Period, 1735–95, ink and colours on paper. Perfect Imperial Pekingese bearing auspicious Buddhist markings gambolling among peonies and rocks.

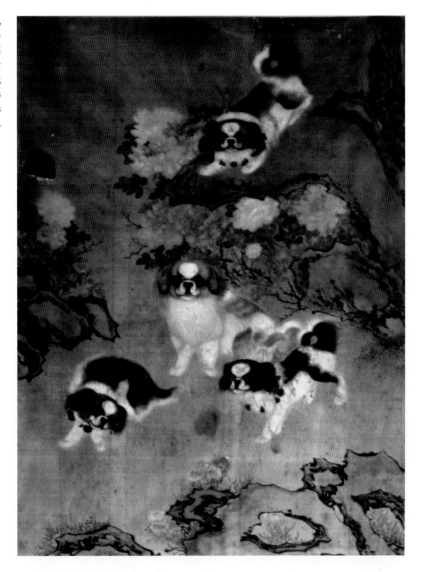

to have a mutilated dog), they at least do not endure the horrors that the Pekingese of the Chinese dynastic courts underwent.

As long ago as the first century AD, emperors were keeping what are known as Dog Books, painted volumes which contained examples of perfect dogs – an early and extremely demanding laying down of aesthetic standards. Taxed with producing supreme champions were the palace's eunuchs, who by the eighteenth and nineteenth centuries numbered over a thousand. The rewards for

producing a champion were magnificent. Rivalry and back-biting were intense.

Pekingese puppies were taken from their mothers and put to suckle at the porcelain breasts of the Imperial Ladies in Waiting. At around four days old, the cartilage in their noses was broken with chopsticks to produce the much desired flat face and soon afterwards their bodies were shut in close-fitting wire cages to restrict their growth and keep them fashionably small. The area between their shoulder blades was relentlessly massaged, day after long day, to increase the width between their shoulders and their tongues were forcibly stretched to give that crucial protruding

126 Friedrich Wilhelm Keyl, *Looty*, 1861, oil on canvas.

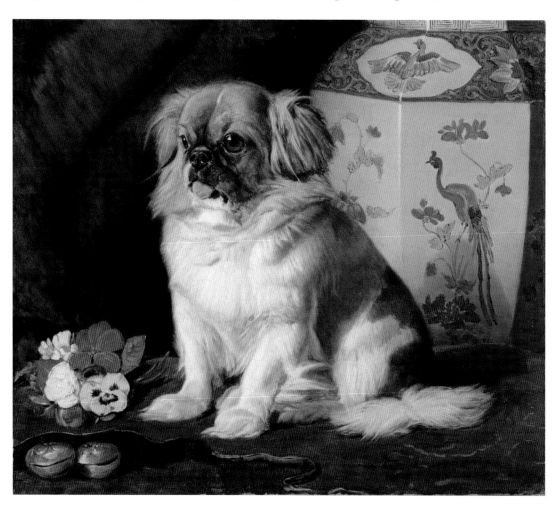

pink tongue look. After modification, imperial favourites led a life of unparalleled pampered luxury, being carried around on sumptuous silken palanquins and receiving an elaborate daily toilette which included being sprayed with fine perfume.[2] Whether they enjoyed this is perhaps another matter.

When the English looted and destroyed Peking's Summer Palace in 1860, one of the treasures that made its way back to England was Looty. British captain John Hart Dunne wrote in his diary, 'I have been able to retain a good many trifles that I bought in the French camp, also a pretty little dog, a real Chinese sleeve dog. It has silver bells round its neck. People say, it is the most perfect little beauty they have ever seen.'[3]

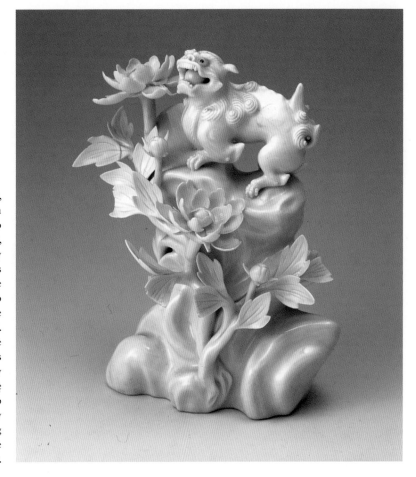

127 *Karashishi* (lion-dog, dog of Fo) with peonies on a rock, late Japanese Edo Period (1801–50), ornament, made of white porcelain clay with a clear glaze. This extremely fine and subtle example comes from Japan to where both Buddhism and the image of the lion-dog spread. A tour de force of the porcelain modeller's art has created this extraordinary delicate figure from white porcelain. The lion-dog is so lovingly and magically rendered that despite it being a fantasy it is hard to believe it doesn't exist in reality.

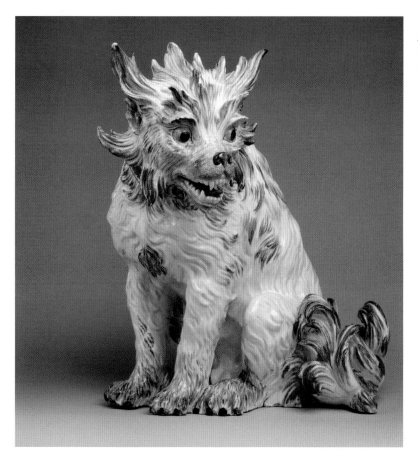

128 Meissen Manufactory, Johann Gottlieb Kirchner (modeller), Bolognese dog, *c.* 1733, hard-paste porcelain.

Queen Victoria, the sleeve dog's new owner, immediately commissioned a portrait of him, and he has been drawn sitting in front of a Chinese vase to give us a sense of his diminutive size. Beside him, rather poignantly, lies his little collar.[4] In China, Looty would have spent some of his day being carried around in his owner's silk sleeves, extra-wide-sleeved versions of this attire being produced specifically for the purpose. A kind of early Eastern version of today's Burberry bag in which so many Yorkshire terriers and miniature Dobermans are destined to spend their days, it too was rather chic.

Western breeders seized on these tiny creatures and selectively bred them to further increase the flatness of their faces, considering this deformity to be more attractive and adorable than a skull

that allowed the animal's respiratory system to function correctly. And the thickness of their coats was so increased that many Pekes had and still have problems walking. A classic example of the dog as a desired object – as a living trinket or artwork.

As Buddhism became increasingly important in China, so did the need to personify one of its most important symbols, the lion. Unlike the natives of India, where Buddhism was born, the Chinese had never seen lions, but from the descriptions foreign Buddhists gave them they concluded that this deeply revered feline had some resemblance to their much-admired Pekingese. And so the Chinese Lion-Dog or Dog of Fo was born. Once conceptualized, they multiplied. Some were carved from massive blocks of stone to guard temples; others were moulded from porcelain and decorated as vibrantly as the rainbow; and still others perched on the top of scholars' seals or became incense burners. For the Chinese it seemed that there was no medium or object that could not be decorated with, or transformed into, a Dog of Fo.

The constituents of hard paste porcelain, a fabulously expensive and much desired commodity, had been a zealously guarded Chinese secret since its discovery during the Yuan dynasty of 1279–1368. And it was not until 1707 that Western manufacturers Böttger and von Tschirnhaus of Meissen finally worked out its formula. This exquisite translucent white substance particularly lends itself to the creation of the fantastical, and the German Meissen, together with the other great European manufacturers, were quick to capitalize on their clientele's desire to own status-enhancing *objets de luxe* and on their love affair with dogs.

In around 1733 Meissen's master modeller, Johan Gottlieb Kirchner, created a dazzling Bolognese dog (illus. 128), who in his hands has taken on both supernatural and mythological aspects. Its fiery fur highlights and glowing red eyes almost make us believe that it could burst into fire at will or, like a dragon, breathe flames when displeased.

In Adriaen van Utrecht's *Banquet Still-life* a rather more realistic Bolognese is portrayed, along with all the other objects, living, dead and manufactured, that were so desirable to the seventeenth-century Dutch bourgeoisie. In an era when wealthy merchants commissioned large paintings for their luxurious homes (this one was probably intended to hang above a fireplace), this magnificent oil also acted as a potent advertisement. For when visitors called, their admiration and that very human emotion envy would stimulate the desire to possess a van Utrecht themselves. And with a virtuoso work such as this, the artist was showing them that whatever the subject, he was up to the job.

Breeds went in and out of fashion on the whims of ladies and the rise and fall of the royal houses with which they were associated. In England the spaniels so beloved of Charles I featured in

129 Adriaen van Utrecht, *Banquet Still-life*, 1644, oil on canvas.

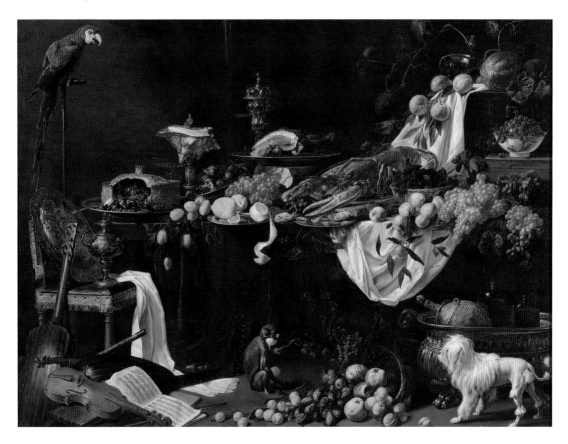

almost every family portrait that court artist Anthony van Dyck executed for him. This so inextricably linked them to the monarch that when he was executed in 1649, it was said that every King Charles spaniel in England cried. As well they might, as with the advent of the Netherlandish William III in 1689 they were utterly eclipsed by the all-conquering pug.

Pugs had been *de rigueur* in the Netherlands ever since one saved William the Silent's life in 1573. The Dutch were at war with the Spanish. It was midnight and the prince was sleeping peacefully when a thousand armed Spaniards forced their way into his headquarters. They did so with such silence and speed that the Prince's guards only realized what had happened when they saw their comrades being herded into the Place of Arms in front of the prince's tent. Oblivious, the prince slept on, but his dog 'fell to scratching and crying and withall leapt on the prince's face' and woke him.[5] Although many were killed, the prince eventually managed to escape on a horse. In gratitude he kept a stalwart pug by his side until his dying day.

130 Jan Wyck, *A Dutch Mastiff (called Old Vertue) with Dunham Massey in the Background*, 1700, oil on canvas.

Pugs originated in China, where they were known as *Lo-chiang*. By 900 they had spread into Japan, where they were used as fighting dogs. With the advent of the Dutch East India Company trade they quickly overran the Netherlands. Initially known as Chinese mastiffs,[6] by 1618 Sir Roger Williams was describing them as 'white little hounds, with crooked noses called Camuses' (*camus* being French for a flat nose).[7] Then, with the arrival of William III on English shores, they became known as Dutch mastiffs. Old Vertue, a sterling example of the breed as it was in those days, was the favourite of George Booth, 2nd Earl of Warrington (1675–1758), and was immortalized in oils in 1700, a sign of favour never granted to Booth's wife.[8] He looms large over Booth's stately home. Monumental in both scale and presence, we are left in no doubt about who the true master of Dunham Massey is.

By the 1720s, Dutch mastiffs began to be known as pugs. The name may be derived from the word *pugnaces*, a nod to their Japanese fighting past.[9] Or not. *Pug* in old English was a term of sweet endearment and the West Flemish word *pugge*, besides meaning small, was also used as a pet name for a person and presumably anything else that was adored.[10] And by 1780, when the breed name 'pug' was well established, Sheridan's dictionary was defining the word as 'anything tenderly loved'.

Large and pugnacious as pugs once were, it was not long before they too were turned into little furry bundles of desire, both figuratively and literally. The difference between Old Vertue and the pug in Goya's spun-sugar-coloured confection *The Marquesa da Pontejos* (illus. 131) says it all. Pug, now reduced to a living toy, and the marquesa's extravagant layers of tulle are artfully colour-coordinated and he is adorned with tinkling bells as a reference to his exotic lineage.

Pugs captured the heart of all Europe. When Pope Clement XII forbade membership of Masonic orders in 1738 many high-echelon Catholics formed themselves into Orders of Mopses (German for

pug), which acted as substitute Masonic lodges. Membership was denoted by the ownership of an expensive and prestigious hard-paste porcelain snuffbox adorned with pugs, modelled by Johann Joachim Kaendler (1706–1775) and manufactured by Meissen.

Meissen's pug output became prodigious. They manufactured figurines of pugs alone, pugs peeping out beneath the skirts of fashionable women, pugs suckling their puppies, pugs sitting up, pugs lying down, pugs, pugs, pugs. And in the ultimate backhanded compliment, the Chinese began copying Kaendler's designs and selling them back to Europe. Porcelain manufacturers of every type strove for their share of the market. Pugs appeared on the top of perfume bottles. They might be extraordinarily exquisite and ludicrously expensive or utterly banal and as cheap as slapdash manufacturing would allow. Throughout Europe, manufacturers strove to outdo one another and customers to be owners of the rarest. Even Cartier was not immune to their commercial lure and in 1907 King Edward VII commissioned Fabergé to produce a carved agate pug with rose-cut diamond eyes.

131 Francisco de Goya, *The Marquesa da Pontejos*, c. 1786, oil on canvas.

132 John E. Ferneley, *A Clipped Water Spaniel*, 19th century, oil on canvas.

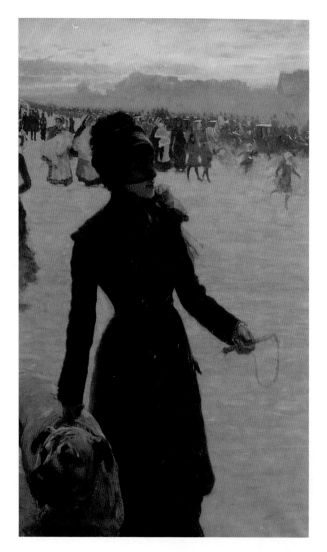

From almost the beginning the pug was a dominant force in the decorative art market. As a testament to its enduring popularity as an image, even today Meissen produce no fewer than 38 different pug items, including a modern porcelain snuffbox, a solid gold pug pendant and a porcelain pendant of a pug wearing a rose gold and diamond necklace complete with Chinese gold bells.

Poodles and other water dog types were once low-class sheepdogs, retrievers of watery game and long-suffering companions of the blind beggars of Paris. They were charming, rough little dogs with gorgeous thick curly fur who loved splashing through muddy ponds. Then, the bourgeoisie realized that those coats were nothing more than a blank canvas ready to accommodate their every fantasy. Goodbye muddy ponds, hello the Champs-Elysées, the fashionable salon, the photographic studio, Hollywood and in the twenty-first century such competitions as the British Dog Creative Stylist of the Year. At first the *tondeurs*, or cutters, were relatively modest in their aspirations – the poodle still more or less resembled a poodle, or as sometimes was the case, the water spaniel, the latter being a breed with a similar coat that nowadays is rarely seen except in the company of the Obamas.

Comparing Ferneley's *A Clipped Water Spaniel* with Stubbs's water spaniel (see illus. 68) reveals clearly the aspirations of both

dogs' owners and in the Ferneley, those of the career 'furdresser', who may be compared to a contemporary celebrity hairdresser. A man more used to painting horses, hunting scenes and hounds than the canine inhabitants of salons, Ferneley has at least placed this coiffured creature outside, a stick by its side, indicating it that it goes for walks in the countryside – something many of its denatured city comrades, such as the hapless creature depicted in Ernest-Ange Duez's *Splendour*, did not. This magnificent and sumptuous rendition of a Parisian lady of high fashion, perhaps the mistress of a profligate banker, says it all. The tiny, tiny dog kept on a lead of gold chain, no doubt real gold, to judge from his mistress's attire, has been swept up in her hand – his tousled fur coordinating exactly with the no doubt carefully chosen rich cream colouring of her lace cuffs. Carried along whether he will or no, this toy is deprived of all the things that make life fun for a dog. No sniffing of fascinating footpaths for him, no chasing other dogs round the Bois de Boulogne. For he is an urban salon dog, a creature kept inside a town house and turned into a little furry human, expected to behave just like his master and mistress – just

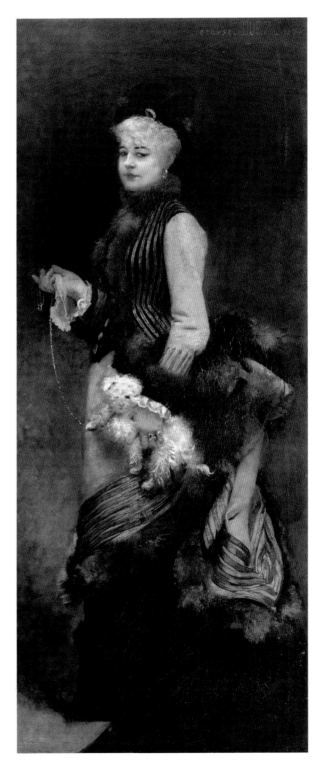

135 Charles Martin, 'La Belle et la Bête: Matinée', plate II from *Gazette du Bon Ton*, I/6 (1913). 'La Belle' is wearing a morning gown of silk crepe. Details of the fetching bow 'La Bête' is sporting were not revealed.

LA BELLE ET LA BÊTE

Matinée

like the twenty-first-century dogs who are imprisoned in designer dog bags and carried like babies from place to place, their paws never touching the earth.

Giuseppe De Nittis's *Return from the Bois de Boulogne* (illus. 133) encapsulates the Parisienne *bon ton*'s preoccupation with showing themselves in the most sumptuous and cutting-edge fashions at the spring races held at the Bois de Boulogne. And dressed in close-fitting black attire, a veil giving her an air of glamorous

mystery, a riding crop held in one hand and an enormous mastiff completely under her spell held by his collar in the other, this woman is style personified. But how different she is from Duez's extravagant Parisian. Her dog is still a fashion accessory, a style statement, but this is a toy with function, an accessory that speaks volumes about his mistress. He is powerful and eminently capable of defending her. He can hunt and guard and, more than this, he is a dog who signals that, like him, his mistress is fit, healthy and strong. Woman and dog are beings who fit into nature as easily as the salons of fashionable Paris – appropriately enough from an artist such as De Nittis, who has within his works something of the works made *en plein air* by the Impressionists.[11]

The dog Nittis portrays was probably a mastiff type, breeds being much less defined in those days. It is interesting to compare his face to those of contemporary mastiffs, who have been selectively bred to have flatter muzzles and droopy faces covered with folds of flesh. Like Pekingeses they have been bred for a 'look' rather than for health and strength and as such suffer from hip and elbow dysplasia.

Poodles were first introduced to America in the 1890s by Henry J. Trevor. At first, chic society rejected them but Count Alexis Pulaski, a man with a flair for self-publicity and a great talent for networking, saw their enormous commercial potential. By the 1950s he had turned poodles into a must-have fashion accessory and Poodles Incorporated, his all-in-one grooming parlour, boutique and stud service on Manhattan's modish Fifth Avenue, became *the* place to visit. Star after star came to Poodles Incorporated. Juan Perón and even the sister of Pope Pius XII, Princess Pacelli, were unable to resist the lure of a Pulaski poodle. These poodle aficionados were able to choose from sixteen different chic cuts, and purchase such necessaries as mink coats and jewelled collars for their treasures. Often poodles were dyed to match their star's Cadillac or soft furnishings, although this was nothing new.

In Europe in the 1860s red, green and blue dogs strutted their stuff along fashionable boulevards, while in the 1780s, poodles' coats were combed as high as possible and sprinkled with coloured powders and confetti. And where the stars led, fans were soon to follow, aided by Miss Cameo's step-by-step guide to clipping and dyeing your poodle. Special cuts were marketed for Easter and Christmas and orchid deemed the *à la mode* colour.[12]

Fifties Hollywood, self-indulgent as it was, would still have been amazed by creative grooming, a craze that has been sweeping through America and which in the twenty-first century has even made serious inroads into the UK in the shape of the British Dog Creative Stylist of the Year competition.

Is one of its finest entries, *A Poodle Creatively Groomed as My Little Pony*, art? In the twenty-first century, perhaps it is. Certainly it is the ultimate in canine objectification and consumerism – a living dog turned into a famous, very pink, child's plaything, My Little Pony. Now something so completely other than itself, this poodle could almost pass for a stuffed cuddly toy. (Fortunately for the poodles, the non-toxic vegetable dyes are washed out after the show.)

136 A poodle creatively groomed as a My Little Pony, 2016, vegetable dyes on clipped fur.

137 Jeff Koons, *Puppy*, 1992, stainless steel, soil and flowering plants, outside the Guggenheim, Bilbao.

So how does it compare to Jeff Koons's *Puppy?*, the 12.4-metre-high (40.7-ft) 'behemoth West Highland terrier carpeted in bedding plants' who guards who the august portals of the Guggenheim Bilbao? A confection of saccharine sweetness besides which the much-derided chocolate box images once employed by manufacturers such as Cadburys to entice their consumers look positively hard-nosed. Koons's intention is to 'relentlessly entice', to 'create optimism' and to instil, in his own words, 'confidence and security', just as the manufacturers of comforting chocolates intended to

with their beribboned kittens and winsome puppies. And does *A Poodle Creatively Groomed as My Little Pony* do any less than this? Does it not draw viewers in? Does it not make them smile? Does it not create a moment's joy in an increasingly unstable world?

The main difference of course is that Koons, the most capitalist artist of them all, has art rhetoric. And the Guggenheim Museum disseminates it for him. His stated desire is to 'communicate with the masses' by drawing on the 'visual language of advertising, marketing, and the entertainment industry'. Has not *A Poodle Creatively Groomed as My Little Pony* done exactly the same, whether this was its creator's stated intention or not? It did after all receive nationwide coverage in both the *Daily Telegraph* and the *Daily Mail*, something many contemporary artists would kill for. And without doubt it is aimed at the general public.

Koons, the Guggenheim gushes, explores the meaning of art in 'a media-saturated era and presents art as a *commodity* that cannot be placed within the hierarchy of conventional aesthetics'. With *Puppy*, Koons 'engaged both past and present, employing sophisticated computer modelling to create a work that references the 18th-century formal European garden'. *Really?* 'Its size both tightly contained and seemingly out of control (it is both literally and figuratively still growing), and juxtaposing elite and mass-cultural references (topiary and dog breeding, Chia Pets and Hallmark greeting cards), the work may be read as an allegory of contemporary culture.'[13]

A Poodle Creatively Groomed as My Little Pony definitely can't be placed in the hierarchy of conventional aesthetics. And if its creator had written 'My work is both tightly contained and seemingly out of control (it is both literally and figuratively still growing)' and continued 'its body shape is constant but the medium of its fur is a constantly renewing resource which references both the current environmental need for recyclable objects and the monstrous ladies' hair fashions of the Georgian era', would we

think any differently about it? Is art in the late twentieth and early twenty-first centuries simply intention, as when Marcel Duchamp (1887–1968) decided that 'readymades' were art and created a sensation by showing a urinal and a crude metal bottle stand bought from a local shop? Or is it in the eye of the beholder? Are either *Puppy* or *A Poodle Creatively Groomed as My Little Pony* art, both of them or neither of them? Your call.

Dogs' myriad, sometimes extraordinary forms, as *Puppy* attests, lend themselves so readily to the caprices of artists that they become things of astonishing wonder and invention. And the dachshund, an animal that can hardly be seen without bringing a smile to the face (perhaps this is why it has been beloved by so many artists from Warhol to Picasso), is a particularly delicious vehicle. Robert Bradford, who creates the fantastical and the mythical and does not hesitate to turn his extraordinary talents to the imaginings of the owners of monumental Chinese shopping malls, has created the inimitable *Dasch*, a canine whose 'sausage dog' image has been enhanced in wondrous ways. He has become larger than life 'and a little monumental whilst maintaining a degree of cuteness . . . (and ambition)!' 'None of my usual materials seemed suited to the flat sleekness of his type of coat,' said Bradford, 'and the (available :-)) coloured pencils seemed like a possibility . . . As he turned out he seemed to me to have a kind of landscape/marine quality which I sought to enhance with the butterflies . . . Which also seemed to me to have a kind of promiscuous symbolism.'[14]

One might think that sight hounds, those masters of the desert sands, of the Russian steppes and French forests, would have avoided being turned into living fashion accessories. No lap dogs are these: a borzoi may bring down a wolf, greyhounds may take a lion, the blood of the ancestral wolf flows warmly through their hunters' veins. Their fur is unsuitable for clipping or dyeing. They are strong; they run at 64 kilometres per hour (40 mph). And that is their weakness. The aerodynamic and physiological design

138 Robert Bradford, *Dasch*, 2015, found objects on wood.

that allows them such skills also invests them with long elegant limbs, a slender, aesthetically pleasing frame and a certain visual delicacy. No sight hounds were to escape from the clutches of the voguish.

Although a few salukis had made their way into England during the nineteenth century (mainly gifts from wealthy Arabs), they did not appear in significant numbers until after the First World War when admiring Army personnel brought them back from North Africa. Like the borzoi before them, they were pounced upon by the fashionable set of the day, their popularity fanned by the Egyptomania sweeping through Europe following Sir Howard Carter's discovery of Tutankhamun's tomb. Carter himself pronounced them to be 'dogs of graceful form, the very embodiment of aristocratic bearing, with feathered drooping ears, feathered

tails and quarters, flexible loins, deep chest, and long lithe limbs admirably adapted for the chase',[15] while Vita Sackville-West, doyenne of the arts, declared them 'a marvel of elegance'.[16] They, like the borzoi, were doomed.

In 1876 the French Orientalist Georges Clairin (1843–1919) painted *Sarah Bernhardt with a Borzoi* (illus. 139), a portrait which speaks of the luxury and imagined decadence of the East, of the Russian courts, of fashion and sophistication – and reduced the magnificent wolfhound to nothing more than a prop for a feted actress.

Sight hounds honed for the chase for thousands of years were now condemned to strut the streets of London's fashionable Knights-bridge, Paris and New York. Places singularly devoid of wildlife – unless one factors in the omnipresent rat. American *Vogue* summed up the trend in a 1917 article entitled 'Love fashion, love her dog'. By 1929 (just one year before the great economic crash) the magazine was declaring that it was 'lacking exceedingly in chic to be seen out without your dog. The underground rooms of the Embassy Club are carpeted with dogs. The more modish . . . Great Danes, Borzois and the like lean against the bar awhile with their mistresses, watching the rhythmic shaking of cocktails.'[17] Happy days before the draconian rules of health and safety.

Greyhounds, borzois, salukis and even one melancholy-eyed sloughi (an ancient breed of North African sight hound found principally in Algeria and Morocco) all starred on the early covers of *Vogue*. The sloughi, like its owner Madame Gentien, was dressed in style for the occasion by Coco Chanel and sported a red visiting coat trimmed with blue. The American luxury car manufacturers Buick chose a borzoi for their advertising, comparing it and its owner to their own fantastic smartness, and in 1930 Edith Sitwell was photographed by Cecil Beaton with her borzoi Feo. Feo was also photographed with the avant-garde Sitwell, proving yet again his tremendous natural style.

140 Georges Barbier,
plate from *Personnages
de comédie* (1922).

One of the most stylish and *arty* 1920s *Vogue* covers was a
1922 fantasy greyhound complete with Cubist-style square black
spots walking along a beach on the Cote d'Azur. Helen Dryden,
Vogue declared firmly, had a 'pretty aesthetic' all her own,[18] although
she was obviously very heavily influenced by France's iconic Georges
Barbier, who designed for art deco fashion magazine *La Gazette
du Bon Ton* and had been at the forefront of illustration since
mounting his first exhibition in 1911. The wonderful illustration
from his *Personnages de comédie* (illus. 140), published in 1922,
embodies all the style of art deco, or perhaps more properly art
moderne, as it was called at the time. A marvellous magical fantasy,
this elegant greyhound, colour coordinated into the illustration by

139 George Clairin,
*Sarah Bernhardt with
a Borzoi*, 1876,
oil on canvas.

141 Pierre Bonnard,
Two Poodles, 1891,
oil on canvas.

sporting two-tone light dusty-purple fur, amazingly has managed to
obtain the attention of a man who is presumably his master, despite
the fact that a diaphanously dressed beauty with colour-coordinated
lilac hair is pressing herself languorously and provocatively against
him. But a dog is, as everyone must know, a man or woman's very
best friend . . .

However, perhaps the first artists to turn the dog into a purely
decorative form were the revolutionary French brotherhood of
the Nabis (Hebrew for 'prophet'). A short-lived phenomenon (1888–
98), it was founded on Paul Sérusier's personal interpretation of
Gaugin's symbolism, garnered after a visit to the master.

Gauguin himself had declared: 'Don't copy too much after
nature. Art is an abstraction: extract from nature while dreaming
before it and concentrate more on creating than on the final result.'[19]
His 1892 Tahitian-era *Arearea* (Joyousness) followed this philo-
sophy, being a work in which dreams and ideals became a form

of primitive, innocent and pure reality in which our companion from prehistory, the dog, must of necessity loom large. And in this painting it loomed largely *red*. When exhibited in Paris in 1893 along with his other Tahitian works, it received a lukewarm reception. The dog in particular 'provoked much sarcasm'.[20]

The Nabis took things one stage further. 'There are no paintings; there are only decorations' was their dictum. Its members abandoned perspective and celebrated pattern and ornament, free form and colour. Often their works were designed to complement a particular interior – the artist embracing the *bête noir* of the art world, the client who wants something green 'to match the sofa'. In Paris Pierre Bonnard, Maurice Denis and Édouard Vuillard were the Nabis' most celebrated exponents, Bonnard being the *Nabi très japonard*, his work celebrating the Japanese aesthetic.

In *Two Poodles* Bonnard created a flat plane in which texture and pattern picks out the poodles. They are reduced to flat decorative images, a gambolling circular fantasy whirl of energy. And yet not quite a fantasy, for dogs do whizz never-endingly round in circles, sniffing one another. 'We were trying to go further than the Impressionists and their naturalist impressions of colour,' he said of his youthful years. 'After all, art is not nature!'[21] Perhaps not, but as in life, so in art – the dog, decorative or not, remains.

If Bonnard makes a pattern from nature, Dalí gives us a nature in constant flux, in constant metamorphosis. In the extraordinary 1938 work *Apparition of Face and Fruit Dish on a Beach* (illus. 142), the central image is a large brown-and-white dog, a pointer. And yet it is also a beach of soft white sand, reminiscent of his native Catalonia, a bowl of luscious, curved fleshy pears, a face staring out at us. And behind all this, ever-shifting mythological life goes on in magical grottos peopled by Dalíesque creatures, some reminiscent of those of de Chirico's fertile mind, and a miniature version of the bowl of fruit.

The more one looks, the more one sees. But perhaps the greatest shock the painting holds is hidden in the dog's seemingly meticulously rendered head. For when we look into his eyes, seeking reassurance in a shifting world, instead of trusting eyes scanning this alien world on our behalf, we see nothing. His eye sockets are cavernous holes, the pupil and iris simply the blue of the mountains beyond and a distant white building, shining in the sun.

Trompe l'oeil, although absolutely intended as decoration, is the polar opposite of the work of Bonnard and Dalí and *style*. It is a painterly deceit designed to create a spectacular visual illusion. A deceit that makes us believe that there is no painting, only a tactile, absolutely normal reality. In the hands of an adept, it has viewers trying to take ornaments out of painted niches and stroke dogs

142 Salvador Dalí, *Apparition of Face and Fruit Dish on a Beach*, 1938, oil on canvas.

composed of nothing more than oil paint. *Trompe l'oeil* was at its height in the seventeenth century and a supreme exponent was Samuel van Hoogstraten (1627–1678), a former pupil of Rembrandt. His 2.6-m-high (8½ ft) painting *A View through a House* currently hangs at the end of a corridor at England's Dyrham Park, making us believe that the space is much longer than it is. It is of course the parrot, the cat and the dog which really make us believe in the illusion. They look so startled to see us that we want to put out a reassuring hand to the dog and call to the cat. And the positioning of the dog, as it so often did in Renaissance works, draws our eye into the picture, or in this case into the reality of the illusion. Samuel Pepys saw this painting in 1663 when it was owned by Thomas Povey and was moved to write in his diary, 'above all things, I do the most admire his piece of perspective especially, he opening me the closet door and there I saw that there is nothing but only a plain picture hung upon the wall.'[22]

143 Samuel van Hoogstraten, *A View through a House*, 1662, oil on canvas.

In southern continental Europe, Hamen y León (1596–1631) was Spain's greatest painter of still-life; an innovator in floral compositions and a master of *trompe l'oeil*. He was also a great portraitist and in *Still-life with Flowers and a Dog* (*c.* 1625) he combines in one striking package his four specialities.

The flowers and the foodstuffs (together symbolizing courtly hospitality) and the dog are created in *trompe l'oeil* with such consummate skill that we believe the flowers are there just so we may inhale their perfume, that the dog awaits our caress. His large

paws are firmly planted on the chequered floor, a device also used in *A View through a House*; it gives a great feeling of depth. His fur is slightly ruffled upon his deep strong chest, smooth upon his legs. He wears an expression of forbearance, resignation even, as if time has been passing slowly in the court of the king. It is hard not to whisk him away for a walk in the sun.

144 Juan van der Hamen y León, *Still-life with Flowers and a Dog, c.* 1625, oil on canvas.

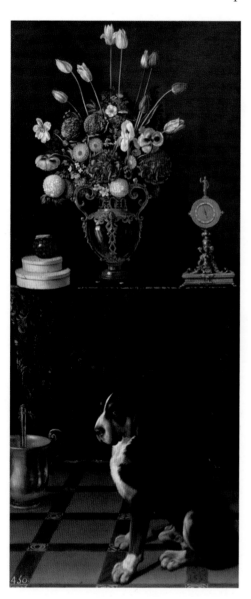

One of a pair, the other *trompe l'oeil* featured a puppy of the same breed; they were both commissioned by the Count de Solre, captain of the Flemish Royal Guard of Archers, who at the time were in the service of the Spanish monarch, who acquired the works on the count's death. As it would be more usual to have a pair of hounds or similar to flank the doorway to an important room, it seems likely that these dogs belonged to Solre, and were related, or perhaps that these images depict the same dog at different stages of its life.[23]

The extraordinary decline of painting, and in particular the fact that any form of representational painting is in free fall in the twenty-first century, means that *trompe l'oeil* has been consigned to the great canvas graveyard in the sky. A particularly demanding genre requiring observation, dedication and great technical skill, few contemporary artists would even consider it, even fewer be capable of realizing it. However, Alan Weston, an English West Country artist, has revitalized this fabulous genre to create life-size *trompe l'oeils* of animals and birds. These fantasies and confections use sleight of hand and skill to produce delights so real that every hair on his Jack Russell seems to bristle.

145 Alan Weston,
Jack Russell, 2017,
oil on canvas.

overleaf:
146 Guy Peellaert,
*David Bowie,
Diamond Dogs*,
1974, photomontage
and paint on paper.

If 'living' *trompe l'oeil* dogs hold within themselves all the wondrous energy of life and its boundless potential, then David Bowie's Diamond Dogs are its polar opposite – utter entropy, the dissolution of what we think of as civilization and nature. The sphinx-like man-dog hybrid on his 1974 album cover must be art's most striking example of the dog being transformed into something utterly *not* itself. Enigma and familiarity are here combined to produce the unfathomable, the utterly unknowable. And yet it is also a symbol of how close we are to the canine race in particular and the wildness of nature in general, both emotionally and instinctively. A wildness that even in the so-called civilization we all inhabit lurks below wafer-thin layers of prescribed behaviour.

Guy Peellaert (1934–2008) rocketed to fame with the publication of his million-copy-selling *Rock Dreams*, a collection of more than 120 'false' photo-realistic portraits (composed of photomontage and paint) featuring everyone from Bob Dylan to Cassius Clay. Biba's celebrated Rainbow Rooms hosted the exhibition of Peellaert's originals and at the private view everyone who was anyone was there, including of course David Bowie. Ever struck by and in pursuit of the unusual, the mythical, the avant-garde Bowie invited Peellaert to breakfast – an unusual choice of meal for those who tripped the light fantastic, unless it were a breakfast after a night of sensation and before the time of real dreams. And after breakfast the pair departed to meet with Terry O'Neill, one of the Swinging Sixties' most famous photographers.

Bowie wanted O'Neill to take a photograph of him in a similar pose to those Boris Lipnitzki had taken of the jazz musician Josephine Baker in 1926. Lying semi-naked on the floor, her hands raised like those of a sleek big cat readying to strike those who might come too near, Lipnitzki had transformed her into an exotic and irresistible wild animal.

As it turned out, O'Neill took several photos of Bowie, including the well-known image of him wearing a top hat, accompanied

by a huge white dog jumping up on its back legs, an image which when painted by Peellaert in *Rock Dreams* style almost became the album cover for *Diamond Dogs*. However, back in Paris Peellaert, using fragments of O'Neill's photographs, created what Bowie had been hankering after: a Josephine Baker-inspired image that went so much further than Lipnitzki had dared to by completely breaking down the thin barrier between man and animal and turning Bowie into a man-dog hybrid. And he gave the entire image a 1970s twist by painting the hybrid against the background of a Coney Island freak show – a freak show that, Peellaert's painting seems to say, will soon be the new everyday reality.[24] This everyday yet bizarre dystopic vision became one of the best-known album covers of all time.

Curiously in an era of such unbridled loucheness and sexuality, having initially featured the hybrid with the genitalia it was entitled to, EMI, overcome with sanctimoniousness, censored this 'outrageous' image and airbrushed out the creature's most intimate parts.[25] A denaturing even more complete than that visited on nineteenth-century Parisian dogs. But despite this neutering, Peellaert had succeeded in creating a world in which the great carnivores roamed again, a universe in which dogs and wolves might again become top predators. For sweet little Fido is, after all, simply a wolf in dog's clothing, biding his time.

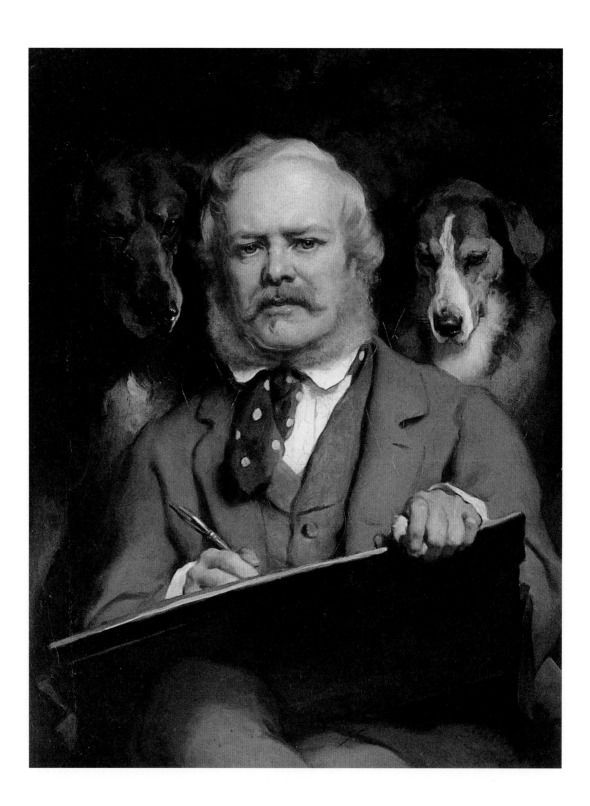

An Artist's Best Friend

'I would have no pleasure living in a world where dogs did not exist.'
ARTHUR SCHOPENHAUER

An artist's best friend has so often been a dog that in our mind's eye the image of an artist toiling in their studio, a dog by their side, comes to mind quite naturally. And sometimes the reality of that vision has been incredibly poignant, as was the case with Edwin Landseer, that most adored and feted of all animal painters.

The first dog that Landseer loved and lost was Brutus, who features in *Ratcatchers* (see illus. 36). Like so many before and since, Landseer despaired of finding another to take this favourite's place. And so he determined that 'he would try to make up in quantity for the quality which he had lost and ever afterwards was attended by a body guard of several dogs'.[1]

Two of this bodyguard may be seen humorously depicted in his self-portrait *The Connoisseurs: Portrait of the Artist with Two Dogs*, in which he awaits the assessment of his work by the two consummate art critics Myrtle the retriever and Lassie the collie. Part of a bodyguard she may have been, but when Landseer was engaged in the monumental task of sculpting the lions for Nelson's column in Trafalgar Square – a task which broke his health and spirit – it was Lassie who was his constant companion and consolation.

Ballantyne's double portrait of Landseer and Lassie, painted in 1865 towards the end of Landseer's agonizing labour, shows the

147 Sir Edwin Landseer, *The Connoisseurs: Portrait of the Artist with Two Dogs*, before June 1865, oil on canvas.

pair dwarfed between the vast front paws of the lion in progress while two further lions look uncaringly, proudly, into faraway vistas. Dog and man seem resigned to their fate, although Landseer's stoicism cannot hide the unhappiness that lies beneath, and Lassie, like all dogs, has the beguiling escape of sleep until life and Landseer again offer her diversion. The lions were unveiled in 1867 and there they remain, providing a magnificent spectacle as visitors approach the National Portrait Gallery, where this painting is housed. A haunting reminder of the fate of their creator. A man who felt too much, as did Mexico's Frida Kahlo (1907–1954).

Kahlo suffered throughout her life both with excruciating physical pain and with the never-ending agonies of love unfulfilled and of children unborn. Aged seven, polio left her with a withered leg; aged sixteen, a tram crash impaled her on a bar, leaving her with a damaged spine and terrible internal injuries. The second 'accident' in her life, as she refers to it, was meeting Diego Rivera, the chronically unfaithful artist who was to become her husband. He was a man so profligate that he could not even resist having an affair with her sister.

She sought solace not only with lovers of her own, including Leon Trotsky and Isamu Noguchi, but in nature, and surrounded herself with parrots, little Mexican monkeys and, of course, dogs. Although only part Indian, Kahlo identified herself so completely with Mexico's pre-Columbian past that she eschewed her natural birthdate and instead, when required, gave that of the Mexican Revolution – 20 November 1910. As such it was inevitable that her canine companions should be xolos, those living representations of the ancient Aztec deity Xolotl (see illus. 15), and that her first xolo should be called Señor Xolotl. Of course, the xolos also gave her the unquestioning and unjudgemental love she so needed and several photographs show her sleeping peacefully with them. Like the ancients, she sought not only love but warmth and healing from their comfortably plump

bodies and restorative spirits. And so, she kept a whole tribe of comforting xolos who followed her around, sat on her lap and rested with her under the Mexican sun. Constant companions in an inconstant world.

Kahlo's diaries and letters are paeans to Rivera, cries from the heart on the cruelty of love and of pain bravely dealt with. They also contained strange fantasies created from ink blots, curious musings on life composed of free-associated words and thoughts on the eternal difficulties of politics. But two pages in her diaries (started in the mid-1940s) are somewhat different. One shows the unalloyed pleasure of watching her dogs tumble and play together, a pleasure in which for once neither illness nor unhappiness intrude. A happy 'colourful curlicue' of crayon lines gives the impression that her dogs are romping with balls of unravelling string. The other shows Señor Xolotl standing proud, imbued with his mythological aspect by the words:

> The Lord <u>Xolotl</u> AMBASSADOR
> ~~Chancellor~~ of the
> Universal Republic of
> <u>Xibalba Mictlan</u>
> Chancellor Minister Plenipoten-
> tiary <u>Here</u> –
> How do you do
> Mr Xolotl?

Xibalba is the name of the Mayan culture's underworld, Mictlan that of the Aztec culture's equivalent, so here Kahlo is including two mythological pasts over which Mr Xolotl rules. (In the original diary, 'How do you do/ Mr Xolotl?' was written in English.)

Señor Xolotl also featured in many of her paintings. In *The Love Embrace of the Universe, the Earth (Mexico), Myself, Diego and Señor Xolotl*, it is Rivera she cradles as a baby while Señor

Xolotl rests on her arm as their protector. In *Self-portrait with Monkey and Señor Xolotl* (illus. 148), Frida draws on her own personal 'dictionary of symbol and allegories'.

The nail driven into the wall probably refers to the Mexican saying *estar clavado* – literally, to be nailed; metaphorically to be let down or deceived – and thus must surely allude to Rivera. The monkey, which in Western European tradition symbolizes lasciviousness and sensuality, in Kahlo's work seems to always represent a faithful and devoted friend. Señor Xolotl, as we know, is all this and more, being also a symbol of Mexico's ancient cultures, as is the pre-Columbian statue in the background.[2] She links her two pets, the statue and the nail with a yellow ribbon (in her lexicon of colours, the hue of yellow reminds her of 'Madness, sickness, fear' but is also 'Part of the sun and of joy', and she also refers to yellow love in one of the first pages of her diary).[3] The messages in this painting would seem to be that although she can't trust Rivera, she can draw strength from her ancestral past and from those who are loyal to her.[4] As is so often the case, it was her dog that was the loyalest friend of all.

Any detailed knowledge of artists and their relationships with their dogs only truly begins in the eighteenth century. Prior to this, the majority of artists reveal little of their dogs, or indeed their own lives. We know for instance that Paolo Veronese (1528–1588) must surely have owned dogs, since he painted so many, but we know nothing of them. We do not know their names or even which of the dogs in the paintings were his pets and which were simply models. And the information on Dürer, who coincidentally died in the year Veronese was born, 1528, and who also drew, painted and etched so many glorious canines, is equally sparse. But Colin Eisler, author of the truly beautiful *Dürer's Animals*, has put together a cunning and irresistible theory regarding one little dog who bounds in and out of Dürer's paintings and drawings for over twenty years. A theory I cannot resist.

148 Frida Kahlo, *Self-portrait with Monkey and Señor Xolotl*, 1945, oil on masonite.

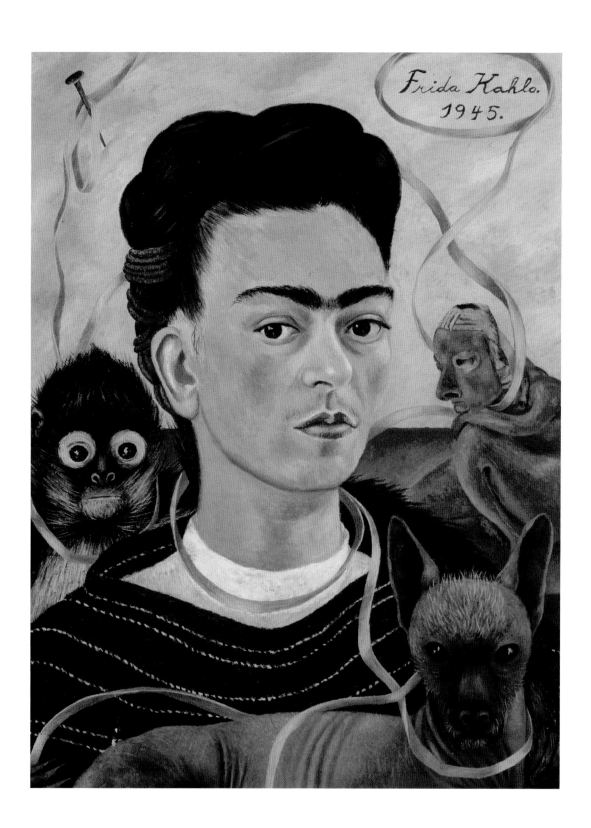

Dürer's father was a goldsmith, and no ordinary one: he worked for the Holy Roman Emperor Maximilian and thus was involved in making complex pieces such as extravagant wine-gushing gold and silver fountains. His workshop would have been crammed with pattern books containing every type of animal and bird, and it was from these pattern books that Dürer first learnt to draw animals. We forget the natural world. Those who live in dense skyscraper cities may never see an animal. Pigeons are ruthlessly cleansed, insects poisoned, stray cats killed. In the twenty-first century animals do not inhabit a city dweller's consciousness; they have been replaced by 'must have' items and images on screens. But in those days animals were central to life, even in the most bustling of cities. Existence without their presence would have been unthinkable, unliveable. Both hunting companions and the hunted, they provided everything from food to companionship, from horse power to leather, and in the countryside they made the world a place of beauty. People lived among them. Horses, dogs, cattle, pigs and every manner of bird would have been everyday sights. And so in Dürer's day animals and birds decorated simply everything. They gambolled over tapestries and clambered up drinking horns and decorated boxes. As in life, so in art.[5]

If Joachim Friess's work containing fifteen or so creatures stuns us with its skill imagine the impression one of Maximilian's beloved fountains containing hundreds of different figures – everything from hissing serpents to flocks of sheep – would make. Dürer represented this miniature world tenderly in his *Our Lady of the Animals* in 1503. A world in which there was one of the many representations of the little dog that appears in so many of Dürer's paintings. The little dog, sporting a chic lion cut and cheeky expression, must surely have been his beloved pet, posits Eisler. A pet indulged from the tip of his black moist nose to the end of his curly tail. Dürer blesses him by painting him with the luscious strawberry of heaven above his head, but his pet is restless. In a

world such as this, there is so much to explore – all of it more interesting than sitting quietly at the feet of a human, even if she is the Virgin Mary – and so Dürer has placed an intriguing stag beetle in front of him, to keep him occupied.[6]

According to Eisler, the first time this jaunty creature appeared was in a drawing for Terence's *Andria* in 1492, accompanying the dandy Pamphilus. His last outings, in 1515, whether taken from Dürer's memories or from life in his last months on earth (tiny

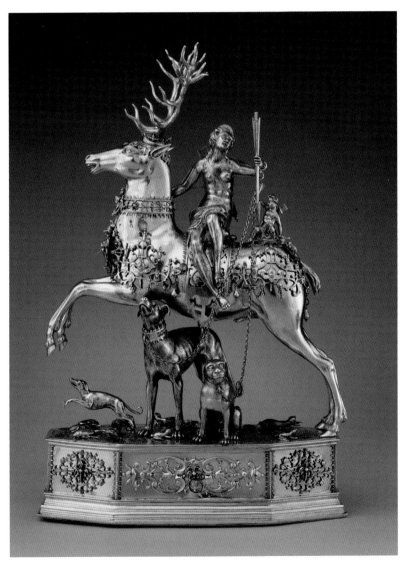

149 Joachim Friess, *Diana and the Stag*, c. 1620, partially gilded silver, enamel, jewels (case); iron, wood movement). Not as extravagant as the fountains of Maximilian, but nonetheless a substantial 38-cm-high (15-in.) master-piece by a master goldsmith, created for the extremely wealthy. A glorious novelty, this emblem of conspicuous consumption contained a wind-up mechanism which turned hidden wheels – causing it both to 'vibrate as if with life' and move across a dining table. And it held a secret – a drinking cup beneath the stag's head. But what of the dogs that accompany Diana? As we might expect Friess has fashioned the huntress a magnificent sight hound sporting the wide wrought-gold collars that were so fashionable at the time, as well as a smaller leaping sight hound, perhaps a miniature Italian greyhound and a stocky, rather benign-looking mastiff type. But the goldsmith has not contented himself with just the main players: scurrying among the stag's hooves and the dogs' great paws are a whole host of lizards, frogs and even what appears to be a stag beetle.

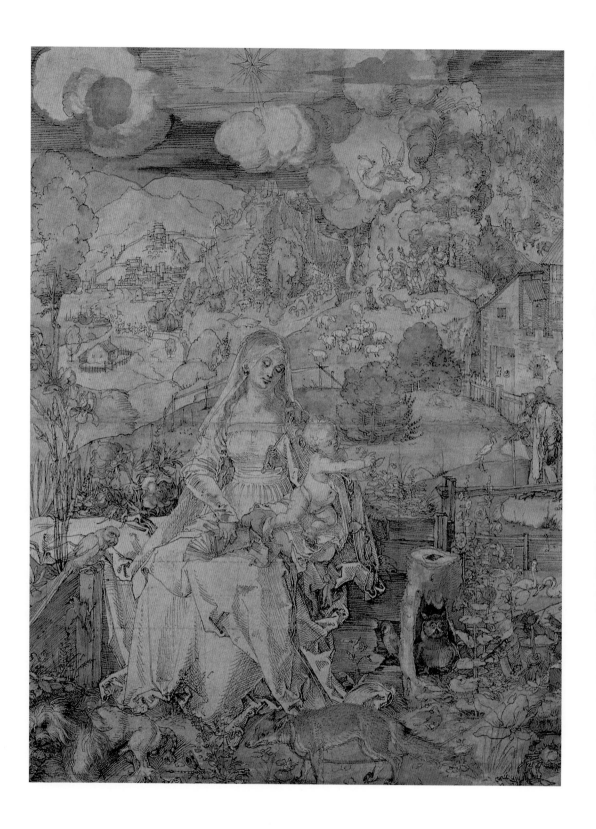

dogs can sometimes have surprisingly long lives – often living to well over twenty), were in Maximilian's *Book of Hours*. Here, ever more lion-like, he marches across the book's borders, his spiral tail now longer than his own body length – spot of comic relief. The little löwenpinscher (or lion terrier) takes on many roles. A dog for all seasons, sometimes he seems simply to be an addition to Dürer's monogram; at other times he is a diminutive trusty companion, as when he accompanies the fifteenth-century theologian Jean Gerson on his pilgrimage to Compostela in Spain. In *Knight on Horseback and the Lansequet* (mercenary) he springs up from Dürer's monogram as he gambols alongside the knight. He is also present at important events such as the *Martyrdom of St John*, in which he lies next to his all-powerful master as boiling oil is ladled over the saint. He looks out towards us part bored, part grumpy, part resigned, perhaps wondering if the follies of humanity will ever end.

He also attends *The Flagellation* (from *The Large Passion*) where his long fur, artfully hiding one eye, gives him a piratical image. And again he looks out to the reader, metaphorically shaking his head as he must again be a witness to the foolishness of man.

We see him at his piratical best in *Christ and the Physicians* (1495–6). Here finally we get to see the varied colouring of his untidy mop of hair and appreciate his trademark grumpiness in gorgeous Technicolor thanks to the glorious pigments oil paints give. The artist's pet, almost winking, is inviting us to laugh at the comical aspect of the doctors who thought themselves so learned but have been defeated in discourse by 'simple' Jesus. (Another attribute ascribed to dogs by Horapollo being laughter.) And who is the wisest of them all? Why, the dog. (Wisdom being another of the sterling qualities that dogs represented, according to Horapollo.) They also of course represent a good sermon and we cannot help but have the impression that Dürer's little dog knows it.

150 Albrecht Dürer, *Our Lady of the Animals*, 1503, pen, ink and watercolour.

151 Albrecht Dürer, detail
of *Christ and the Physicians*,
from *The Seven Sorrows*,
1495–6, oil on panel.

William Hogarth (1697–1764) is one of the first artists whose
life and canines are revealed to us in any detail. Although like many
artists, from Lucien Freud (whippets) to René Magritte (Pomeran-
ians), Hogarth was never without a succession of dogs of the same
breed, in his case pugs, one of his pets stands head and shoulders
above the rest: Trump.

Hogarth came from a cultured but impoverished background.
Unable to burst into the world of art because he needed to earn

a living, he initially turned his talented hand to engraving and etching, skills at which he excelled. But Hogarth had ambitions and, determined to make his mark on the world, he began to take art lessons from the famous, socially eminent and extremely accomplished painter Sir James Thornhill. In 1729, in a daring move which perhaps combined love with ambition, Hogarth eloped with Thornhill's daughter. Thornhill was furious, for Hogarth was way below him socially, but a combination of his daughter's attention and love and Hogarth's clearly visible talent soon reconciled him to the *fait accompli*. And it is in one of Thornhill's sketches of his extended family that we have our first glimpse of a Hogarth pug.[7] This is most likely the pug that was mentioned in this classified advertisement in *The Craftsman*, placed on 5 December 1730:

> LOST
>
> From the Broad Cloth Warehouse in the Little PIAZZA Covent Garden. A light coloured Dutch DOG with a black muzzle and answers to the Name of Pugg. Whoever has found him, and will bring him to Mr Hogarth, at the said place, shall have half a guinea reward.[8]

Was Pugg found? We do not know, but it is hard to imagine that the prospect of half a guinea, a substantial amount of money in those days, did not induce someone to accede to the demands of *conscience*.

Pugs and a cross-section of all of London's variegated breeds provide comic relief as they romp gaily, mischievously, boldly in almost all of Hogarth's works, be they his morality satires such as *Marriage A-la-Mode* (c. 1743) or his more formal, privately commissioned conversation pieces. Were the pugs all portraits of his current pet? Most likely, for why would Hogarth have painted another? Certainly the pug acting as a counterweight to the family

spaniel in Hogarth's *The Strode Family* bears the same demeanour, the same endearing expression, as his pug Trump in *The Painter and his Pug* (illus. 152). And Trump certainly appears in Hogarth's *Captain Lord George Graham in his Cabin* (1742–4), where, sitting upright on his back legs, he sports the captain's enormous wig and looks out at the convivial musical gathering over an important-looking paper propped up in front of him, which might even 'bear a trace of Hogarth's signature (upside down)'.[9] (Hogarth and Graham were old friends and, more than this, they were Masonic brothers; Hogarth may have been placing his alter ego in this painting.)

Many would say *The Painter and his Pug* is a portrait of Hogarth with Trump. But if we look more closely at the work, Hogarth himself is simply a painting of a painting – 'the simplest head and shoulders portrait, in the familiar oval he used for his run-of-the-mill sitters . . . just another object in still life'.[10] It is the other subjects that are real: the books representing the literary basis for his 'comic history' painting, 'The LINE of BEAUTY And GRACE' – a kind of teaser which Hogarth would not explain until he published *The Analysis of Beauty* in 1753 – and above all Trump. Inimitable Trump, Hogarth's alter ego, his mask, if you will. This painting stated clearly that Trump stood for Hogarth, that each was as pugnacious, determined and mischievous as the other. Soon afterwards *The Painter and his Pug* was engraved and, known as *Gulielmus Hogarth*, it became the frontispiece to collections of Hogarth's engravings such as the *Rake's Progress*, in the fifth plate of which Trump, incidentally, 'woos a one-eyed bitch'.

Trump, then, was Hogarth's representative in the world and the world took him as such. Hogarth's detractors, of which there were many, took to calling him Painter Pugg, and when Paul Sandby, a deeply conservative watercolourist, satirized Hogarth in his *Pug's Graces* (1753), he transmogrified the painter into Trump. Hogarth, one imagines, must have secretly been rather pleased.

152 William Hogarth, *The Painter and his Pug*, 1745, oil paint on canvas.

238

Later in life, when Hogarth quarrelled bitterly, and very publicly, with his former friend the drunken clergyman Charles Churchill over his (Hogarth's) satiric portrayal of their mutual friend John Wilkes, Hogarth again turned to Trump for support. Drawing inspiration from 'Pug's Reply to Parson Bruin', a pamphlet published in Hogarth's defence, he took the plate of *Gulielmus Hogarth*, replaced his portrait with that of an enormous bear wearing filthy clerical bands, clutching a foaming tankard of ale and leaning on a wooden staff whose knot holes bear the legend 'Lyes', and removed the 'Line of Beauty'. Trump, as Hogarth's alter ego, naturally remains firmly in place, and quite literally pisses upon Churchill's *An Epistle to Hogarth*, now placed at his feet. *The Bruiser*, as this engraving was titled, sold around six hundred copies, making Hogarth a healthy £30 15s.[11]

In the late 1740s Hogarth's close friend the supremely talented French sculptor Louis-François Roubiliac (1705–1762) created terracotta models of both Hogarth and Trump. Hogarth's now graces the National Portrait Gallery. That of Trump is lost, last

153 Louis-François Roubiliac and the Chelsea Porcelain Factory, *Hogarth's Dog, Trump*, 1747–50, soft-paste porcelain.

being seen at Watson Taylor's sale at Erlestone Park in 1832 as Lot 171 and described thus: 'Hogarth's favourite dog Trump, Modelled in Terracotta by one who had often caressed him, his Master's friend, the celebrated Roubiliac'.[12]

The by now late middle-aged Trump was full of character. One ear is cocked to the side listening for noises off; one ear is down to concentrate on events in the room. His expression is concerned, as indeed it was in *The Painter and his Pug*. The fur is masterful, while the little rolls of fat speak to us of an indulgent and loving master. The whole is impossibly tactile. How do I know? Because Trump lives on, immortalized in soft-paste porcelain by the Chelsea Porcelain Factory at around the same date. Porcelain was all the rage, thanks to its status as an indicator of conspicuous consumption, and this, combined with Hogarth's celebrity status, the general desirability of pugs and the particular appeal of Trump, made Chelsea's white porcelain model a 'must have' item of the era. In short, it was a best-seller.

The Painter and his Pug had ushered Trump onto the world stage. His sculpture secured his position and he has maintained his eminence to this day, despite the arrival of nouveau canine celebrities such as Andy Warhol's dachshund Archie.

Fittingly, Jim Mathieson's contemporary statue of Trump with Hogarth was unveiled in 2001 by that other staunch admirer of dogs, David Hockney, together with Ian Hislop, editor of the satirical publication *Private Eye*. It sits on London's Chiswick High Road, near the lovely mansion Hogarth lived in from 1749 until his death in 1764.

Unlike impoverished, city-bound Hogarth, Henri de Toulouse-Lautrec (1864–1901) came from a wealthy, artistically talented aristocratic family whose principal interests, other than art, were dogs, hunting, horses and falconry. Toulouse-Lautrec grew up embracing nature and playing with the denizens of the family menagerie, 'two dozen dogs, the horses in the stables, Zybeline, the

tame marten, and the whole "colony" of canaries' at their Château du Bosc near Albi.[13] His first sketchbooks, from around the age of nine, are full of his animal friends.

Toulouse-Lautrec, although no one realized it at the time, was suffering from an inherited bone disease which prevented his legs from growing properly and which also meant that he suffered several severe breaks to them during his adolescence. He was left crippled and stunted, unable to ride or embrace the outdoors life for which he had been destined. Thrown back on his own resources, he began to paint and sketch in earnest, making 'three hundred drawings and fifty paintings' in 1880 alone,[14] works that, like the majority of his future works, showed everything around him, even the life that was now lost to him.

The next year he painted his hound Flèche (Arrow) in a characterful study which demonstrates clearly both Toulouse-Lautrec's acute ability to observe life and his innate fondness for dogs. (He was to own several during his short life.) Strong paws and a noble head give the charming Flèche a certain gravitas as he looks out somewhat sadly, completely ignoring the hen at his feet – a detail that reveals to us that Flèche is a fine and well-trained hound. Here we see the surfacing of Toulouse-Lautrec's particular genius, portraiture. For his portraits went beneath the surface to reveal the strengths and weaknesses of his subjects, be they dogs, the celebrities of Montmartre or its prostitutes. Even though Toulouse-Lautrec's early work was necessarily influenced by his tutor Princeteau, a competent academic painter of horses and dogs, we can see here Toulouse-Lautrec's own unique style struggling to be born in the loose paintwork, the strong image caught in bold, rich-coloured brush strokes.

Toulouse-Lautrec did not indulge in self-pity. He did not bewail his fate – he took it and ran with it. Moving to Paris to take art lessons, he immersed himself to the full in Paris's bohemia, forging strong friendships and enjoying the love of its wild prostitutes, its

absinthe and its rum. He took in the sights of
the Parisian theatre and circuses and made
them his own in his art.

He remained fascinated and entranced
by the company and personalities of animals
and they continued to appear in his works. A
painting of Folette (which may be admired in
the Museum of Art Philadelphia), executed
nine years after that of Flèche, shows just
how much his personal style had evolved and
how it had developed into a form of expressive
modernism. This study, executed using 'long,
diluted streaks of paint to which he added,
often in the background, short dashes or
comma like strokes',[15] reveals to us a feisty
yet affectionate little dog with an indomi-
table yet sweet, feminine character. White-
blonde fur grown into a large ruff frames
her face with its enormous ears and large
black eyes, which show us a certain pensive-

154 Henri de Toulouse-
Lautrec, *The Artist's Dog
Flèche*, 1881, oil on wood.

ness. She sits upright and alert, and we can well imagine her being
the devoted mother that Toulouse-Lautrec described her as in his
letter to her of 1880. For he knew Folette well: she belonged to
his Aunt Josephine, Mademoiselle du Bosc.

As your nice letter yesterday announced, maternity's joys are
yours once again. There you are, once again the head of a
family; grave responsibilities weighing down your curly little
head. What care you will have to lavish on these warm and
rosy little creatures, feebly stirring their little paws at the
bottom of your basket. I'm sure your nice mistress and Mélanie
will help you with this difficult task and that they will make as
much, and even more fuss over your children as you yourself.

I also know you must have a crazy urge to eat the aforesaid Mélanie when she wants to touch your progeny and the echoes of your G-r-r-r-G-r-r-r will resound in the living-room.

So, first of all, I implore you not to eat all of the above-mentioned Mélanie and to leave at least a little piece of her to care for your nice mistress; second to lick your babies very thoroughly, so that the good people of Castelnau will be able to raise their hands to heaven and say, amid tears of emotion, 'Oh God, they're just like their mother!'

In closing I send you heartfelt congratulations and pray you to lick your mistress's hand for me.

I squeeze your little paw,

Henri de Toulouse Lautrec

P.S

Remember to give my best to Flavie, Mélanie, and Benjamin.[16]

Although there was a central period in his truly profligate bohemian days when dogs featured somewhat less in his life and work, they never disappeared entirely. And just as he painted Montmartre's human characters, so he painted its canine ones, such as the very present Bouboule. Bouboule was the resident bulldog of La Souris, and had, according to reports of the time, a penchant for disappearing underneath the restaurant's tables to pee on its lesbian clientele's long dresses.[17] (And from Bouboule's point of view, why not? La Souris was after all her home, the diners mere interlopers. She was only marking her territory.)

As the years went by and a certain madness brought on by the all too common dual ills of alcoholism and syphilis began to take hold of Toulouse-Lautrec, dogs such as Bouboule, his friend Calmès' mongrel and J. Robin-Langlois' collie began to feature ever more frequently in the lithographs for which he is so famous. For where there is life there are faithful and amusing dogs, and

155 Henri Toulouse-Lautrec, *Folette*, 1890, oil on cardboard.

perhaps in these last sad and desperate handful of years, this knowledge gave him a certain comfort.

Pierre Bonnard's (1867–1947) succession of dachshunds were little friends who provided him with a means of escape from the ceaseless presence of Marthe, his live-in lover. Bit by slow bit, Marthe had morphed into an agoraphobic, neurotic, deeply anti-social jealous woman who literally refused to go out. Unsurprisingly, Bonnard fell in love with his beautiful young model Monchaty and proposed. When Marthe realized this she went on a mad rampage, destroying every painting of Monchaty that she could find. Bonnard, in guilty response, sacrificed his love and the vitality of his entire life and finally, after 32 years of keeping her as his mistress, married Marthe. Less than a month later, Monchaty killed herself, something Bonnard never recovered from. His life might have been so different – so full of energy and passion – had he stayed with Monchaty. As it was, he was to spend many years isolated from Paris, isolated from his friends in a house in the hills overlooking Cannes, with a woman who sought to constantly hide herself and to keep Bonnard physically, repressively, next to her. A woman who was increasingly depressive, mad even. That Bonnard loved Monchaty seems evident in the one painting which survived Marthe's rage; an unfinished painting which Bonnard could only bring himself to complete, or perhaps more accurately *could* only complete, after Marthe's death, shows the blonde, beautiful, vital Monchaty looking out from the centre of the painting, while on the very periphery we see a dark, hovering, small part-profile of Marthe. Bonnard, at last able to do as he pleased, added a brilliant yellow ground 'gilding the canvas in memoriam'. And there, next to Monchaty, is his ever-constant, ever-faithful, never judgemental companion – his dachshund – their two images linked by his signature. How could it be otherwise in a painting that had such intense emotional resonance for Bonnard?

156 Pierre Bonnard, *Young Women in the Garden (Renée Monchaty and Marthe Bonnard)*, 1921–3/1945–6, oil on canvas.

Bonnard's dachshunds (a series of sleek dogs all called Pouce) must have been a wonderful outlet of calm and uncomplicated affection in a web of pooling emotions, passions, death, isolation and misery. There are many photographs and even little clips of film that show Bonnard with one of his series of dachshunds upon his lap. And he appears so sad, so lonely and distracted.

It is said Bonnard stops time in his paintings, that he freezes moments. And certainly Marthe never ages; her body remains as it must always have been. She lies often in a bath, but the bath resembles a sarcophagus, Marthe as mummified flesh, preserved by a mysterious science. Marthe as Bonnard must have preferred to remember her. And the dachshunds are also ever renewed, but they are flesh and blood – a never-ending stream of eternal dogs.

Dogs which were his accomplices. Dogs which even before his incarceration above Cannes furnished him with so many reasons, so many excuses, to slip out of the house that Marthe inhabited. Out to take the dog for a walk, a walk to meet close friends such as Alfred Jarry (Bonnard completed more than one hundred drawings of Jarry's monstrous character Père Ubu) in a café. When Jarry died Bonnard named one of his dogs Ubu in his memory: esteem indeed.

Bonnard's dogs slip in and out of so many of his paintings. Sometimes they hold centre stage. Sometimes they are a nose poking up from a margin, as in *The Dining Room*. And even when they are not there, we know they are just beyond the edge of the painting or waiting beneath the table with its oft-repeated red-and-white tablecloth. If Landseer often conjured up the *owner* of a dog, then Bonnard conjured up the *dog*. Bonnard's scenes are nothing if not familiar. If Marthe or a certain jug are there, then, we can be sure, so is the current Poucette.

The dogs he does paint (always from memory, Bonnard found painting from life too restrictive) are delightful. As Richard Dorment wrote in the *New York Review of Books*, 'You don't love Bonnard for his pictorial innovation. You love him for his pictures of his little dachshund Poucette.'[18] However, one person who did not love Bonnard was Picasso, who dismissed him thus: 'That's not painting, what he does' – and, even more insultingly as far as Picasso was concerned, 'He is not really a modern painter.'[19]

But one thing these painters did have in common was their attachment to dogs. For Picasso, from his early teenage years spent with the family dog Klipper until his death, was never without a dog, and often was with many. His first companion was the rotund terrier Gat (cat in Spanish). Gat was a gift from his old Catalan friend Miguel Utrillo and was probably named after the tavern Els Quatre Gats (the four cats) in Barcelona, where the seventeen-year-old Picasso, Utrillo, Gaudí and other budding modernists of the era used to meet. And it was Gat, along with his friend Junyer

157 Pierre Bonnard, *Dressing
Table and Mirror*,
c. 1913, oil on canvas.

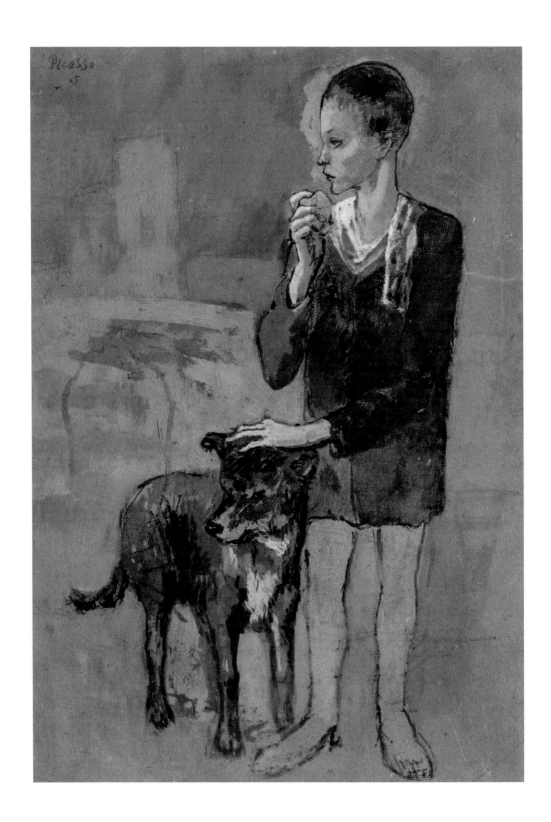

Vidal and his important paintings, who accompanied Picasso to Paris in 1904 when he set up home and studio in the Bateau-Lavoir, so named because its ramshackle wooden exterior resembled the boats the washerwomen on the Seine employed and because it was always flapping with the thirty or more occupants' laundry. Thrown together, this wooden shanty town boasted only one tap and was draughty, freezing cold, dripping with moisture and redolent with cat's piss.[20]

Gat was soon joined by Feo. In *The Artist with his Dog Feo* a disgruntled, probably half-starving Picasso, dressed in a huge overcoat and wearing that quintessential Parisian accessory, a beret, faces a hostile world with his closest friend. And seemingly it is this same emotionally nourishing companion who accompanies the waif in his *Boy with a Dog*.

Paris was heaving with poverty and here Picasso has captured the sadness, the loneliness and the sufferings that a boy and dog must share in this harsh, cold environment. Although strictly speaking this gouache is not in Picasso's monochromatic Blue Period (1901–4), a palette that spoke volumes both about the horror of cold and Picasso's state of mind, a year later he is still using the colour to conjure up the cold of a Paris winter. The waif rests a protective hand on his dog, his succour. And the dog is close to him, his warm neck touching the boy's thigh in a sign of complicity. The complicity that Picasso must have also felt with Teo and Gat. And yet, contradictorily, in this as in so many things, Picasso seemed to find no conflict between his at times admittedly casual affection for his animal menagerie and his passion for the *corrida* (bullfight), and the bloody suffering it caused to bull, horse and very, very occasionally man.

It wasn't long before the canine love of his life – Frika, half German shepherd, half Breton spaniel – entered Picasso's life. Picasso never forgot how much he had wept when finally, with Frika beyond help and hope, he had had to have her shot by El

158 Pablo Picasso, *Boy with a Dog*, 1905, gouache on brown card.

Ruquetó, a local *garde-chasse*. Just the mention of her name even fifty years later was capable of bringing an expression of regret to his features.[21]

And many, many dogs had come and gone in those fifty years. Elft, an Afghan hound and habitué of the pre-war cafés Picasso frequented, where he begged surreptitiously for sugar lumps – a treat Picasso refused to give him on the grounds that they would ruin his eyes and his teeth. Elft's long silky fur became hanging wads of rather ungainly fur-like hair in one of Picasso's less than flattering portraits of his long-term mistress Dora Maar.

'Have you ever noticed that he can assume poses that are so extraordinary they make you think of anything in the world except a dog?', Picasso said of his next Afghan, Kazbek, to Brassaï, who was soon to be the hound's photographer of record. 'Look at him over there. Doesn't he look more like a giant ray than a dog? Dora (Maar) thinks he resembles an enormous shrimp. Man Ray took some photos of him. Maybe you will too, some day.'[22] Not only a star in his own right, he was also Picasso's muse. 'After all you can only work against something. That's very important. Since I work with Kazbec I make paintings that bite.'[23] And when he worked with Perro, the delicious black-and-white Dalmatian, he made paintings that had *spots*.

And then there was Lump, the dachshund who filled at least some of the emptiness that Frika had left in his heart. Success had finally given Picasso the physical space he needed to surround himself with living creatures in the form of La Californie, a house just outside Cannes. He filled it with paintings, ceramics and sculptures. Its grounds became a forest of art where his animal friends played and loved. Pigeons and doves occupied his upstairs studio, multiplying in a year from two to forty, while an owl kept watch in his downstairs atelier. Spotty dog Perro prowled the grounds. Jan, the adored, smiling, blind boxer of *Woman Playing with a Dog*, slept in a downstairs hall, with books, paints and packing cases

for company, while Cabra the goat dreamt in a straw-filled packing case outside Picasso's bedroom, her droppings considered delicious treats by Jan and Lump.

Lump had come to La Californie as a guest but made it his home. David Duncan, the renowned war photographer who was also the visual biographer of Picasso, had bought the imploring creature from a kennel garden in Stuttgart when he was eight weeks old. The pair had lived in Duncan's apartment in Rome, but this was no marriage made in heaven – it was a canine *ménage à trois*, and the giant Afghan who was the ruling incumbent was deeply jealous.

A year later, Duncan and Lump set out on a cross-country trip to La Californie. Lump bounded out of Duncan's car into dog paradise, a wondrous profusion of objects, crannies and creatures to sniff and play with. Almost immediately, Picasso was painting his portrait on a plate. The date was 19 April 1957, the day, as Duncan put it, 'He dumped me for Picasso.'[24]

There was nothing unrequited about Lump's passion – this was mutual love at first sight, a phenomenon described by Duncan thus: 'Like a wolf under a full moon, he poured all of the mystery in his heart into singing a secret song of love, which Picasso also knew.'[25]

Lump soon dominated La Californie. He found comfort in Picasso's arms. He gambolled constantly with Jan, ran through the long grass and wild flowers, ears flapping in the breeze – a miniature Dumbo. He slept among the tumble of Jacqueline Roque and Picasso's sheets; he ate at table with his own dinner plate, and was not averse to eating the leftovers off Picasso's while sitting on his lap. And he used the 2-metre-high (6.5-ft) bronze *L'homme au mouton* as his personal pissoir. He was even welcome in Picasso's third-floor studio, where he would arrive, his play stone in his mouth, and drop it with a thud on the floor, then wait for Picasso to kick it away so the game might begin again. Lump was truly

'access all areas', being denied Picasso's second-floor studio and pigeon retreat only because he would no doubt at least have *tried* to kill the birds, and who knows, he may have succeeded. When he first arrived at La Californie, despite never having seen a rabbit before – he was, after all, a dog from the mighty metropolis of Rome – he immediately attacked a Picasso-made paper cut-out rabbit and 'thrashed his kill blindingly' (despite their appealing looks and floppy ears, dachshunds were bred to hunt down badgers in their setts. Hence the long narrow bodies – they are also fine ratters). He presented it to Jacqueline and then ate it.[26] Picasso judged Lump thus: 'Lump is not a dog, not a man – he *really* is someone else.'[27]

During 1957, Picasso became obsessed with reinterpreting Velázquez's masterpiece, *Las Meninas*. Mentally embattled, he retired to his studio for increasingly long hours to struggle with his furies and be inspired by his muses. Finally, after a symbolic visit by a huge wild owl, Picasso's *Las Meninas* was born. Naturally it is Lump who replaces Velázquez's noble mastiff in this extraordinary, parodical royal assemblage. Lump appears in many works, but it is in *The Pianist*, another of Picasso's 58 variations on *Las Meninas*, that Lump is seen to best advantage (illus. 159). In Velázquez's original, the mastiff's rest is disturbed by Nicolasito Pertusato – a child jester – who prods him with his foot. Pertusato's hands appear to be trembling, which, according to Ronald Penrose, made Picasso imagine he could have been playing an invisible piano, while Penrose interpreted the black line of the original which was in the panelling behind Pertusato's neck as a cord 'by which the young pianist was hanged like a helpless marionette'. A just retribution, then, for disturbing the dreams of Lump.[28]

In 1961, while Picasso, Lump and his now wife Jacqueline were living in their new chateau at Vauvenargues, Kabul, another Afghan, joined Picasso and immediately joined the long list of Picasso's canine models. If Lump had been the star of *Las Meninas*, then Kabul became the face in the corner, or perhaps more

159 Pablo Picasso, *The Pianist No. 47*, 1957, oil on canvas.

accurately the rather large body in the middle, of Picasso's portraits of Jacqueline.

But even with Lump, perhaps the only living being who had ever dominated Picasso, and who even, according to Duncan, regarded Picasso as something of a 'soft touch', the painter could display a ruthless side. In 1962 (or possibly 1963 – the available chronology is somewhat confusing) Lump suddenly became completely paralysed and David Duncan 'rushed him through an autumn night to a doctor in Stuttgart who took nine months to cure him to where he could wobble through another ten years on eager, infirm legs'. Picasso had objected to this, berating Duncan, saying that it was *Contra la vida . . .* against life.' Lump and Duncan disagreed and for several years the relationship between Picasso and Duncan became as cold as the Bateau-Lavoir in winter.[29]

Before Duncan left to photograph the U.S. marines battling in Vietnam in 1967/8 he called on Picasso, a goodbye to an old friend before danger, for who knows what may happen to a war correspondent, and the ice melted. Lump, however, did not call. He remained chez Duncan, 2 miles up the road, where he 'was curled snugly under his old red plaid blanket . . . which Picasso and Jacqueline knew-and they were glad.'[30]

R.I.P.
Pablo Picasso 1881–1973
Lump (aka Lumpito) 1956–1973

Picasso's dog days end here, and we turn to an artist who was very different from the hot-blooded Spanish Picasso, an artist who was solitary and whose relationships with women were sparse. An introvert who was riddled with terrible angst: the dark Nordic Edvard Munch (1863–1944).

Munch, best known for the classic portrait of modern human alienation *The Scream*, painted, sketched and drew hundreds of

self-portraits, sometimes on a daily basis. Munch suffered terribly from loneliness, in part because he saw his principal and overriding relationship as with art, not with a woman. This loneliness was so deep that he preferred to listen to radio static rather than endure the terrible silence of his life. Another way Munch combatted his isolation was with a large retinue of dogs. Boxers, little terriers, large white furry dogs: a cross-section of canine races to more than rival that of Picasso's variegated tribe.

While Picasso was carousing in cafés and mesmerizing as many women as he could, Munch was exacerbating his loneliness but enhancing his essential humanity by retiring to an estate on the outskirts of Oslo, the beautiful Ekely at Skøyen, where he lived until his death. Inspired by his natural surroundings, Munch's work became more colourful and began to celebrate nature. Instead

160 Edvard Munch, *In the Kennels*, 1916. Some of the dogs who kept Munch's loneliness at bay, including Bamse, the boxer, his cinema-going companion. The lugubrious St Bernard was a close and esteemed friend of Munch's, so much so that the artist valued his critical opinion above his own. If Bamse were to give a film the paws down by barking, Munch would duly get up and leave.

of seeing humanity and nature as separate, he began to recognize that they were both part of a greater whole. *Self-portrait with Dogs*, painted when Munch was in his early sixties, features his terriers Truls and Fips. According to one commentator, it captures 'the moment before a longed-for event actually happened', a time when 'everything is still possible'.[31] The moment, then, when dogs come forward for a caress, for love, the moment before soft fur meets a warm hand. A moment that in truth probably meant considerably more to Munch than Truls and Fips, who besides having one another had a host of other canine companions with whom to romp. Munch has painted sadness and resignation in the faces of his terriers – and this was no metaphor, no Expressionism. The

161 Edvard Munch, *Self-portrait with Dogs*, 1925–6, oil on canvas.

dogs were old at this time and suffering from the vicissitudes that brings, as the photo of Fips shows (illus. 162). Munch captured the terriers' inner feelings with delicacy. He strove in art to capture the innermost emotions of the soul and not only that of humanity but here, of dogmanity – members of which, in the end, were his only friends.

The final artist in this potentially infinite chapter is the king of Pop art, the Pied Piper of the beautiful people – Andy Warhol (1928–1987). By the mid-1970s Pop art was well past the height of its fashionability. Warhol, however, stayed cool and in the public eye, thanks principally to his magazine, *Interview*, which was to become one of the chicest publications of the next couple of decades, but also because, rather revolutionarily at the time, he took to taking portrait commissions at $25,000 each, a very substantial sum in the 1970s and '80s. At one time he even advertised in the Neiman Marcus catalogue – something that he lived to regret, as it was seen as a rather downmarket move.

In 1973 Warhol's boyfriend Jed Johnson introduced Archie, a dachshund as inscrutable as Andy, into their lives. A couple of years later, Archie's lifelong friend Amos arrived. Warhol often took a reassuring breakfast with his Filipino housekeepers and the dachshund duo for company before setting out into a demanding world. And the dogs must have eaten just as well as Andy, as his diary for 29 September 1977 records, 'Ate some of Archie's food then started walking up to 730 Park Avenue . . .'.

Thanks to their daily constitutionals, Amos and Archie were neighbourhood personalities and in some circles were as famous as Warhol himself. Amos even inspired a cookie brand – Famous Amos. Warhol wrote on Wednesday, 9 November 1977, 'It was the most beautiful picture of a cookie that I've ever seen, and I went in and bought it, but when I opened the package the cookies were really little. It was the first time I was ever deceived!' The Famous Amos cookie baker said it took too long to make them

162 Edvard Munch, photograph of an aged Fips in the sun on the porch of Munch's house, Ekely. The shadow is Munch's as he takes the photograph.

162 Edvard Munch, photograph of an aged Fips in the sun on the porch of Munch's house, Ekely. The shadow is Munch's as he takes the photograph.

look like the ones on the picture. At least Amos and Warhol enjoyed *eating* the cookies. And Archie and Amos's fame stretched way beyond cookies. They also had their very own dummies made by 'the Lewis Allen people' to accompany Warhol's dummy robot in the play 'An evening with Andy Warhol'.

Curiously, for one who was not known for his love of the countryside, Warhol became friends with the artist Jamie Wyeth and frequently visited him on the south Pennsylvania farm that had also been the base for his father Andrew Wyeth, that magnificent realist chronicler in art of Brandywine. Jamie Wyeth follows in his father's artistic traditions and could hardly be described as an habitue of Manhattan's strictly metropolitan East side, so the friendship at first glance seems unlikely – but in 1976, the year Warhol immortalized Archie, they even held a joint show in which they painted one another's portraits. In 2017, the hundred-year anniversary of Andrew Wyeth's birth, which led to a slew of events including a retrospective at the Brandywine River Museum, Jamie Wyeth decided to create some further portraits of Andy based on the detailed sketches he made in 1976. But this time, they included the inimitable Archie.

One, painted on a screen door, now hangs in the Brandywine; yet another hangs in Jamie Wyeth's living room. In this work,

Warhol is not even the 'face in the corner'. Jamie Wyeth has painted him cut off at the chin, so that the focal point of the painting is entirely Archie. Why? Because

> Archie meant a huge amount to Andy. He carried that dog everywhere, even to Studio 54! So he became Andy personified, without the make up and the wig.
>
> Archie was the mirror of his boss. He'd sit there and stare at people. And just like Andy he didn't say a word.[32]

In yet another, *A. W. Working on the Piss* (illus. 164), Jamie Wyeth has captured all the true vulnerability of Warhol and exactly what Archie means to him. For here he holds Archie as if he were a piece of valuable and fragile porcelain, something that he must cling onto at all costs or risk disaster.

Besides his regular silkscreens, Warhol also made very speedy dog paintings. During the early 1980s, he was endeavouring to create joint art works with Jean-Michel Basquiat. On Monday 16

163 Andy Warhol, *Amos*, 1976, acrylic and silkscreen ink on canvas. This Pop art portrait of Amos in shades of subdued blue, although created in happier, pre-split times (1976) seems to presage the sadness and tragedy yet to come for Warhol, Archie and of course, Amos himself.

April, he diarized: 'I did a Dog painting in five minutes at five of 6:00. I had a picture and I used the tracing machine that projects the image onto the wall and I put the paper where the image is and I trace. I drew it first and then I painted it like Jean Michel.'

Jed and Andy split up over Christmas 1980 and Archie and Amos found themselves subject to joint custody. Andy took weekdays, Jed weekends, which became particularly hard for Warhol. On 19 April 1981, he wrote: 'It was Sunday so Jed had come and taken the dogs for the day. I cried three times. I decided to pull myself together and go to church.' Things didn't get much better, for years later Andy was still utterly unhappy. So much so that in December 1985 he decided not to attend a *musicale* because it was being held in the apartment next to Jed's and he just couldn't take 'hearing Archie and Amos barking in Jed's apartment . . . on their weekends off'.

Warhol gained a reputation for being utterly detached, but perhaps the truth is that, just like Landseer, he felt far too much and tried to protect an overwhelming emotional vulnerability by appearing off-hand. Real love expresses itself not in words but in deeds, and when in March 1985 Amos suffered a crushed vertebra, Warhol confided to his diary, 'So I slept on the floor with him last night. I'm on the floor now, still, with the phone, being a martyr' (20 March 1985). How many people would do this to keep even their lover company?

But Archie and Amos were getting older and sicker and after a distressing visit to the vet Warhol diarized: 'I told Jed I'd give him one of the Dog paintings. Life's so short and a dog's life is even shorter – they'll both be going to heaven soon.'

As it turned out it was Andy who went to heaven first, just over two months later on 22 February 1987.

REFERENCES

Introduction

1 '9/11: My Brave Guide Dog Led Us to Safety in Tower Inferno', www.express.co.uk, 11 September 2011.

1 In the Beginning

1 Nicholas Glass, 'The Oldest Art Gallery on Earth', *Sunday Telegraph*, 28 December 2003.
2 Mietje Germonpré, Martina Láznicková-Galetová and Mikhail V. Sablin, 'Palaeolithic Dog Skulls at the Gravettian Predmostí Site, the Czech Republic', *Journal of Archaeological Science*, XXXIX (2012), pp. 184–202.
3 Ibid.
4 George Catlin, *Letters and Notes on the Manners, Customs, and Condition of the North American Indians; written during eight years' travel amongst the wildest tribes of Indians in North America in 1832, 33, 34, 35, 36, 37, 38, and 39 . . .*, 2nd edn (London, 1841)
5 *Encyclopædia Britannica*, 'Western Painting, Early Classical Period', www.britannica.com, accessed November 2016.
6 'Margarita's Epitaph', www.britishmuseum.org, accessed November 2016.
7 Professor Mary Boyce, 'The Dog in Zoroastrianism', www.cais-soas.com, referring to *Vidêvdâd* 13.49, accessed 21 May 2017.
8 Ibid., *Vidêvdâd* 15.19, accessed 21 May 2017.
9 Ibid., according to a lost Avestan passage, preserved through Pahlavi translation in the Bundahišn (tr. *Anklesaria*, 13.28).
10 Ibid. See Mary Boyce, 'Dog in Zoroastrianism', www.cais-soas.com, accessed 4 March 2019.

11 Ibid., quoting *Šayest nê šayest*, 2.7.
12 Peter Clark, *Zoroastrianism: An Introduction to an Ancient Faith* (Brighton, 1988), pp. 89–81.
13 Mary Boyce, *Zoroastrians: Their Religious Beliefs and Practices* (London, Boston and Henley, 1979), p. 158.
14 Professor Mary Boyce, 'The Dog in Zoroastrianism', www.cais-soas.com, accessed 21 May 2017.
15 Felipe Solis Olguin, 'Art at the Time of the Aztecs', in Eduardo Matos Moctezuma and Felipe Solis Olguin, *Aztecs*, exh. cat., Royal Academy of Arts, London (2002).
16 Alfredo López Austin, 'Cosmovision, Religion and the Calendar of the Aztecs', in *Aztecs*.
17 Fig. 140, 'Head of Xolotl', ibid.
18 Ibid., from the accompanying wall panel *The Natural World*.
19 'Shaman Guarded Shaft Tomb for 1,500 Years', www.thehistoryblog.com, 23 March 2014.
20 Robert Rosenblum, *The Dog in Art* (London, 1988), p. 87.
21 Gallery label from 2009, Rufino Tamayo, *Animals*, see www.moma.org/collection, 7 December 2017.

2 The Supreme Predator

1 Kate Smith, *Guides, Guards and Gifts to the Gods* (Oxford, 2006).
2 'Fragment of a Desert Hunt', http://metmuseum.org/art/collection, accessed 12 December 2016.
3 E. C. Ash, *Dogs and their History and Development* (London, 1927).

4 Patrick F. Houlihan, *The Animal World of the Pharaohs* (Cairo, 1996), pp. 67–9.

5 Hannah Osborne, 'Hyena Burger? Saudi Taste for Wild Meat Threatens Species Extinction', www.ibtimes.co.uk, 21 June 2013.

6 Gaston III Phoebus, Count of Foix, trans. Ian Monk, *The Hunting Book of Gaston Phébus* (Madrid, 2002), p. 24.

7 Gaston III Phoebus, Count of Foix, commentary by Wilhelm Schlagg, *The Hunting Book of Gaston Phébus* (London, 1998), p. 31.

8 Ibid., p. 33.

9 Mark Brown, 'Edwin Landseer's Otter Speared: Rare Display for "Gruesome" Painting', www.theguardian.com, 9 May 2010.

10 Rosa Bonheur, *Brizo*, http://wallacelive.wallacecollection.org, accessed 15 June 2016.

11 Katherine MacDonogh, *Reigning Cats and Dogs* (London, 1999), p. 8.

12 Mary Morton, with essays by Colin B. Bailey et al., *Oudry's Painted Menagerie*, exh. cat., J. Paul Getty Museum, Los Angeles, Staatliches Museum Schwerin, Museum of Fine Arts, Houston and Schloss Ludwigslust, Ludwigslust, Germany (Los Angeles, CA, 2007), p. 12.

13 Loyd Grossman, *The Dog's Tale* (London, 1993), p. 147.

14 Hamilton Hazlehurst, 'The Wild Beasts Pursued: The Petite Gallerie of Louis XV at Versailles', *Art Bulletin*, LXVI/2 (1984), pp. 224–36.

15 Xavier Salmon, *Versailles: les chasses exotiques de Louis XV*, exh. cat., Musée de Picardie and Musée national des château de Versailles et de Trianon (Paris, 1995).

16 'Old Master and 19th Century Paintings, Drawings and Watercolors, Sale 2415 Part 1, Jean Léon Gérôme, *Master of the Hounds*, Lot Essay', www.christies.com, 26 January 2011.

17 Jane Lee, *Derain* (Oxford, 1990), p. 97.

18 '*Ratcatchers*, Sir Edwin Landseer', https://museum.wales/collections/online, accessed 25 January 2017.

19 Malcolm Warner, *The Paul Mellon Bequest: Treasures of a Lifetime*, exh. cat., Yale Center for British Art (New Haven, CT, 2001), p. 336.

20 Ibid.

3 From the Dark Ages to the End of the Renaissance

1 Kathleen Walker-Meikle, *Medieval Dogs* (London, 2013), p. 60.

2 Ibid., p. 78.

3 Kenneth Clark, *Animals and Men* (London, 1977).

4 'History of Oil Paint', www.cyberlipid.org, accessed 20 March 2016.

5 'Episode 1: Gods, Myths and Oil Paints', *The Renaissance Unchained*, BBC Four, 6 July 2017.

6 Rachel Billinge and Lorne Campbell, 'The Infra-red Reflectograms of Jan van Eyck's Portrait of Giovanni(?) Arnolfini and his Wife Giovanna Cenami(?)', *National Gallery Technical Bulletin*, XVI (1995), pp. 47–60, www.nationalgallery.org.uk.

7 'The Conjurer', http://boschproject.org/#/artworks, accessed 20 December 2017.

8 'Episode 4: Hell, Snakes and Giants', *The Renaissance Unchained*, BBC Four, 27 July 2017.

9 See 'Piero di Cosimo', www.nationalgallery.org.uk, accessed 21 June 2017.

10 All quotations from this section from Rodolfo Signorini, *Opus hoc tenue: la camera dipinta di Andrea Mantegna* (Mantova, 1985). All information on Rubino trans. Susie Green, pp. 186–93.

11 Colin Eisler, *Dürer's Animals* (Washington, DC, and London, 1991), p. 243.

12 Robert Hewison, *John Ruskin: The Argument of the Eye* (London, 1976), chap. 8.

13 Xavier F. Salomon, *Veronese: Magnificence in Renaissance Venice*, exh. cat., National Gallery, London (2014), pp. 17–20.

14 Kathleen Walker-Meikle, *Medieval Pets* (Woodbridge, 2012), p. 59.

15 Xavier F. Salomon, *Veronese: Magnificence in Renaissance Venice*, exh. cat., National Gallery, London (2014), p. 71.

16 Roderick Conway Morris, 'Ferrara Inaugurates a Partnership with the Hermitage Museum in Exhibition of Works by Il Garofalo', www.newyorktimes.com, 18 April 2008.

17 '*Two Hunting Dogs Tied to a Tree Stump* by Jacopo dal PONTE, known as Jacopo BASSANO Bassano del Grappa', http://cartelen.louvre.fr, accessed 21 September 1917.

4 The Dog Stands Alone

1 'Jacopo dal PONTE, known as Jacopo BASSANO Bassano del Grappa, *c.* 1510 – Bassano del Grappa, 1592 *Two Hunting Dogs Tied to a Tree Stump* 1548', http://cartelen.louvre.fr, accessed 21 September 1917.

2 Alessandro Ballarin and Giuliana Ericani, *Jacopo Bassano e lo stupendo inganno dell'occhio*, exh. cat., Museo civico di Bassano del Grappa (Milan, 2010), p. 87.

3 Miguel Falomir, ed., *Tintoretto*, exh. cat., Museo Nacionale del Prado, Madrid (2007).

4 E. C. Ash, *Dogs and their History and Development* (London, 1927).

5 See 'Imperial Salukis', available at https:// harvardmagazine.com.

6 *Rembrandt by Himself*, ed. Christopher White and Quentin Buvelot, National Gallery, London, 1999, and the Royal Cabinet of Paintings Mauritshuis, The Hague, 1999–2000 (London, The Hague and New Haven, CT, 1999), pp. 18–19.

7 H. Perry Chapman, *Rembrandt's Self-portraits: A Study in Seventeenth-century Identity* (Princeton, NJ, 1990).

8 Jakob Rosenberg, *Rembrandt* (Cambridge, MA, 1964), p. 37.

9 *Rembrandt by Himself*, pp. 18–19.

10 Aristotle, *Nichomachean Ethics*, 1170a25, in 'Cogito ergo sum', https://en.wikipedia.org/wiki, 25 August 2017.

11 Brian Sewell, 'I'd Rather Lose Art than My Beloved Dogs', www.express.co.uk, 27 October 2013.

12 See Peter Conrad's interview with David Hockney, *Observer Magazine*, 52 (25 October 1992).

13 Rosina Buckland, Timothy Clark and Shigeru Oikawa, *A Japanese Menagerie: Animal Pictures by Kanawabe Kyōsai* (London, 2006), p. 27.

14 Ibid.

15 Arne Eggum, *Munch and Photography* (New Haven, CT, and London, 1989).

16 Edvard Munch, *Diary*, 22 January 1892.

17 Catherine Whistler, *Baroque and Later Paintings in the Ashmolean Museum* (London, 2016), Image 44.

18 Claude d'Anthenaiseet et al., *Vies de chiens* (Paris, 2000), p. 16.

19 Mary Morton, ed., *Oudry's Painted Menagerie*, exh. cat., J. Paul Getty Museum, Los Angeles, Museum of Fine Arts, Houston, TX, and Staatliches Museum, Schwerin, Germany (Los Angeles, CA, 2008), p. 12.

20 Robert Fountain and Alfred Gates, *Stubbs' Dogs* (London, 1984), p. 13.

21 Ibid., p. 15.

22 Robin Blake, *Stubbs* (London, 2005), p. 260.

23 Desmond Shawe-Taylor, 'The Prince of Wales's Phaeton, George Stubbs', www.royalcollection. org.uk, accessed 15 January 2017.

24 Robert Rosenblum, *The Dog in Art* (New York, 1988), p. 29.

25 Laurence Libin, 'Philip Reinagle's "Extraordinary Musical Dog"', *Music in Art*, XXIII/1–2 (1988), pp. 97–100.

26 Andy Warhol *The Andy Warhol Diaries*, ed. Pat Hackett (London 2010), p. 516.

27 Diane Perkins, 'Tristram and Fox by Thomas Gainsborough', www.tate.org.uk, August 2003.

28 Michael Rosenthal and Martin Myrone, eds, *Gainsborough*, exh. cat., Tate Gallery, London, National Gallery of Art, Washington and Museum of Fine Arts, Boston (London, 2002), cat. no. 107.

29 'The Newfoundland in Art and Literature', www.ncanewfs.org, accessed 22 December 2017.

30 W. Cosmo Monkhouse, *The Works of Sir Edwin Landseer, RA* (London, 1877).

31 'Gamekeeper and Dogs by Constant Troyon', www.musee-orsay.fr, accessed 18 February 2017.

32 Deborah Chotner, *American Naive Paintings* (Washington, DC, and Cambridge, 1992), p. 380.

33 Nikolai Gol, Irina Mamonova and Maria Haltunen et al., trans. Paul Williams, *The Hermitage Dogs* (London, 2015), pp. 167–9.

34 'The Fascinating Edible Dog', http:// caninechronicle.com, accessed 9 August 2018.

35 Jean Marie Carey, 'Eyes be Closed: Franz Marc's "Liegender Hund Im Schnee"', *Digitales Journal für Philologie in Textpraxis*, XII (January 2016), www.uni-muenster.de/ Textpraxis.

36 Rosenblum, *The Dog in Art*, p. 78.

37 David Robson, 'There Really Are 50 Eskimo Words for "Snow"', www.washingtonpost.com/ national/health-science, 14 January 2013.

38 Carey, 'Eyes be Closed'.
39 Ibid.

5 My Best Friend and I

 1 Carlo Ludovico Ragghianti and Licia Ragghianti Collobi, *National Museum of Anthropology, Mexico City* (New York, 1970), pp. 18–19.
 2 Hannah E. McAllister, 'Art of the Ancient Near East', *The Metropolitan Museum of Art*, XXXIV/8 (1939), p. 197.
 3 Nikolai Gol, Irina Mamonova and Maria Haltunen et al., trans. Paul Williams, *The Hermitage Dogs* (London, 2015), p. 140.
 4 M. Falomir, '*Federico Gonzaga 1st Duke of Mantua* by Titian', www.museodelpradi.es/en/the-collection, accessed May 2017.
 5 M. Falomir, '*The Emperor Charles V with a Dog* by Titian', www.museodelpradi.es/en/the-collection, accessed May 2017.
 6 Katharine MacDonogh, *Reigning Cats and Dogs* (London, 1999), p. 77.
 7 Joaneath Spicer, 'The Archdukes Visiting the Collection of Pierre Roose', www.thewalters.org/chamberofwonders, accessed on various dates in 2017.
 8 Katharine Baetjer, '*A Woman with a Dog* by Jean Honoré Fragonard', www.metmuseum.org, 2016.
 9 Cosmo W. Monkhouse, *The Works of Sir Edwin Landseer* (London, 1879/80) chap. 1 and p. 87.
10 '*Princess Mary of Cambridge with Nelson, a Newfoundland Dog* by Sir Edwin Landseer', www.royalcollection.org.uk, accessed May 2017.
11 'Lot Essay, *An African Groom Holding a Stallion, with a Dog*, Alfred de Dreux', www.christies.com/lotfinder, 19 May 2006.
12 'Norman Rockwell: A Brief Biography', http://collections.nrm.org/about, accessed September 2017.
13 '*Breaking Home Ties*, Norman Rockwell', http://collections.nrm.org, accessed September 2017.
14 John Ruskin, *Modern Painters*, vol. I (London, 1843).
15 *The Guardian*, 29 December 2002, p. 10.
16 *Alex Colville*, dir. Andreas Schultz (Berlin 2010).
17 Helen J. Dow, 'The Magic Realism of Alex Colville', *Art Journal*, XXIV/4 (Summer 1965), pp. 318–29; *Six East Coast Painters*, exh. cat., National Gallery of Canada, Ottawa (1961), artist's statement.
18 Andrew Hunter, ed., *Colville*, exh. cat., Art Gallery of Ontario, Toronto, and at the National Gallery of Canada, Ottawa (Fredericton, New Brunswick, 2014); 'Alex Colville', www.gallery.ca, accessed June 2017.
19 Emails from John Wonnacott to the author, 16 November 2016 and 29 January 2017.
20 Serena Davies, 'In The Studio: John Wonnacott', 1 November 2005, www.telegraph.co.uk.

6 The Dog's Role as a Model in Life and Art

 1 Katharine MacDonogh, *Reigning Cats and Dogs* (London, 1999), p. 79.
 2 Richard Avedon, 'Borrowed Dogs', in *Performance and Reality: Essays from Grand Street*, ed. Ben Sonnenberg (New Brunswick, NJ, 1989).
 3 Robert Torchia, '*Cape Cod Evening* Edward Hopper', www.nga.gov, 29 September 2016. A Whip-poor-will is an American bird with a distinctive call that lives on the forest margins.
 4 Ibid.
 5 See 'Courbet Speaks', www.musee-orsay.fr/en/collections/courbet-dossier/courbet-speaks.html, accessed 31 October 2018.
 6 '*The Artist's Studio* Gustave Courbet', www.musee-orsay.fr/en/collections/works-in-focus, accessed September 2017.
 7 Jules François Felix Fleury-Husson (1820–1889, Sèvres), pen name Champfleury, was a French art critic and novelist, a prominent supporter of the Realist movement in painting and fiction. He was also the author of the extraordinarily successful 1869 book *Les Chats, histoire, moeurs, observations, anecdotes*.
 8 William Wegman, 'The Art of Photography', film by Ted Forbes, www.youtube.com, 2016.
 9 Elaine Louie, 'For an Artist and his Dogs, The Feelings Are Mutual', www.newyorktimes.com, 14 February 1991.

10 William Wegman, 'West Coast Video Art – MOCAtv', MOCA, www.youtube.com, March 2013.

11 Video for the show 'In the Company of Animals: William Wegman on Dogs and Photography', The Morgan Library and Museum, available at www.themorgan.org.

12 David Hockney *Dog Days* (London 1998), Introduction.

13 Ibid.

14 Email from Robert Bradford to the author.

15 Ibid.

7 The Dog as Adornment in Art and the Flesh

1 Claude d'Anthenaise et al., *Vies de chiens* (Paris 2000), p. 122.

2 E. C. Ash, 'The Pekinese', in *Dogs and their History and Development* (London, 1927), pp. 616ff.

3 'Looty the Pilfered Pekingese', https://nationalpurebreddogday.com, 23 December 2015.

4 '*Looty* Friedrich Key', www.royalcollection.org.uk/collection, accessed April 2017.

5 Sir Roger Williams, *Actions of the Lowe Countries* (London, 1618), p. 49.

6 Katharine MacDonogh, *Reigning Cats and Dogs* (London, 1999), p. 245.

7 Sir Roger Williams, ed. D. W. Davies, *Actions in the Low Countries, 1618* (New York, 1964).

8 '*A Dutch Mastiff (called 'Old Vertue')* *with Dunham Massey in the background*, Jan Wyck', Dunham Massey, The Stamford Collection (National Trust), www.nationaltrustcollections.org.uk, accessed April 2017.

9 MacDonogh, *Reigning Cats and Dogs*, p. 245.

10 'Pug', *Oxford English Dictionary* (Oxford, 1989).

11 Giuseppe De Nittis's *Signora col cane* at http://www.museorevoltella.it, accessed 31 October 2018.

12 Berkley Rice, *Other End of the Leash* (Boston, MA, and Toronto, 1965), pp. 194–213.

13 See '*Puppy*', www.guggenheim-bilbao.eus/en/works/puppy-3.

14 Email to the author by Robert Bradford.

15 Sir Howard Carter, 'Tut-Ankh-Amen: His Hounds and Hunting' , *Cassells Magazine* (May 1927).

16 www.inspiringquotes.us/author/9413-vita-sackville-west/p.9.

17 Judith Watt, *Dogs in Vogue* (London, 2009), pp. 14–15.

18 Ibid., pp. 30–31.

19 Douglas Cooper, 'Paul Gauguin', www.britannica.com/biography, accessed September 2017.

20 '*Arearea* Paul Gauguin', www.musee-orsay.fr/en, accessed May 2017.

21 '*Twilight or The Croquet Players*', Pierre Bonnard', www.musee-orsay.fr/en, accessed May 2017.

22 '*View Through a House* by van Hoogstraten', www.nationaltrustimages.org.uk, accessed July 2017.

23 '*Still Life with a Vase of Flowers and a Dog Juan van der Hamen y León*', www.museodelprado.es/en/the-collection, accessed July 2017.

24 'Diamond Dogs Revisited: An Interview with Orson Peellaert', http://guypeellaert.org/news, 24 August 2014.

25 Ibid.

8 An Artist's Best Friend

1 Cosmo W. Monkhouse, *The Works of Sir Edwin Landseer* (London, 1879/80), chap. 6.

2 'Masterpieces from the World's Museums at the Hermitage, *Self-portrait with Monkey*, Frida Kahlo, From the Museo Dolores Olmedo, Xochimilco, Mexico', www.hermitagemuseum.org/wps/portal/hermitage, 4 November 2015.

3 Frida Kahlo, *The Diary of Frida Kahlo* (London, 1995), p. 211.

4 'Masterpieces from the World's Museums at the Hermitage, *Self-portrait with Monkey*, Frida Kahlo'.

5 Colin Eisler, *Dürer's Animals* (Washington, DC, and London, 1991), chap 1.

6 Ibid., chap. 7.

7 *Hogarth: One Man and his Pug*, BBC Four, 26 March 2014.

8 R. Paulson, *Hogarth: His Life, Art and Times* (London, 1971), vol. I, p. 205.

9 William Hogarth, *Captain Lord George Graham, 1715–47, in his Cabin*, http://

collections.rmg.co.uk, accessed 5 November 2018.

10 Paulson, *Hogarth*, I, p. 4.

11 Ibid., p. 397.

12 J.V.G. Mallet, 'Hogarth's Pug in Porcelain', *Victoria and Albert Museum Bulletin*, III (1967–8), pp. 45–54.

13 Julia Frey, *Toulouse-Lautrec: A Life* (London, 1994), p. 98.

14 Henri Perruchot, trans. Humphrey Hare, *T. Lautrec* (London, 1960).

15 Gale Murray, *Toulouse-Lautrec, The Formative Years, 1878–91* (Oxford, 1991), p. 194.

16 Herbert D. Schimmel, ed., *The Letters of Henri de Toulouse-Lautrec* (Oxford, 1991), p. 41.

17 Robert Rosenblum, *The Dog in Art* (New York, 1988), p. 58.

18 Richard Dorment, 'What Art Does', *New York Review of Books* (1 December 2005).

19 Michael Kimmelman, 'A Dream World of Painting, Yielding Its Secrets Slowly', www.nytimes.com, 19 June 1998.

20 John Richardson, *A Life of Picasso*, vol. I: *1881–1906* (London, 1991–2007), p. 298.

21 John Richardson, *A Life of Picasso* (London, 1991–2007), vol. II, May 1913.

22 Brassaï, *Picasso & Co.* (London, 1967), p. 74.

23 André Malraux, 'As Picasso Said, Why Assume That to Look is to See?; A Talk Between Malraux and the Master', www.nytimes.com, 2 November 1975.

24 Susie Green, 'Pablo's Dog Days', *Guardian Magazine*, 8 September 2001.

25 David Douglas Duncan, *Lump: The Dog who ate a Picasso* (London, 2006), p. 61

26 David Douglas Duncan, *Goodbye Picasso* (London, 1974), p. 54.

27 David Douglas Duncan, *Viva Picasso* (New York, 1980).

28 Green, 'Pablo's Dog Days'.

29 Duncan, *Viva Picasso*, foreword.

30 Ibid.

31 Iris Muller-Westermann, *Munch by Himself*, exh. cat., Moderna Museet, Stockholm, Munch Museet, Oslo, and Royal Academy of Arts, London (London, 2005).

32 Brett Sokol, 'Meet Archie Warhol, the Art World's Second-most-famous Dachshund', www.nytimes.com, 17 July 2017.

BIBLIOGRAPHY

Aldin, Cecil, *An Artist's Models* (London, 1930)

Anthenaise, Claude d', et al., *Vies de chiens* (Paris, 2000)

Ash, E. C., *Dogs and their History and Development* (London, 1927)

Ballarin, Alessandro, and Giuliana Ericani, *Jacopo Bassano e lo stupendo inganno dell'occhio*, exh. cat., Museo civico di Bassano del Grappa (Milan, 2010)

Blake, Robin, *Stubbs* (London, 2005)

Boyce, Mary, *Zoroastrians: Their Religious Beliefs and Practices* (London, Boston and Henley, 1979)

Brassaï, *Picasso & Co.* (London, 1967)

Buckland, Rosina, Timothy Clark and Shigeru Oikawa, *A Japanese Menagerie: Animal Pictures by Kanawabe Kyōsai* (London, 2006)

Chapman, H. Perry, *Rembrandt's Self-portraits: A Study in Seventeenth-century Identity* (Princeton, NJ, 1990)

Clark, Kenneth, *Animals and Men* (London, 1977)

Dow, Helen J., 'The Magic Realism of Alex Colville', *Art Journal*, XXIV/4 (Summer 1965), pp. 318–29

Duncan, David Douglas, *Goodbye Picasso* (London, 1974)

—, *Viva Picasso* (New York, 1980)

Eisler, Colin, *Dürer's Animals* (Washington, DC, and London, 1991)

Fountain, Robert, and Alfred Gates, *Stubbs' Dogs* (London, 1984)

Frey, Julia, *Toulouse-Lautrec: A Life* (London, 1994)

Gaston III Phoebus, Count of Foix, commentary by Wilhelm Schlagg, *The Hunting Book of Gaston Phébus* (London, 1998)

Germonpré, Mietje, Martina Láznicková-Galetová and Mikhail V. Sablin, 'Palaeolithic Dog Skulls at the Gravettian Predmostí site, the Czech Republic', *Journal of Archaeological Science*, XXIX (2012), pp. 184–202

Gol, Nikolai, Irina Mamonova, Maria Haltunen et al., trans. Paul Williams, *The Hermitage Dogs* (London, 2015)

Grossman, Loyd, *The Dog's Tale* (London, 1993)

Hewison, Robert, *John Ruskin: The Argument of the Eye* (London, 1976)

Houlihan, Patrick F., *The Animal World of the Pharaohs* (Cairo, 1996)

Hunter, Andrew, ed., *Colville*, exh. cat., Art Gallery of Ontario, Toronto, and at the National Gallery of Canada, Ottawa (Fredericton, New Brunswick, 2014)

MacDonogh, Katharine, *Reigning Cats and Dogs* (London, 1999)

Moctezuma, Eduardo Matos, et al., *Aztecs*, exh. cat., Royal Academy of Arts, London (2002)

Monkhouse, Cosmo W., *The Works of Sir Edwin Landseer, RA* (London, 1877)

Morton, Mary, et al., *Oudry's Painted Menagerie*, exh. cat., J. Paul Getty Museum, Los Angeles, Staatliches Museum Schwerin, Museum of Fine Arts, Houston and Schloss Ludwigslust, Ludwigslust, Germany (Los Angeles, CA, 2007)

National Gallery of Canada, Ottawa, *Six East Coast Painters*, exh. cat. (Ottawa, 1961)

Paulson, R., *Hogarth: His Life, Art and Times* (London, 1971)

Rice, Berkeley, *Other End of the Leash* (Boston, MA, and Toronto, 1965)

Richardson, John, *A Life of Picasso*
 (London, 1991–2007)
Rosenblum, Robert, *The Dog in Art* (London, 1988)
Salmon, Xavier, *Versailles: les chasses exotiques de
 Louis XV*, exh. cat., Musée de Picardie and
 Musée national des château de Versailles et
 de Trianon (Paris, 1995)
Salomon, Xavier, *Veronese: Magnificence in
 Renaissance Venice*, exh. cat., National Gallery,
 London (2014)
Signorini, Rodolfo, *Opus hoc tenue: la camera
 dipinta di Andrea Mantegna* (Mantova, 1985)
Smith, Kate, *Guides, Guards and Gifts to the
 Gods* (Oxford, 2006)
Walker-Meikle, Kathleen, *Medieval Dogs*
 (London, 2013)
Warhol, Andy, ed. Pat Hackett, *The Andy Warhol
 Diaries* (London, 2010)
Warner, Malcolm, *The Paul Mellon Bequest:
 Treasures of a Lifetime*, exh. cat., Yale Center
 for British Art (New Haven, CT, 2001)
Watt, Judith, *Dogs in Vogue* (London, 2009)
White, Christopher, and Quentin Buvelot,
 eds, *Rembrandt by Himself*, exh. cat.,
 National Gallery, London, 1999, and the
 Royal Cabinet of Paintings Mauritshuis,
 The Hague, 1999–2000 (London,
 The Hague and New Haven, CT, 1999)

ACKNOWLEDGEMENTS

The author is grateful to so many people and institutions for helping her with this book – it would not have been half the book it is without their help. (Some of course, she is less than grateful to . . . but they know who they are . . .) The London Library in St James' Square is such a rich repository of art books, obscure and mainstream, that without it this book would certainly not have been as diverse. And the staff of the London Library? I can only speak in their praise. They were unfailingly helpful, going above and beyond the bounds of duty to find me books hidden in strange corners and fascinating volumes for my research where I would never have expected them to be. James Murray, Latin scholar and knowledgable member of Adrian Harrington Rare Books and Hall's Bookshop in Tunbridge Wells, who kindly translated the Latin inscription on the tomb of one Rubino, faithful friend to the Renaissance Gonzaga dynasty, and Ludovico in particular. The portrait painter John Wonnacott RP CBE, for the insights that he gave me into his work and for his kind permission to use *Mrs Janet Sheed Roberts aged 110 with Freuchie Aged 4* and *Reclining Nudes, Watching the Beautiful Lady*, the images of which he also kindly provided. The artist and photographer William Wegman, and also Christine Burgin, for so kindly providing the spectacular *Eames Low*, and the kind permission for use. The artist Jamie Wyeth, and also Marie Beth Dolan, for so kindly providing the fascinating *A.W. Working on the Piss*, and the kind permission for use. Philip Mould and Co for their generous permission to use the copyright image of *A Black Servant*, Colonial School, 1770. The Estate of Alex Colville/Ann Colville for provision of the arresting *Child and Dog*, 1952, and such kind permission for use. The Italian artist Luca Bellandi for permission to use *Red Song* and also his UK Gallery The Ransom in Pimlico for allowing me to monopolize their time while photographing it. Dr Mitchell Merling, Paul Mellon Curator and Head of the Department of European Art, and the extremely patient and understanding Howell W. Perkins, Image Rights Licensing Coordinator for the outstanding Virginia Museum of Fine Arts, who so kindly arranged to have James Barenger's *Jonathan Griffin, Huntsman to the Earl of Derby's Staghounds, on Spanker* photographed without charge and allowing me to use it. Alan Weston, *trompe l'oeil* artist extraordinaire, for his most kind permission to use the superb image of *Jack Russell*. Robert Bradford, deerhound admirer and creator of extraordinary sculptures, for provision of *Dasch, Deerhound Head*, and *Arty, a Work of Art* and kind permission for use. Richard Blurton, curator at the British Museum, for locating for me, several years ago now, a marvellous image of Shiva riding a parrot, which only now has come into its own. And Clive Head and Blains for kind permission to use *View of San Francisco*, an incisive view of the future. I would also like to thank Zaheen Qaiser at the National Portrait Gallery, London, who most kindly brought forward improvements on the search engine software, enabling me to search for portraits of people with dogs. San Francisco Museum of Modern Art for their kind provision of Daido Moriyama's *Misawa* (1971), which sadly I was unable to use because despite trying to contact the photographer via email and gallery I never received a reply regarding permission to use. American

museums are often outstandingly generous to all but I would like to give a particular mention to the Met in New York, the NGA in Washington and The Walters in Baltimore. And last, but of course no means least, for without him and his insight there would be no book at all, my publisher Michael Leaman at Reaktion Books. If I have forgotten anyone – I can only apologize – but my thanks and gratitude are there just the same!

PHOTO ACKNOWLEDGEMENTS

The author and publishers wish to express their thanks to the below sources of illustrative material and/or permission to reproduce it. (Some information not given in the captions for reasons of brevity is also given below.)

Photo akg-images / Erich Lessing: 60; Albertina, Vienna: 150; © 2019 The Andy Warhol Foundation for the Visual Arts, Inc. / Licensed by DACS, London: 163; The Art Institute of Chicago, Chicago: 88; photo The Artchives / Alamy Stock Photo: 99; Ashmolean Museum, Oxford: 1, 65; The Barnes Foundation, Philadelphia (© DACS 2019 – photo Bridgeman Images): 78; Bayerische Staatsgemälde-sammlungen, Munich: 109; courtesy the artist (Luca Bellandi): 21; Bibliothèque de L'Arsenal, Paris (photo INTERFOTO / Alamy Stock Photo): 45; Bibliothèque Nationale de France, Paris: 25; courtesy Blains Fine Art: 81; reproduced by kind permission of the artist (Robert Bradford), © Robert Bradford: 122, 123, 138; British Library, London: 40, 86; British Museum, London: 3, 6, 11, 51, 97, 113, 125, 127; courtesy The British Sporting Trust: 132; Castello di S. Georgio, Mantua: 48, 49, 50, 52; from George Catlin, *Letters and notes on the manners, customs, and condition of the North American Indians . . .* (London, 1841): 2; photo Chronicle / Alamy Stock Photo: 119; classicpaintings / Alamy Stock Photo: 155; photo Steve Collins / Barcroft Media / Getty Images: 136; Dunham Massey, Cheshire: 130; Dyrham House, Gloucestershire (Art Collection 2 / Alamy Stock Photo): 143; Egyptian Museum, Cairo: 7; © the Estate of Guy Peellaert, all rights reserved: 146; Galleria degli Uffizi, Florence: 57; Gallerie dell'Accademia, Venice: 55; from *Gazette du Bon Ton*: 135; Getty Center, Los Angeles (Open Access): 64; Grand Palais Musée d'Orsay, Paris: 73, 98, 116; photos Susie Green: 2, 145; Harvard Art Museums, Cambridge (photo Harvard Art Museums/Arthur M. Sackler Museum, gift of Charles A. Coolidge): 61; Hereford Cathedral: 41; photo Heritage Image Partnership Ltd / Alamy Stock Photo: 36; Hermitage, Saint Petersberg: 56, 75, 85, 91, 99, 158 (© Succession Picasso/ DACS, London 2019); The David Hockney Foundation: 121 (© David Hockney – photo Steve Oliver); Lady Lever Art Gallery, Port Sunlight (photo Antiques and Collectables / Alamy Stock Photo): 115; Library of Congress, Washington, DC: 82; photograpy Livius Organisation: 14; Los Angeles County Museum of Art, Los Angeles (Open Access): 18; Louvre, Paris: 28, 59, 105; photo Masterpics / Alamy Stock Photo: 73; Metropolitan Museum of Art (Open Access): 8, 9, 12, 19, 23, 24, 84, 92, 96, 111, 128, 149; Munch Museum, Oslo: 63; Munchmuseet, Stockholm: 160, 161, 162; Musée d'Art Modern, Troyes (© ADAGP, Paris and DACS, London 2019): 35; Musée des Arts Decoratifs, Paris: 134; Musée d'Augustine, Toulouse: 31, 53; Musée de la Chasse et de la Nature, Paris: 30, 66; Musée Municipal, Saint Germain-en-Laye: 44; Musée du Petit Palais, Paris: 110, 139; Musée de Picardie, Amiens: 32; Museo Civico Revoltella Galleria d'Arte Moderna Trieste: 133; Museo Dolores Olmedo Patiño, Xochi, Mexico (© Banco de México Diego Rivera Frida Kahlo Museums Trust, Mexico, D.F. / DACS 2019): 148; Museo Picasso, Barcelona (© Succession Picasso/ DACS, London 2019): 159; Museo Regional de Puebla,

INDEX

Illustration numbers are indicated by *italics*